TONY HILLERMAN'S LANDSCAPE

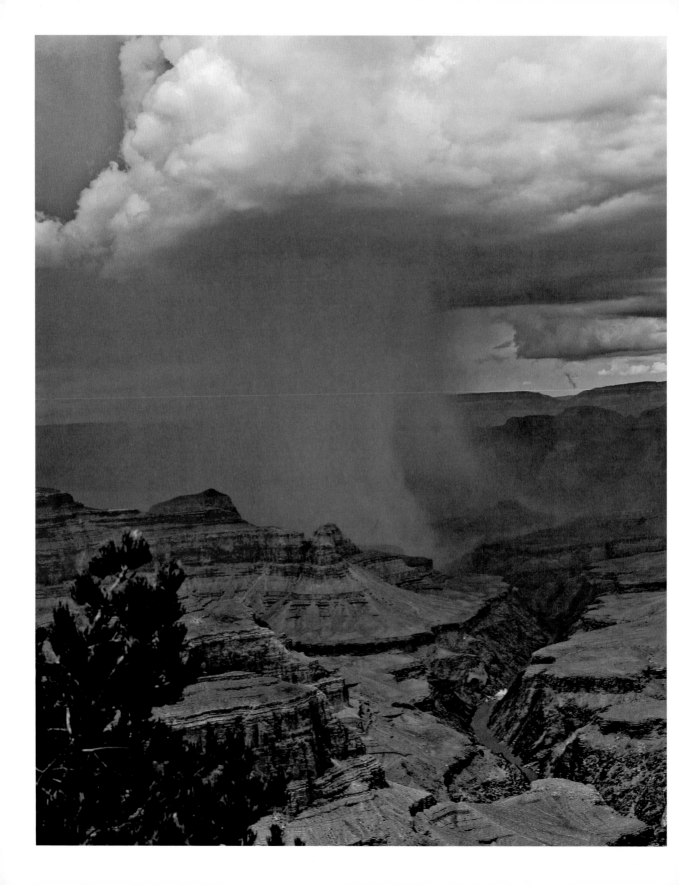

TONY HILLERMAN'S LANDSCAPE

On the Road with an American Legend

Anne Hillerman

PHOTOGRAPHS BY DON STREL

HARPER

An Imprint of HarperCollins*Publishers*

TONY HILLERMAN'S LANDSCAPE. Copyright © 2009 by Anne Hillerman. Photographs copyright © 2009 by Don Strel. All rights reserved. Printed in the United States of America. No part of this book may be used or reproduced in any manner whatsoever without written permission except in the case of brief quotations embodied in critical articles and reviews. For information, address HarperCollins Publishers, 10 East 53rd Street, New York, NY 10022.

HarperCollins books may be purchased for educational, business, or sales promotional use. For information, please write: Special Markets Department, HarperCollins Publishers, 10 East 53rd Street, New York, NY 10022.

FIRST EDITION

Designed by Leah Carlson-Stanisic

Library of Congress Cataloging-in-Publication Data

Hillerman, Anne, 1949–
 Tony Hillerman's landscape: on the road with an American legend/ by Anne Hillerman; photos by Don Strel.—1st ed.
 p. cm.
 ISBN 978-0-06-137429-6
 1. Hillerman, Tony—Settings. 2. Hillerman, Tony—Settings—Pictorial works. 3. Southwest, New—Description and travel.4. Southwest, New—Pictorial works. I. Strel, Don. II. Title.
 PS3558.I45Z68 2009
 813'.54—dc22
 2009007184

09 10 11 12 13 OV/QWT 10 9 8 7 6 5 4 3 2 1

FACING PAGE: *White House Ruins and petroglyphs at Canyon de Chelly, Arizona*

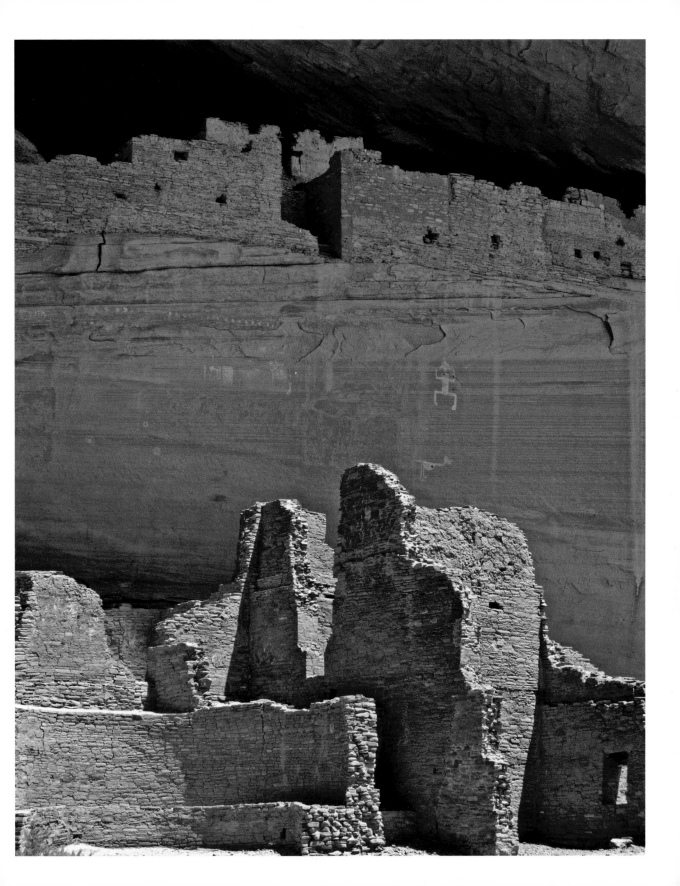

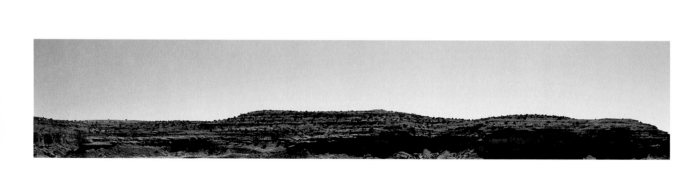

CONTENTS

FOREWORD

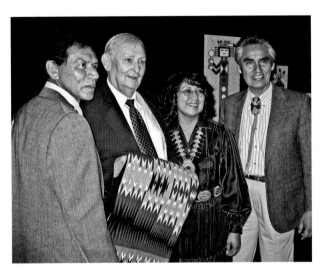

Actor Wes Studi, Tony Hillerman, Dr. Joe Shirley Jr., President of the Navajo Nation and his wife, Vikki Shirley, at the Notable New Mexican dinner, which honored Hillerman in Albuquerque in 2004.

COMES A TIME, comes a man who can read the landscape, and by it come to know a people, then tell their story, and enlighten the world to a whole new way of life.

Tony Hillerman had certainly come to understand the culture of Navajo people, a culture found in and tied to the land where Navajos dwell.

Who better than Tony Hillerman could read the landscapes and by it come to understand the ways of a people, which makes him a son of the Navajo people?

What is presented here, in this book, are some of the places where Tony Hillerman's stories about Navajos are found, heard, seen, and lived; Navajos call them sacred lands.

In the land are found Navajo people, and Tony Hillerman found them. No story can be told about Navajo people without referring to the land where they are.

In the same way, I hope you come to find a culture, a way of life, and a people in the story told through the landscapes depicted in this book.

Better yet, I invite you to come and see us on our sacred lands.

Dr. Joe Shirley, Jr.
President, The Navajo Nation

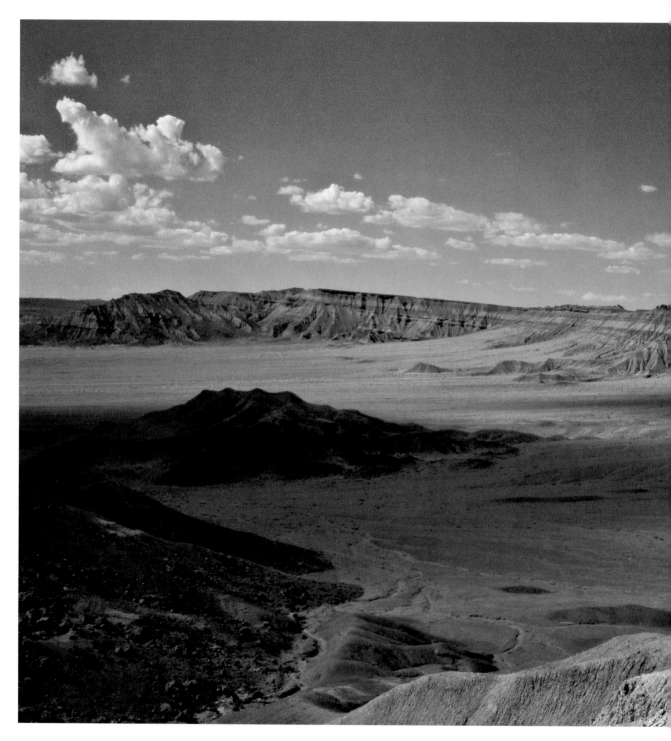

Badlands near Tuba City

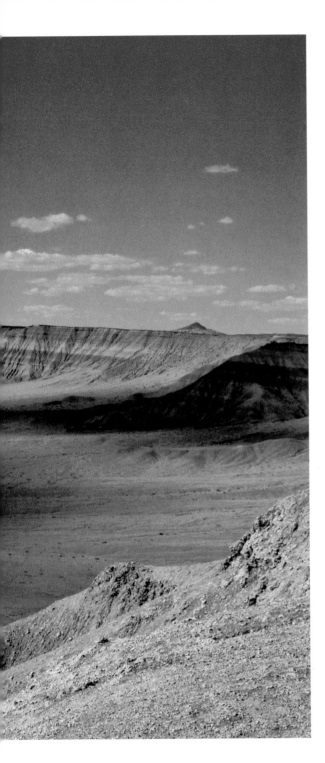

INTRODUCTION

Browsers expecting this book to be devoted to page after page of lovely vistas, dazzling sunsets, snowcapped peaks, and so forth will be not surprised by what they find. I don't think the photography will disappoint them.

Don Strel, a former college art professor, museum director, and a much published photographer, first suggested the project. His wife, a nonfiction writer and my senior daughter Anne, provided a wealth of ideas.

Our plan was to take readers with Jim Chee and Joe Leaphorn, the two Navajo detectives in my mystery stories, to *Dinetah*, a translation of "Land of the Diné" and homeland of the Navajos since long before Christopher Columbus was born. So Anne spent countless hours poring through the eighteen tales of Navajo tribal police activities, looking for scenic or otherwise notable places where old Lieutenant Leaphorn and young Officer Chee had found clues to the crimes and nabbed the criminals who beset the Diné.

That done, Anne obtained a contract from HarperCollins, my publisher for the latest of those novels, to use excerpts describing the scenery, explaining what had happened at the sites of

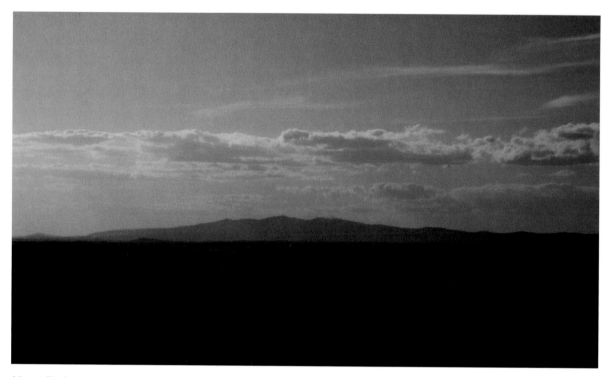

Mount Taylor as the Navajos may have seen it returning from Bosque Redondo

the photographs you will soon be looking at. The text sometimes talks about what had transpired in the mythical past to cause that mountaintop to be rated as holy ground. Or why stepping on the pattern running water had left in a certain streambed was taboo among traditional Navajos and that, therefore, the suspect the FBI agents were looking for probably was not the man they needed to be seeking.

Alas, there isn't a way to show in photographs the key cultural beliefs that made me rate traditional Navajos the world's most humane culture. If the crime Joe Leaphorn must solve involves talk of witchcraft, he will be looking for someone who puts wealth ahead of helping his neighbors— a sure sign of evil since the First Man of Navajo

culture emerged from the flooded Fourth World into this glittering world. The Navajo version of their genesis relates that First Man was a witch himself. When he realized that he had left his medicine bundle and all the magic within in the flood below, he told a heron to dive down and recover it for him. But he warned the bird not to mention the evil witchcraft materials it contained. "Just tell them it is the way to get rich."

I think that explains why the culture of the people whose home is "Between the Sacred Mountains" puts giving ahead of receiving and why accumulating wealth without being generous is a serious social failing. The tribe demonstrated their belief in that value system after the Civil War, when the United States government sent a

delegate to the Bosque Redondo concentration camp where the tribe had been imprisoned. The delegate described to the assembled tribesmen the glories of the fertile and well-watered land by the Arkansas River in "Indian Territory," where their crops and sheep would fare much better, and life would be much easier for them, far better than the rocky, barren, and almost waterless land they had occupied.

Here's how Barboncito, one of the Diné leaders, responded: "What we want is to be sent back to our own country. Even if we starve there we will have no complaint to make."

Tribal leaders signed a "peace treaty" on June 1, 1868. Escorted by four companies of U.S. cavalry, the Long Walk home began for the ten-mile-long column of men, women, and children. The marchers averaged walking ten miles per day to cross more than 300 miles, taking what remained of their cattle and sheep with them. On July 5, they crossed Tijeras Canyon and looked down from the next ridge across the little town of Albuquerque by the Rio Grande. Beyond, eighty miles to the west, stood the peak of Turquoise Mountain outlined against the horizon, one of the four sacred mountains marking the borders of their homeland.

One of the commanders of the Army troops who escorted the Navajos wrote about the moment in this report to Lt. Gen. William T. Sherman, who had headed the commission that freed the tribe from captivity: "We paused for a rest there, and when the Navajo saw their mountain on the western horizon, the whole column broke out in shouts and tears of joy."

But how can you show that in a photograph?

Tony Hillerman
Summer 2007

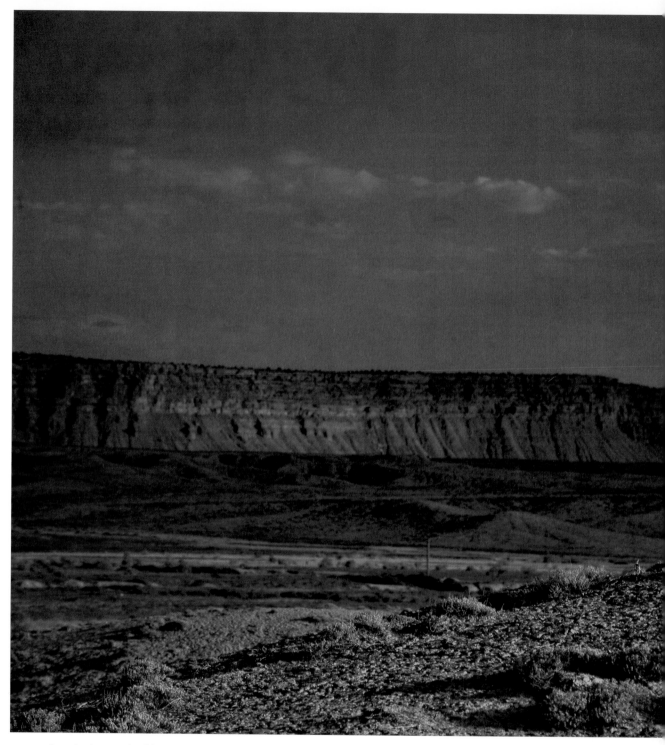

Anne looks over the Chimney Rock landscape north of Shiprock, New Mexico.

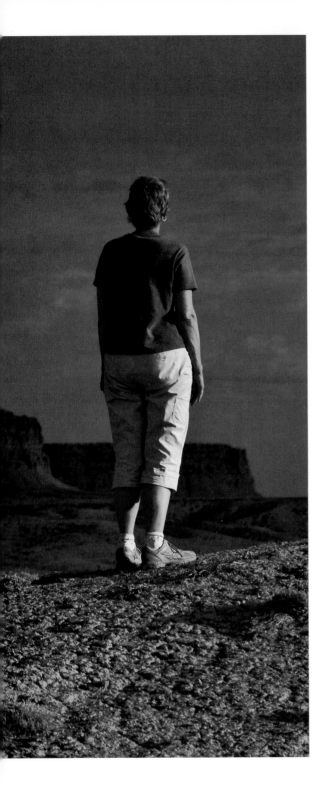

ON THE ROAD WITH CHEE AND LEAPHORN

A Daughter's Recollections

ANNE HILLERMAN

IN JUNE 2007, I had the pleasure of accompanying Tony Hillerman to two events. Dad was 82 at the time.

First, we went to a reunion of a group he fondly referred to as "ink stained wretches," men with whom he had worked when he was editor of *The* [Santa Fe] *New Mexican* in the 1950s. (I'd been a reporter and editor at the same newspaper myself for 13 years.) As I negotiated the traffic between Albuquerque and Santa Fe, past casinos and new housing developments, Dad talked. In addition to spontaneous critiques of my driving, he reminisced about how the road and the sights along it had changed. He and Mom had been driving this highway for more than fifty years, beginning before engineers smoothed the curves, eased the steepness, and ultimately transformed it into part of Interstate 25 that runs from the landscape of *Sinister Pig* near Las Cruces to the Colorado border.

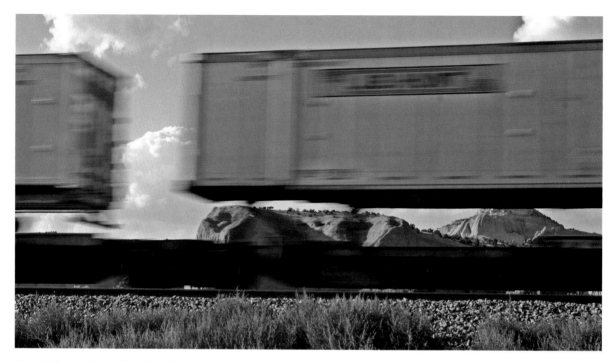

Tony Hillerman loved the red rock landscape near Gallup, New Mexico.

"Back then, we could drive for miles without seeing a car. Some of the cars we did see were off on the shoulder. Steaming. Overheated from climbing La Bajada [a steep incline about twenty miles south of Santa Fe]." He studied the view out the window, Santo Domingo Pueblo land passing by at eighty miles per hour and the blue ridge of mountains far west on the horizon. "I always loved this stretch of highway," he told me. "Look at the Jemez [Mountains] over there." He paused, ever the storyteller. "Of course, in those days, we couldn't drive so fast."

Our second outing came the following week. The Association for Communication Excellence brought its annual conference to Albuquerque and honored Dad with an award. A few intrepid souls brought copies of his books to the session, and, not surprisingly, Dad signed and chatted instead of eating the lunch I'd gathered for him at the buffet tables. Pleasant conversation always nourished him.

When plates had been cleared, the conference organizer invited him to join her onstage to talk about his life and career. Dad mentioned his newest projects: a pending Jim Chee/Joe Leaphorn novel with mercury poisoning as a subplot, and a nonfiction book, *Confessions of an Ink Stained Wretch.* That book would answer fans' frequently asked questions: Questions such as his schedule for writing and where he found ideas.

"Sitting at a computer is the place for taking a clunky sentence and smoothing it out, making it

read better," he told the moderator. "I do some of my best writing in my head before I fall asleep for my afternoon nap. I recommend that!" The audience chuckled. "In the book I'll talk about the way I write, think things through, say, when I'm driving on a familiar road."

He explained how, in days past, he would head out to the Navajo reservation, park in a shady spot, and sit, thinking his thoughts surrounded by the gift of natural beauty, away from the pesky telephone. (Dad never had a cell phone and strongly disagreed with the notion that a person should be reachable at any time, anywhere on the planet.) His inspiration came when he found quiet, a rare commodity for many years in the house where he and Mom raised a family of active kids while Dad kept a journalist's grueling schedule. Later, he juggled the demands of working simultaneously as a teacher, department head, and college newspaper advisor with his publisher's requests for revisions and new manuscripts.

The search for quiet often led him to the vast empty country that I've nicknamed "Hillerman's Landscape."

This book grew from my desire to immerse myself in my father's world, part real, part imagined. I wanted to stand where he stood and see what he saw. Many of Dad's descriptions in the eighteen books featuring Lieutenant Joe Leaphorn and Officer Jim Chee of the Navajo tribal police ring with such elegance that they made me wonder: How much was his writerly skill and how much, in fact, was the geography itself. When a fine writer meets a fine landscape, who could accuse him of exaggeration?

I'd visited some of the sites before, the familiar stars of Indian country: Painted Desert, Monument Valley, Canyon de Chelly, Grand Canyon. I'd been to Gallup, Farmington, Zuni. I had seen Ship Rock and Mount Taylor. Other sites were new to me. This project provided a wonderful opportunity to see these places as my husband, photographer Don Strel, took countless photos. The book connected me to the two most important men in my life.

When we set out, I expected to be impressed by the landscape, but I didn't expect to find so many people whom Dad's words had touched. After his death, the overwhelming kindness of people who felt connected to me because of their love of Dad's stories often moved me to tears.

Several months after Dad died I received an e-mail from a woman who shines shoes at the Albuquerque Airport. When Dad flew for various book events, he'd stop by for a shine and conversation. She hadn't been a reader, but over the years became a fan. She put a paperback in her purse for him to sign. Time went by and the novel grew dog-eared, so she took the book home. The next week Dad showed up, and as she polished his shoes she told him about the book. When she was done, he went to the closest magazine stand, bought his collection of short stories, *The Great Taos Bank Robbery*, and signed it for her with his usual flair. "I am still in awe of that most generous gesture," she wrote. "To me, that spoke volumes as to the kind of person he was, a true gentleman!"

For most of Tony Hillerman's favorite landscape, highway travel is the only way to get there. After some research, Don and I start our series of road

trips. We head out through the shallow brown valley of the Rio Puerco, country populated by rattlesnakes, roadrunners, hardy desert plants, and people who commute into Albuquerque or Grants. The highway rises through cliffs of Jurassic sandstone formed some 200 million or so years ago, dramatic scenery that serves as the platform for one of Dad's favorite anecdotes. I recall it from hearing him tell the story many times:

Traveling on a train to Los Angeles, I walked to the observation car to take in the full expanse of the same landscape. The tracks parallel the highway for much of the route from Albuquerque to Gallup. Towering cumulus clouds cast deep shadows that moved across the plain and canyons. A thunderstorm growing over Mount Taylor looked ominous and powerful and the low angle of the late afternoon sun made the desert glow red.

I shared the car with two men from elsewhere wearing suits and ties. The businessmen stood silently for a moment, looking at the sight. Then one said to the other, "My God, why would anyone want to live here?" From the tone of voice, I knew that he couldn't imagine it. But I was thinking, "Why would anyone want to live anywhere else?"

The encounter raised a recurring question, a subtle refrain that reappears throughout the thirty-six years of the series: Those who don't respond to the scenery in the Navajo mystery are always the bad guys.

———

Encompassing parts of Utah and Arizona as well as New Mexico, the Navajo Nation—the setting for at least part of each Chee/Leaphorn novel—sprawls over 27,000 square miles, larger than ten of the fifty United States. According to a 2000 estimate the population of *Diné Bikéyah*, Land of the People, included about 200,000 Navajo residents. This is a good place to live if you like your own company. And a good place to set your stories if, like Dad, you create characters who enjoy the drama of sudden thunderstorms and the freedom of views that can stretch more than a hundred miles.

They were driving past the Bisti Badlands now, looking into the edge of a wilderness where eons of time had uncovered alternating layers of gray shale, pink sandstone, yellow caliche and black streaks of coal. Wind and water had played with these varied levels of hardness and carved out a weird tableau of gigantic shapes—toadstools and barrels, gargoyle heads, rows of fat babies, the raw materials of the most frantic imaginations.

"Wow," Janet [Pete] said. "This country is always ready to surprise you."

[CHAPTER 26, *Sacred Clowns*]

———

Although Mom, Dad, and baby me moved to New Mexico in 1952, Dad had first encountered the landscape that captured his imagination a few years earlier. After his service in the infantry during World War II, he found a job driving a truck from Oklahoma to the Navajo reservation oil fields. South of Borrego Pass, in the isolated

A Navajo girl at Monument Valley, Arizona. About a dozen Navajo families live inside the park.

Chaco Canyon country of the Navajo reservation, he saw a dozen Navajo men and women on horseback, dressed for a ceremony. He discovered that he had happened upon a delegation bringing necessary elements for an Enemy Way for a couple of Navajo marines just back from the war with Japan. The rituals designed to cure them of the evil effects of involvement with so much death would restore the men to harmony with their people. Outsiders were welcome to attend as long as they behaved.

What he observed not only became a scene in his first novel, *The Blessing Way*, but the seed of Dad's lifelong affinity for the Navajo culture.

———

"When I returned from France, I was treated like nobody special," Dad told me a few years ago. He and I sat in his kitchen, where many of our best conversations took place. "These men were my age, had been through probably much the same thing. They were welcomed with a special ceremony to bring them back in rhythm with their people. I thought that was a fine idea, and that it said a lot about what was important to the Navajo."

He glanced out the window, calling my attention to a fat roadrunner that had hopped onto the patio wall to survey the greenery below. I watched the bird as Dad collected his thoughts.

"I didn't have any complaints about what had

happened to me. But I was impressed with their culture, which teaches Navajos to set aside anger, regret, bad memories and focus on the good." The image of the mounted ceremonial delegation stayed with him, percolating in his imagination as he wrote news stories as a reporter and editor. He returned to the reservation many times as a respectful visitor, made Navajo friends, and learned more.

———————

Calling the landscape of the Southwest's Indian Country "sacred" is more than metaphor. This geography of red mesas, volcanic outcroppings, and empty spaces, formed in the age of the dinosaurs, reverberates with stories of spirit beings and human emergence. While working on his Chee/Leaphorn mysteries, Dad heard Navajo and other Native American legends that dignify these arid places, linking them to holy people, divine clowns, and supernatural troublemakers. Outsiders might describe this startling scenery as barren, "barren" translating to "no trees to block the view." The barren and sacred exist together here. Dad believed that this ruggedly beautiful environment encouraged humankind to simplify life's complications and focus on our connections to each other and to the divine.

In the years since Dad wrote the inaugural Joe Leaphorn novel, *The Blessing Way*, traffic heading west from Albuquerque on Interstate 40 has increased dramatically. Back then, a person could cruise along for miles without seeing a big rig. Now, as Don and I head toward Gallup on I-40,

East of Winslow, Arizona, summer 2008

it's harder to enjoy the scenery. Trucks the size of houses block us in on both sides. We have to pay more attention to the road than Dad did when he first drove it more than sixty years ago. We find fewer opportunities to study the red mesas, to admire Mount Taylor on the horizon, to appreciate the surprise of a hawk floating over the sagebrush.

But, despite the busyness and the new casinos, this landscape can still take our breath away.

We get off the interstate for gasoline and lunch at the Acoma Sky City Casino. Enchanted Mesa, the traditional home of Acoma Pueblo, rises majestically a few miles south of the highway, accessible to visitors by guided tour. But there's nothing enchanted here, just slot machines creating an unharmonious chorus, flashing to entice the quarters out of our pockets. The restaurant, strategically placed behind the slots and blackjack tables, offers a hot buffet, salad bar, and a table of pies and cakes covered with plastic wrap. TVs tuned to sports stations blare out from nearly every wall, as if to preclude any possible chance of silence.

Nothing inside is as stunning as what's outside. Between here and Grants, the road runs along a broad black river of hardened lava. Mount Taylor, an ancient volcano, towers above us at 11,389 feet. The traditional Navajo know it as *Tsoodzil*, or Turquoise Mountain, the sacred mountain of the south. Dad mentions it in eleven of his mysteries. In *Coyote Waits*, an old Navajo recounts its origins to officer Jim Chee:

"They teach us that everything has two forms," Hosteen Pinto said, starting even further back than Chee had expected. "There is the mountain

Bunkers at Fort Wingate from the north with the Zuni Mountains in the background

we see there beside Grants, the mountain the biligaana [white people] call Mount Taylor. That is the outer form. And then they say there is the inner form, the sacred Turquoise Mountain that was there with the Holy People in the First World, the Dark World at the very beginning. And First Man brought it up from the Third World and built it on his magic robe and decorated it with turquoise."

[CHAPTER 14]

It's February, and we drive toward the edge of a weak storm. Halfhearted snowflakes melt when they hit the windshield. New Mexico is in a record drought; any snow is welcome. We pass Grants, a town built by the railroad and reinvigorated in the 1950s by uranium mining, and watch for the turnoff to Fort Wingate. We're looking for the bunkers Dad described in *The Wailing Wind*. We drive to the village of Fort Wingate instead, past the campus of Fort Wingate High School and see bunkers in the distance, but no roads toward them. We continue to the end of the pavement. Don goes into the post office and the postmistress points us in the right direction.

The entrance to Fort Wingate lies a few miles down the road at the next freeway exit, beneath a metal arch, past an abandoned guardhouse. At the end of the road a crew of young men shovels frigid mud, fixing a broken water pipe. The short, round-faced leader looks like he could be an American Indian but tells us he was born in

Guam. I'll call him Paul. He's delighted to take a break from his job to act as our tour guide.

From its establishment by the Army in the 1860s until its closure in 1993, Fort Wingate stored many tons of ammunition. Why here? Paul tells us the Army used the railroad to ship what it needed, and Gallup, about ten miles away, was one of the Southwest's major rail centers. TPL, Inc., a private technology development company, managed 1,000 acres, 200 storage bunkers, and some buildings here until April 2007. Operating a state-of-the-art demilitarization facility, TPL recycled the old bombs and ammunition under contract with the U.S. government.

I drive on slick clay with Paul in the front seat. Over the next rise, we see hundreds of bunkers. They remind me of huge inverted canoes. From the dirt piled on top, stalks of dead grass stand as straight as a buzz haircut. We stop. Don climbs out to photograph—pleased that no power lines mar the view. A quartet of graceful ravens make black circles against the pewter sky. I stand in the quiet of the afternoon and feel the wind blow cold. I think of the woman in *The Wailing Wind*, trapped in the bunker's darkness, alone and starving. This would be a lonely and miserable place to die. I imagine Dad standing in this very place and thinking the same thing many years before.

Back on the interstate, we head west to Gallup, a sprawling railroad town distinguished by the red cliffs surrounding it. We drive on to Window Rock, Arizona, capital of the Navajo Nation. As we continue through the suntanned country, I notice the maze of dirt roads angling off the broad four-lane highway, roads like those Chee and Leaphorn bounce along in search of evidence or suspects. According to the Navajo Department of Transportation, there are more than 9,000 miles of public roads on the reservation, and 78 percent of them are dirt or graveled. It's Friday afternoon and traffic is heavy. The speed limit drops to fifty-five miles per hour and Navajo police cars mix with the flow of vehicles.

———

The Navajo Tribal Police headquarters occupies a large, plain, pinkish building with a generic institutional look. Nothing romantically Southwestern about the place where Leaphorn worked until he retired to become a private investigator.

We enter through a side door. The building consists of small offices with flat low ceilings and ready-made wood veneer doors. The receptionist, a Navajo woman in her thirties with wavy brown hair, gives us a welcoming smile even though it's near the end of the day on Friday. She directs us to the chief.

Navajo Chief of Police Jim Benally is a slim man in a black jacket. His car keys and sunglasses are in his hand but he invites us to sit down. We explain our project and Don takes a picture of the chief with a map that shows the vast law enforcement districts of the Navajo Nation. It's marked with pushpins, just like the map Leaphorn so often consults when he's investigating a crime. The chief introduces us to the chief of detectives, a large man with the last name of Cowboy.

As we leave, the receptionist smiles again and tells us she had her picture taken with Dad on one of his visits here a few years ago. "I wish I had it with me," she says. "I'd like to show it to you."

At our motel the next morning, we strike up

a conversation with Rose, the Navajo woman in charge of the breakfast room. She's a Hillerman fan, she tells us, but she thought *Skinwalkers*, Dad's novel about Navajo witchcraft, was far too scary.

Before we leave, Rose gives us a sack with treats for the road—a banana, an apple, a cereal bar, and a bottle of water. Her kindness reminds me of my childhood.

When I was a girl, Mom always packed snacks for our road trips. When we lived in Santa Fe, on Sundays after mass Dad often said, "Let's go for a drive. Let's have an adventure!" I loved the ride in our lumbering green station wagon out Agua Fria Road. We stopped at fields and waited for well-used horses to come to the fence to nuzzle up old carrots we brought for the occasion. While we kids fed the horses, Dad's attention went to the deep blue bulk of the Jemez Mountains rising to the west beyond the Rio Grande Valley. He'd tell us how those peaks were born from ancient volcanoes. As the story unfolded, I could smell the acrid lava fumes and feel the rumbling earth.

I relished our occasional trips to the Pueblo Indian ruins at Bandelier, in those same Jemez Mountains. The site sits southeast of Los Alamos—the place where scientists created a different explosion, the first atomic bomb. After Dad pulled into the parking lot, we didn't linger to enjoy the perfume of the pine trees or the music of the nearby stream. We rushed straight for the trail to the cliff dwellings. We scurried up ladders into caves where Indians once lived. I loved the way one path squeezed between the big rocks, so narrow grown-ups had to turn sideways. I placed my steps inside the ancient footprints as Dad in-

vited me to consider how many trips to the river and back the Indians must have made to wear that trail into the rock.

———

Don and I head north toward Shiprock. We pass a store with a hay barn, horse trailers, bags of coal, and huge piles of wood for sale, a ready-made setting for a Chee/Leaphorn novel. The traffic flows fast and heavy, mostly pickup trucks. Northwestern New Mexico rises in beauty on all sides. The Chuska Mountains sprawl low to the west; volcanic plugs dot the horizon. Flocks of off-white and gray sheep melt into the landscape.

I'm navigating, looking for a turnoff. A large faded sign with an arrow points the way: Historic Two Grey Hills Trading Post. We head toward a compound of government housing set against sandstone buttes and all-encompassing sky. We spot another hand-painted directional sign and turn onto a lonely road. When the pavement ends, we go left toward the store.

The low stone building with a large front porch seems to be deserted. Not a car in sight. I've never seen the place before, but it looks exactly as I'd imagined from the references to it in *The Ghostway*. The proprietor, Les Wilson, is there along with Shirley Brown, his Navajo assistant and a weaver. The merchandise includes disposable diapers, metal pots, DVD rentals. In a display case, I discover a beautiful hand-beaded Navajo Santa Claus.

Wilson warms to us as he learns of our project and invites us to see the rug room. He has about thirty rugs here, rolled like cigars for storage, all created in the beautiful, understated Two Grey Hills geometric style named for this place.

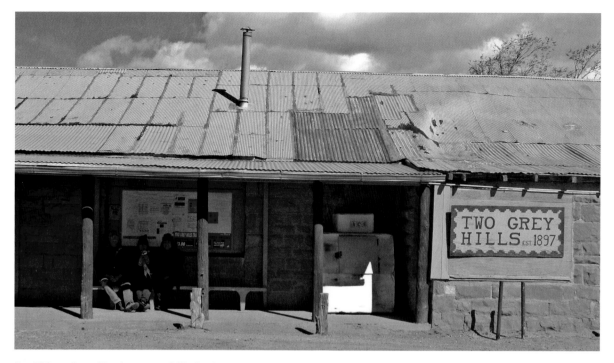

Les Wilson, Irma Henderson, and Shirley Brown in front of Two Grey Hills Trading Post, established in 1897

Shirley holds up a rug she wove so we can see the patterns. She used natural wool that gets its black, brown, white, beige, and gray from undyed fleece. Wilson shows me a postcard tacked on the wall. In his characteristically flowing penmanship, Dad had written: "Two Grey Hills is where the West starts."

A tall, lanky, unhurried man, Wilson offers us an album of historic photos of the trading post, then leads us through the back of the store, a ramshackle storage section more than a hundred years old. Outside, four good-natured dogs of mixed heritage greet us and we meet Wilson's Navajo wife, Irma Henderson. Irma joins us holding Margarita, a tiny Chihuahua in a red sweater, the only dog that barks at us.

Don asks Les, Irma, and Shirley to sit for a photo on an old wooden bench outside the trading post. I remember reading of the retired Joe Leaphorn sitting here, thinking over his latest dilemma, waiting for his ethnologist friend Louisa Bourbonette to finish shopping inside.

We backtrack to Shiprock, looking for lunch. The magnificently eroded volcanic core known as Ship Rock—and spelled as two words—rises 1,450 feet above the plain, its black walls of igneous rock radiating out like broken spokes on a wheel. The Navajo call it the "Rock with Wings" and, because it is sacred, usually deny mountain climbers permission to ascend, a key point in *The Fallen Man*.

In town, we cross the San Juan River on a nar-

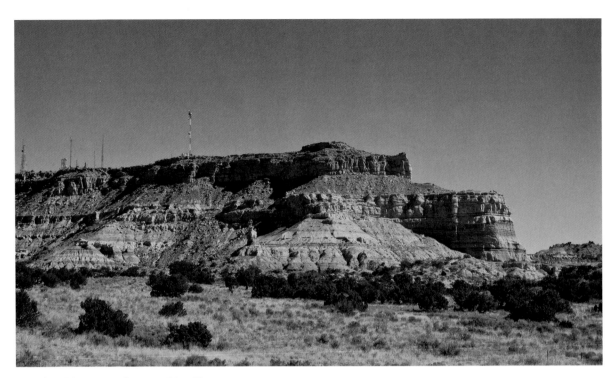

Huerfano Mesa in northwestern New Mexico

row bridge. The river is broad and slow here, different from the San Juan closer to Utah, that wilder river Leaphorn navigates in a kayak to find looted ruins and save a woman's life in *A Thief of Time*.

We stop for lunch at a local drive-in and I order green chili stew with soft warm fry bread—a classic combination popular on the reservation, impossible to find in my hometown of Santa Fe. Dad and Mom moved our family to Albuquerque in 1963 when Dad went to work for the University of New Mexico. I moved back to Santa Fe, an hour's drive north, fresh out of college, and have lived there ever since.

I drive as Don looks for a place to capture a photo of both Ship Rock itself and the community below. We stop at the Navajo police headquarters for advice, and an officer tells Don which dirt road to take for the best pictures. I think of Jim Chee's trailer home, planted in the shade of a big cottonwood tree along the San Juan. I think of Bernadette Manuelito (finally Mrs. Chee, in *The Shape Shifter*) as a teenager, playing high school basketball in the Shiprock gym.

On our way back to Albuquerque we pass Huerfano Mesa. Known as *Dzil Na'oodilii*, this is the Navajo Sacred Mountain of the Center, the place where Changing Woman gave birth to the legendary Warrior Twins. In *A Thief of Time*, the traveling minister Slick Nakai bemoans the

defacement of this revered mountain by an unholy display of roads and radio towers. He was right—they are an ugly addition.

Unlike the interstate, U.S. 550 is quiet. I drive and Don falls asleep. In the silence, I recall other car trips, the many happy Sunday afternoons I spent as a girl riding through New Mexico with my parents. Trips to the high-country Jicarilla landscape Dad later used in *The Shape Shifter*, and down to Las Cruces and El Paso, scenery that became home to *The Sinister Pig*. Dad wrote at night in those years. I remember occasionally waking up after midnight, needing reassurance, and finding him at the rolltop desk tucked into a corner of the bedroom. Seeing him there made me feel safe.

When Dad became a university administrator in the mid-1960s, the job came with an office away from the house he could use on weekends, a temporary escape from the distractions created by six children. When I enrolled at the University of New Mexico as a freshman, he and I rode to campus together each morning. Dad kept writing what became *The Blessing Way*.

When I was a college junior, Dad got his big break. I was attending the University of Massachusetts on an exchange program when he came east on UNM business. He'd been in New York and had called the editor to whom he had sent that first novel. She wanted to publish it! Dad tended to be a happy guy, but I can't remember having ever seen him happier.

The editor was Harper & Row's legendary mystery expert, Joan Kahn. He'd sent her a letter asking her opinion after his agent had advised him to abandon thoughts of writing fiction or, at the very least, to come up with a better novel "getting rid of the Indian stuff." I'm glad he got a second opinion. Ms. Kahn asked to see the manuscript, beginning Dad's long association with what is now known as HarperCollins. Unlike many authors, he never changed publishers.

———

The greatest gift my father gave me was the time we spent together. I loved his stories and he loved to tell them, but both of us let work and life's distractions keep us from spending as much time together as we would have liked. I envisioned this book, *Tony Hillerman's Landscape* as a magnet to pull us together. I pictured Dad in the car with Don and me, the unfolding landscape prompting his memories. But Dad always declined our invitations to ride along. At eighty, he treasured his afternoon naps and knew what it would be like to travel with a photographer who has to stop and stop again for the right shot. He and his photographer brother, Barney, had worked together on *Hillerman Country*, published in 1991. Like Don, my soft-spoken uncle refused to rush a picture.

I was disappointed by Dad's refusal, but not surprised. Declining health had ended his book signings and speaking engagements, both of which he loved. He'd stopped attending the First Friday Albuquerque authors' luncheons and only showed up occasionally at the poker game he'd long enjoyed.

———

After Dad died on October 26, 2008, my brain fogged as I sat to write about his work. He'd always told me that the cure for writer's block was simple:

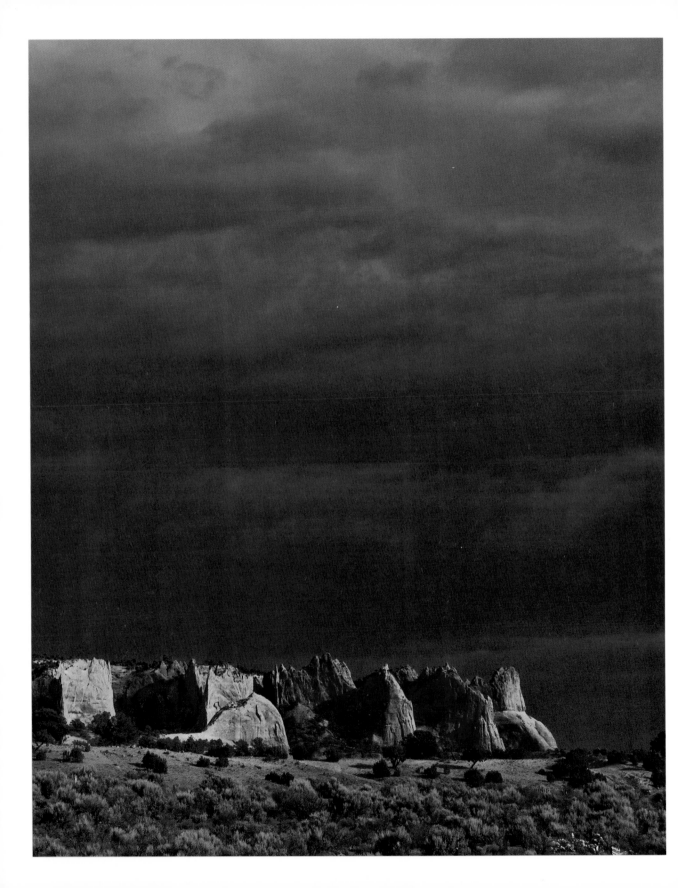

Sit down and keep writing. But I knew conjuring his stories hadn't always come easily for him.

When he was really stuck, he and Mom would drive to the scene of the crime, usually a distant spot on the sprawling Navajo reservation. The expansive scenery led to expanded thoughts. Dad told me that of all his novels, *The Sinister Pig* gave him the most trouble, and he blamed it on the change in location—the majority of that book is outside of Navajo country.

———————

The first trip Don and I make after Dad's death, returning to our project, takes us to Zuni Pueblo, the site of *Dance Hall of the Dead*. Tribal officials treat Don and me like honored guests. Councilor Arden Kucate escorts us to the Middle Village so we can photograph the dance plaza featured in the book. Beyond it, Corn Mountain rises against a clear blue sky. I feel a deep sense of calm joy as I stand in that quiet, ancient, and blessed space on that January afternoon.

Later, I'm looking for Dad's description of that scenery. I open *Dance Hall* to find the section where Leaphorn is comforting a young woman distraught over the deaths of two young boys.

Leaphorn said, "Maybe death should only be for the very old. People who are tired and want some rest." . . . Leaphorn talked about it quietly. He told her how the Navajo mythology dealt with

The Navajo Nation landscape north of Window Rock, Arizona

it, how Monster Slayer and Child Born of Water took the weapons they had stolen from the Sun and how they killed the monsters that brought death to the Diné but how they decided to spare one kind of death. "We call it Sa," Leaphorn said. "The way my Grandfather told me the story, the Hero Twins found Sa sleeping in a hole in the ground. Born of Water was going to kill him with his club but Sa woke up. He told the twins they should spare him so those who are worn out and tired with age can die to make room for others being born."

[CHAPTER 11]

———————

I had the honor of being with Dad in an Albuquerque hospital during the last two weeks of his life, bringing him sips of coffee, turning his pillow so the cool side sat against his skin, sitting with him and Mom and other family members who shared the vigil. Like any child whose parent dies, I wish Dad and I had more time together. But I saw that, supported by his deep Catholic faith, he faced death as friend, with no hesitation. When Sa came that Sunday afternoon, my father welcomed him. He was ready for what he often called "the next great adventure."

Dad loved it when strangers came up to talk to him about his writing, to shake his hand, to offer a well-read paperback for him to autograph. Until arthritis and fatigue made it impossible, he enjoyed book signings even when the lines were hours long. After his death, many other writers told me of the encouragement Dad offered them, including cover endorsements for their books. (Dad laughingly called himself "a blurb slut"

Tony Hillerman signing books at the Tony Hillerman Writers Conference: Focus on Mystery with daughters Jan Grado, illustrator of Hillerman's **The Boy Who Made Dragonfly** *(left), and conference organizer Anne Hillerman*

because he gave commendations with notorious generosity.)

My family received hundreds of messages of condolence, many from people who had never met my father, or us. At Dad's wake, a Native American man who wore his shiny dark hair in two long braids greeted our family and asked if he could offer a song in his own language in honor of Dad. He sang "Amazing Grace," his clear deep voice resounding throughout the church.

On the pages ahead, readers will find a tour through Dad's landscape in his own words supplemented by Don's remarkable photographs and my research and reminiscing. I organized this book chronologically with the exception of one chapter on books set on the Hopi reservation and another that groups the novels in which Chee and

Leaphorn travel far from home. We considered adding the two non-Navajo works, *Fly on the Wall* and *Finding Moon*, but decided the project flowed better with the Chee/Leaphorn focus.

The following chapters include a photo of the cover from each book's first edition. Beginning in 1986 with *Skinwalkers*, the covers took on the distinctive look created by Peter Thorpe. Using Navajo sand paintings as his guide, Thorpe designed the covers of more than forty editions of Tony Hillerman's mysteries.

Don and I were honored when Dad asked us to do this project. Working on the book was a privilege and a deep, deep pleasure. Visiting the landscapes that provided his settings and his inspiration moved and inspired me. I hope this book will do him proud.

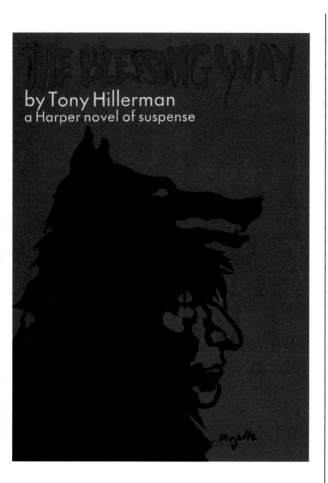

THE BLESSING WAY

The Story: Navajo Tribal Police Officer Lieutenant Joe Leaphorn hunts for a suspect on the Navajo reservation, following a trail of kinship, mysticism, and murder. He saves the life of the novel's central character, Bergen McKee, a friend and college professor who has come to the reservation to research Navajo witchcraft. Settings include Kam Bimghi (Kah Bihghi) Valley, Beautiful Valley, Ceniza Mesa, Lukachukai Mountains, Chuska Mountains, Agua Sal Valley, and Los Gigantes Buttes.

Of Interest: The novel that introduced Joe Leaphorn was a finalist for the Best First Mystery Novel Edgar Award in 1971, losing to *The Anderson Tapes* by Lawrence Sanders. The American Library Association named it one of the notable books of 1970.

Reviewers reacted favorably, including a mention in *The New York Times Book Review* that praised Joe Leaphorn as a more interesting character than Bergen McKee. Hillerman agreed; McKee appears no more.

Tony Hillerman's Comments: "I used the word *jubilation* a moment ago, and I will use it again

The Hubbell Trading Post, a National Historic Site, is the oldest continuously operated business on the Navajo Nation.

to describe the time the Harper & Row business rep came through Albuquerque with a copy of *The Blessing Way* dust jacket in his briefcase. And a third time as I opened a package [editor] Joan Kahn sent me and pulled out a copy of the actual book. After writing for more than a quarter century I was now, formally, officially, and incontestably an author."

[FROM *Seldom Disappointed*, HILLERMAN'S 2001 MEMOIR]

NAVAJO TRADING POSTS

Bergen McKee had spent most of the afternoon in the canvas chair beside the front door in Shoemaker's [Trading Post]. It was a slow day for trading and only a few of The People had come in. But McKee had collected witchcraft rumors from three of them, and had managed to extract the names of two Navajos who might know more about it. It was, he felt, a good beginning.

He glanced at Leaphorn. Joe was leaning against the counter, listening patiently to another of the endless stories of Old Man Shoemaker.

[CHAPTER 4]

ABOUT NAVAJO TRADING POSTS AND THE HUBBELL TRADING POST

Shoemaker's Trading Post was a product of Dad's imagination, drawn from insights gleaned as a visitor at dozens of trading posts throughout the Navajo Nation. In later books he created Short Mountain Trading Post, and also used real trading posts such as Two Grey Hills, Teec Nos Pos, and Toadlena. He never set a story at the Hubbell, but we use it here because it is one of my favorites and highly photogenic.

Trading posts came to Navajoland in 1868 when The People returned from their confinement at Bosque Redondo with an appreciation for Anglo-American goods. The first posts went up near Fort Defiance, the first U.S. Army base in Arizona, but they quickly spread throughout the reservation and along its borders. In *The Blessing Way* Leaphorn's visit to Shoemaker's Trading Post provides an opportunity to make initial contact with the villain, a coincidence that ultimately helps him solve the crime.

Hubbell Trading Post is the longest continuously operating trading post on the Navajo Nation. It now does business as a National Historic Site. The Hubbell's authentic ambiance recalls the days when Navajos exchanged wool, hides, lambs, rugs, jewelry, and baskets for Arbuckle's coffee, sugar, flour, and farm tools. Nearly everyone of note in the nineteenth century who passed through northeastern Arizona stopped here, often as guests of the legendary proprietor John Lorenzo Hubbell. President Theodore Roosevelt, author and New Mexico governor Lew Wallace, and prolific mystery writer Mary Roberts Rinehart were among the many visitors. Artist E. A. Burbank spent several months in the Hubbell home; many of his paintings and drawings hang on the walls today. The curious can peek inside the historic house on guided tours.

Hubbell Trading Post is one mile west of Ganado, Arizona, and fifty-five miles northwest of Gallup, New Mexico. The visitor center features demonstrations of Navajo weaving and an assortment of books, including Dad's novels. Dad and Mom enjoyed stopping here, and I recommend it to you.

BEAUTIFUL VALLEY

They had passed Chinle now, Leaphorn driving the white carryall at a steady seventy. The highway skirted the immense lifeless depression which falls away into the Biz-E-Ahi and Nazalini washes. It was lit now by the sunset, a fantastic jumble of eroded geological formations. The white man sees the desolation and calls it a desert, McKee thought, but the Navajo name for it means "Beautiful Valley."

[CHAPTER 4]

ABOUT BEAUTIFUL VALLEY

This lowland area in Apache County, Arizona, stretches some twenty miles south from Chinle, comprising the southern end of the Chinle Valley. The rich colors of the soft, easily eroded Chinle Formation sandstone here match those as you'll see in the Painted Desert and Petrified Forest.

After spending most of the afternoon at Hubble Trading Post, Don and I headed north on U.S. 191 toward Chinle. We'd been focusing on the beautiful baskets and jewelry in the museum shop and then on the classic nineteenth-century art in the

Hubble home. The broad vistas now left us breathless. We pulled off the road when we found a place to take a memorable photo of Beautiful Valley to the east and the bulk of Black Mesa hugging the horizon to the west. We sat silently, soaking in the colors. What a gift! I imagined Dad driving here, saying to Mom, "Would you look at that?"

Earlier that day, we had lunch with Navajo Nation President Dr. Joe Shirley, Jr., at a restaurant in St. Michael's, Arizona. President Shirley was on his way in to work at Window Rock from his home in Chinle. He drives past Beautiful Valley coming and going, one of the world's most beautiful commutes. Dad admired Shirley and the feeling was mutual. President Shirley represented the Navajo Nation in 2004 when the Albuquerque Museum honored Dad as a "Notable New Mexican."

SILVER HAT BANDS

The Big Navajo had taken a silver concho band from his hip pocket. He let it hang over his wrist while he handed Shoemaker the bills and waited for his change. The metal glowed softly—hammered discs bigger than silver dollars. McKee guessed the conchos would bring $200 in pawn. He looked at the big man with new interest. The Navajo was slipping the silver band down over the crown of his hat . . .

"Can you tell me why that man would lie about somebody stealing his hat?" Leaphorn asked. His face was intent with the puzzle. "Or if he wasn't lying, who would steal an old felt hat and leave that silver band behind?"

[CHAPTER 4]

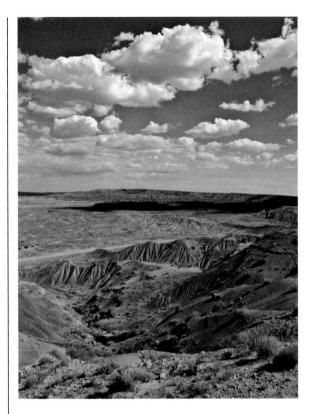

Beautiful Valley, Arizona

Conchos *get their name from the Spanish word for shell. Navajo jewelers often use the design on belts and hatbands. (From Richardson's Trading Post, Gallup, New Mexico)*

ABOUT NAVAJO JEWELRY

The Navajo were the earliest American Indians in the Southwest to master the art of silversmithing. Researchers believe Atsidi Sani, the first Navajo silversmith, learned from a Mexican craftsman and began working with silver between 1853 and 1858. He taught the art to his four sons who, in turn, taught others. After their release from the tragic Bosque Redondo incarceration, Navajo artists began to create beautiful silver jewelry in earnest and never stopped.

The first silver probably came from coins acquired from soldiers at Fort Defiance and Fort Wingate and from Mexican traders. Silversmiths sometimes rounded the coins into buttons or beads. Sometimes, they melted the metal and poured it into hand-carved molds to create a design or form a thin sheet of silver. By the 1880s, the silverwork often included turquoise. Jewelry, easy to carry and good to barter, became an important part of the Navajo lifestyle.

Conchos, elliptical or round disks, may have a radiating center, punched holes, incised or stamped designs, and a scalloped edge. The jeweler might add insets of turquoise, coral, or other stones. Navajo artists use the *concho* style of silverwork Dad incorporates in *The Blessing Way* on belts, bridles, pins, and bolo ties as well as hatbands.

LUKACHUKAI MOUNTAINS

*Behind [Old Woman Gray Rocks], the foothills of
the Lukachukais shimmered in the blinding sun—
gray mesquite and creosote bush, gray-green scrub
cedar and the paler gray of the eroded gullies and
above the grayness the blue-green of the higher
slopes shaded now by an embryo early-afternoon
thundercloud. By sundown, McKee thought,
the cloud would be producing lightning and those
frail curtains of rain which would, in arid-country
fashion, evaporate high above the ground.*

[CHAPTER 7]

ABOUT THE LUKACHUKAI MOUNTAINS
Rising east of Navajo 12 and U.S. 191, the Luka-
chukai Mountains form a high ridge that stretches
for approximately sixty miles, straddling the
Arizona–New Mexico state line. Roof Butte,
9,835 feet, stands as their high point.

The Lukachukais are the site of the *Diné
Bikéyah* Oil Field, the largest producing oil field
in Arizona. Mining companies extracted large
amounts of uranium from the northern Lukachu-
kais in the 1950s. Several species of wild orchids
grow here. Traditional Navajo weavers in the Lu-
kachukai, Upper Greasewood, and Round Rock
area create a unique rug type, Lukachukai Yei,
that depicts representations of the Navajo spirit
beings. In addition to *The Blessing Way*, Dad uses
these mountains as a backdrop of the unfolding
stories in *The Ghostway*, *Skinwalkers*, and *The
Wailing Wind*. He always loved the poetic rhythm
of their Navajo name.

The Lukachukai Mountains

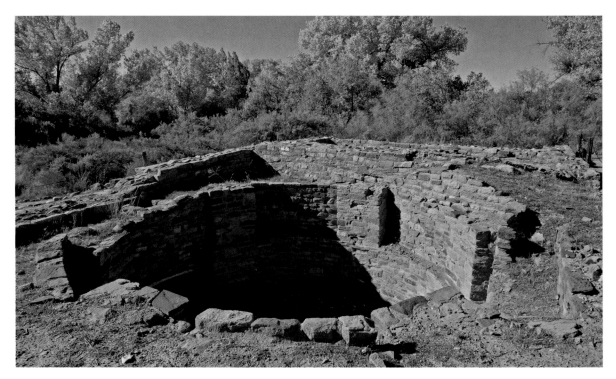

Kira at the Salmon Ruins near Bloomfield, New Mexico

ANASAZI RUINS

[Bergen McKee] sat motionless for a second, perplexed by the dim light and the blank wall before him. Then full consciousness flooded back and with it the awareness that he was sitting, cold and stiff, on the dusty floor of a room in the Anasazi cliff dwelling . . .

. . . It had been built either as a communal meeting place for one of the Pueblo's warrior secret societies or as a storeroom for grain—three stone walls built out from the face of the cliff and, like the cliff, sloping slightly inward at the top. The only way out was the way they had come in—through a crawl hole in the roof where the wall joined the cliff.

[CHAPTER 16]

ABOUT THE ANASAZI

The ancestral Pueblo people, commonly known as the Anasazi when Dad wrote *The Blessing Way*, lived in the Southwest from about the sixth through thirteenth centuries. They abandoned an impressive legacy of artifacts and acres of adobe and stone ruins, some built in inaccessible places like the spot in which the bad guys im-

First Ruin at Canyon de Chelly, home of the ancestral Pueblo people

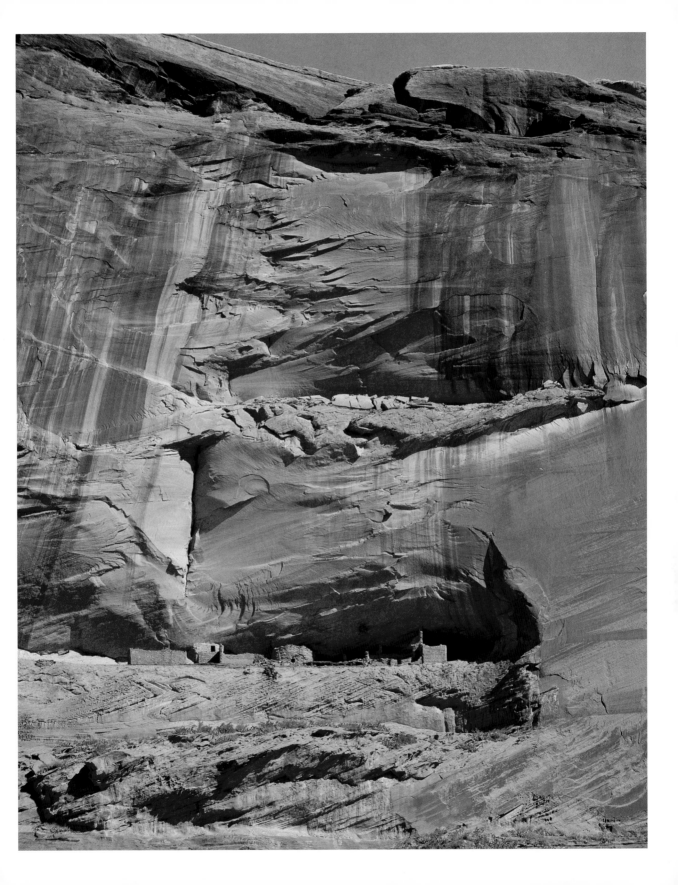

prison Bergen McKee and Ellen Leon. Some of the best-known early Pueblo ruins are preserved at Mesa Verde in Colorado, Chaco Canyon and Pecos National Monument in New Mexico, in Monument Valley, Utah, and in Canyon de Chelly and Navajo National Monument in Arizona.

One of my favorite spots is the visitor-friendly Salmon Ruins. This small stone city sits just west of Bloomfield, New Mexico. Indians occupied the village, an outlier of the important Chaco Canyon complex, during the eleventh century. The families abandoned the Salmon pueblo around 1265 A.D. The buildings reflect several masonry styles,

among them construction that used a rubble core sandwiched between elegant facings of beautiful sandstone. The masons cut each stone to fit, creating a smooth style that looks sophisticated even today. I love the contrast between the bulk of the massive buildings and the delicate, intricate stonework.

The Anasazi were long gone by the time the Navajo settled in Dinetah, but intriguing signs of their presence remain. In *The Blessing Way*, the cliff-side ruins provided a scenic place to stow kidnap victims, and offered Dad the opportunity to share some information about the Pueblo culture.

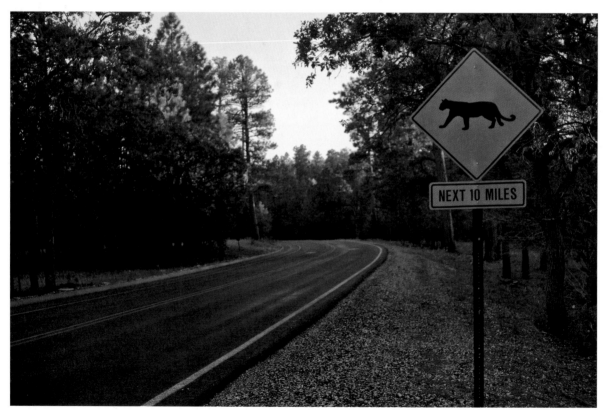

Mountain lion warning sign at the Grand Canyon

DANCE HALL OF THE DEAD

The Story: A Zuni Pueblo boy studying to dance as the Little Fire God disappears, leaving a pool of blood next to his bicycle. His best friend George Bowlegs, a Navajo, is also missing. Does young George know something about the crime? As Navajo Tribal Police Officer Joe Leaphorn investigates, the case grows to include a drug-dealing commune, suspicious activity at an archaeological dig, and the age-old conflict between love and ambition. The action-filled climax takes place at Shalako, the sacred Zuni ceremony in which messengers of the Gods come to bless the world.

Of Interest: The book, the first in which detective Joe Leaphorn is the principal character, won the 1974 Edgar Award for Best Mystery Novel. Hillerman initially described the Folsom Man dig site he uses in *Dance Hall of the Dead* in an article he wrote as a freelance assignment for a national magazine. Hillerman also used Zuni Pueblo as the setting for a children's book, *The Boy Who Made Dragonfly*, which he based on a traditional Zuni story. His daughter Jan Grado did the illustrations.

Tony Hillerman's Comments: "The problem here was how to have Leaphorn understand what was motivating the behavior of George Bowlegs, a fugitive Navajo boy. To do this I had Joe gradually understand Zuni theology as a Navajo (or a white mystery writer) would, and realize the boy was trying to make contact with the Zuni Council of the Gods. Thus the boy (and Leaphorn) would come to the Shalako ceremony, at which these spirits make their annual return to the pueblo, and thus I would have my excuse to describe this incredibly beautiful ceremony."

[FROM *Seldom Disappointed*]

ZUNI PUEBLO AND ITS LANDSCAPE

Behind him, above the red sandstone wall of the mesa, a skyscape of feathery cirrus clouds stretched southward toward Mexico. To the west over the Painted Desert, they were flushed with the afterglow of sunset. To the north this reflected light colored the cliffs of the Zuni Buttes, a delicate rose. Far below him in the shadow of the mesa, a light went on in the camper near the site of the anthropologist's dig.

[CHAPTER 1]

Sunlight struck the east faces of the Zuni Buttes ten miles to the northwest. It reflected from the yellow water tower that marked the site where the government had built Black Rock to house its Bureau of Indian Affairs people . . . It illuminated the early-morning haze of smoke emerging from the chimneys of Zuni Village.

[CHAPTER 7]

Leaphorn's gaze rested on Zuni Village. Halona, they called it. Halona Itawana, the Middle Ant Hill of the World. A hillock beside a bend on the now dry bed of the Zuni River, a hillock of red stone houses jammed together to form the old village and surrounded now by a sprawling cluster of newer houses. Maybe six thousand Zunis, Leaphorn thought, with something like 65,000 square miles of reservation, all but a few hundred of them lived like bees in this single busy hive.

[CHAPTER 7]

The Zuni Buttes, rising to 7,225 feet above sea level, dominate the landscape south of Gallup, New Mexico.

Zuni Pueblo has electricity, but it doesn't power the hornos.

TOP: *The village of Zuni and nearby Black Rock are home to about 6,000.*

BOTTOM: *Zuni hornos, beehive-shaped ovens, are used for baking bread.*

The orgy of baking which caught up the women of Zuni each Shalako season had reached its climax during the morning. Now most of the outdoor ovens were cooling, but a thick layer of blue smoke still hung in the air over the pueblo. It made a faint smear as far northwest as the Zuni Buttes and eastward to the gaudy water tower at Black Rock. Even here, high over the valley and a half mile away, Leaphorn's nose caught the vague scent of baking bread and the perfume of burned piñon resin.

[CHAPTER 18]

ABOUT ZUNI PUEBLO AND ITS PEOPLE

Zuni Pueblo, the largest of New Mexico's Pueblo communities, sits in a scenic valley surrounded by mesas some 150 miles west of Albuquerque. I first visited here when I was taking an anthropology class at the University of New Mexico (I rode to school each morning with Dad) and a friend invited me to the Shalako dances, the most important of the Zuni ceremonies. I'll never forget the clear, bitterly cold November night, the crowd of mostly Indians, and the unearthly music of the Shalako's long snapping beak as it swooped and danced and hooted to the drumbeat.

Dad made many trips to Zuni and was a guest at Shalako, which he re-creates as a setting for the climax of *Dance Hall of the Dead*. He often said that his interest in the Zuni took a serious turn when his middle daughter, my sister Jan, began to date a Zuni boyfriend. The romance faltered, but Dad's connection to the pueblo stayed strong.

Archaeological evidence demonstrates that the Zuni people have lived on this land since at least 1300 A.D., and ancestors of the modern Zuni may have settled in the area as early as 650. To-

Zuni Pueblo dance plaza

day, some 8,000 Zuni tribal members occupy the pueblo proper and its Black Rock suburb. Zuni is unique in its language and its ceremonial life. It was the place of first contact between Spanish explorers, who mistook it for the legendary golden Cities of Cibola, and the indigenous people of the Southwest.

Don and I met with the Zuni tribal council for permission to photograph in January 2009. Governor Norman J. Cooeyate told us that *Dance Hall of the Dead* helped him stave off homesickness as a student in faraway Salt Lake City, Utah. He had never read a Hillerman book before, he said, but the Warrior God on the cover instantly attracted him. "I regret that I never had the opportunity to personally thank Mr. Hillerman for the pleasure

the book gave me." Cooeyate touched his hand to his heart. "I would have told him how much of a difference it made in my life." Dad died a few months before our trip to Zuni.

Council members offered good suggestions for photo locations in a discussion that reflected both their hospitality and their pride in their homeland. Councilor Arden Kucate personally escorted us to the Middle Village. Don and I followed along a narrow ice-covered path between old sandstone buildings to steps rising to a rooftop that overlooked the dance plaza. Ladders led to the kivas

During the Pueblo Revolt (1680–92), families from all six Zuni villages fled to Corn Mountain. When the siege ended, the people consolidated into a single pueblo.

Traces of a hippie commune near Zuni

beneath us. The scene could have come from *Dance Hall*, except for the wonderful bright sunlight.

Back at the tribal offices, we met up with Dan Simplicio, Jr., an affable guide and former member of the Zuni tribal council. Simplicio teaches the Zuni language and culture at the pueblo, and is a jeweler like his well-known father, deceased World War II veteran Dan Simplicio, Sr. Dan helped us find the best vistas of Corn Mountain, *Dowa Yalanne* in Zuni. He also took us to an abandoned commune, a model for the hippie village Dad depicts in *Dance Hall of the Dead*.

Zuni's old mission church, many times rebuilt, includes human-sized murals on the interior walls depicting traditional katsina spirits. [In the years since Dad wrote, *katsina*, the traditional Hopi word for both the dolls and the spirits they represent, has come into broader preferred use. Many scholars use the words *kachina* and *katsina* interchangeably.] For nearly three decades Zuni artist Alex Seowtewa and his sons created these paintings, painstakingly including details of costume and pose. During one of his visits to Zuni, Dad watched the artists working on these Dancing Gods. He was especially impressed with the figure by the railing of the choir loft, the Shalako, a nine-foot-high pyramid topped by a tiny head and supported by human legs. In the novel, Leaphorn admires the murals as he interviews the parish priest. Don and I would have loved a picture of the art, but the pueblo no longer allows photographs.

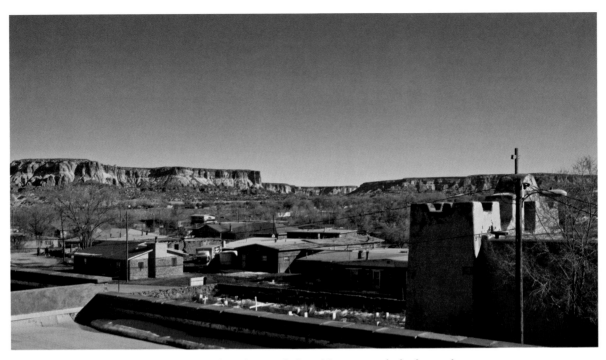

Our Lady of Guadalupe Mission, established in 1629, with Corn Mountain in the background

We stayed at Zuni's only hotel, the Inn at Halona, a cozy bed-and-breakfast. Our host, Roger Thomas, is a longtime Hillerman fan and we found a well-read copy of *Dance Hall of the Dead* on the bookshelf. The hotel and adjoining grocery store rose from the site where the Vander Wagen family established a trading post in 1903. Roger and his wife, Elaine, a granddaughter of the Vander Wagens, have operated the inn and the store since 1974.

The spring before that, graduating students of Zuni High School class of 1973 invited Tony Hillerman to give their commencement address. A talk by an Anglo author was a rare event in Zuni: *Dance Hall of the Dead* had just been published.

Dad told the students: "I urge you, if you leave the Zuni reservation, not to leave the ways of Zuni behind you. You will take with you what you have learned at this school from your teachers here. I hope you will also take with you and use what your families have taught you about what is really valuable in this life. . . . I would be very proud to be a Zuni. I know that you must be too. And I hope that never changes."

After his talk, stern-faced tribal elders asked Dad to meet with them privately. They wanted to know who had told him certain details of Zuni spiritual practices. He reassured them that everything in *Dance Hall* came from published anthropological reports and the workings of his own imagination.

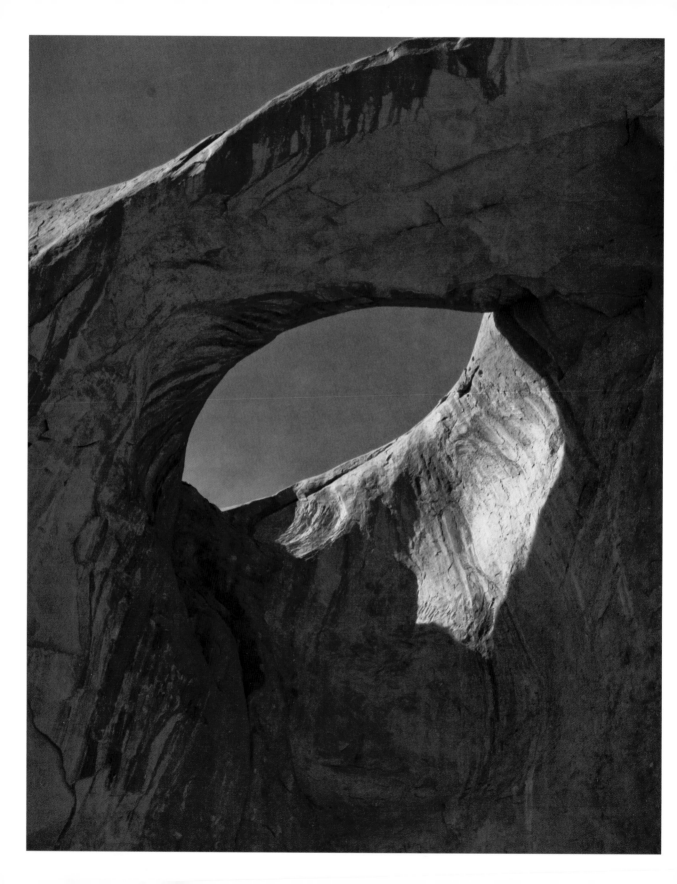

LISTENING WOMAN

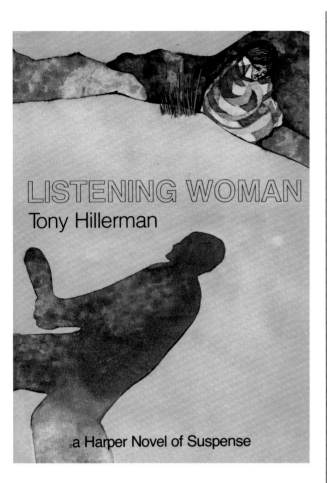

FACING PAGE: *Arches created by rain, wind, and time add to the geology at Monument Valley.*

The Story: Navajo Tribal Police Lieutenant Joe Leaphorn hunts down a cold-blooded killer in a double murder investigation that endangers his own life. The story begins with the blind Navajo Listening Woman and leads Leaphorn to uncover a dead man's long-held secret, the theft of the helicopter, a kidnapping scheme, and a violent conspiracy. Heroin, a heartfelt promise, and conflicts between traditional Navajo beliefs and the modern world help fuel the plot. Settings include the beautiful Rainbow Plateau area east of Page, Arizona.

Of Interest: The third and final book in which Joe Leaphorn appears alone, *Listening Woman* was nominated for an Edgar for Best Mystery Novel of 1979, losing to *Eye of the Needle* by Ken Follett. The book drew praise from fans and reviewers and is remembered as Hillerman's Navajo novel with the most on-page action—fires, floods, dog attacks, and explosions that put Leaphorn at grave risk.

Tony Hillerman's Comments: "This book taught me that inability to outline a plot has advantages.

The plan was to use Monster Slayer and Born for Water, the hero twins of the Navajo genesis story, in a mystery involving orphaned brothers (a 'spoiled priest' and a militant radical) who collide in their campaigns to help their people. I would use a shaman, the last person to talk to my murder victim before he is killed, as a source for religious information meaningless to the FBI but revealing to Leaphorn. After a series of first chapters that led nowhere, I wrote a second chapter in which Leaphorn stops the villain for speeding and, more or less out of whimsy, I have him see a big ugly dog in the backseat of the car, intending to use the delete key on my new (and first) computer to delete said dog later. That un-outlined dog became crucial to the plot. No more trying to outline."

[FROM *Seldom Disappointed*]

MONUMENT VALLEY

The southwest wind picked up turbulence around the San Francisco Peaks, howled across the emptiness of the Moenkopi plateau, and made a thousand strange sounds in the windows of the old Hopi villages at Shongopovi and Second Mesa. Two hundred vacant miles to the north and east, it sandblasted the stone sculptures of Monument Valley Navajo Tribal Park and whistled eastward across the maze of canyons on the Utah-Arizona border. Over the arid immensity of the Nokaito Bench it filled the blank blue sky with a rushing sound.

[CHAPTER 1]

ABOUT MONUMENT VALLEY

Monument Valley, a vast and beautiful expanse of sandstone buttes, mesas, and arches, has provided scenery for movies, commercials, and music videos. The media exposure helped to make this exotic landscape familiar to many people around the world. It's one of those places where Dad found inspiration. I'm sure that's why he used it to set the scene in the quote above, from the very first page of *Listening Woman*.

On his first trip, he and Mom arrived here after a couple of days exploring the reservation and at least one cramped night sleeping in their truck. Dad told me he thought the bed at Monument Valley's Goulding's Lodge was extraordinarily comfortable.

Looking toward Monument Valley from U.S. 163. The sandstone pinnacles, mesas, and buttes tower at heights of 400 to 1,000 feet above the sandy desert floor.

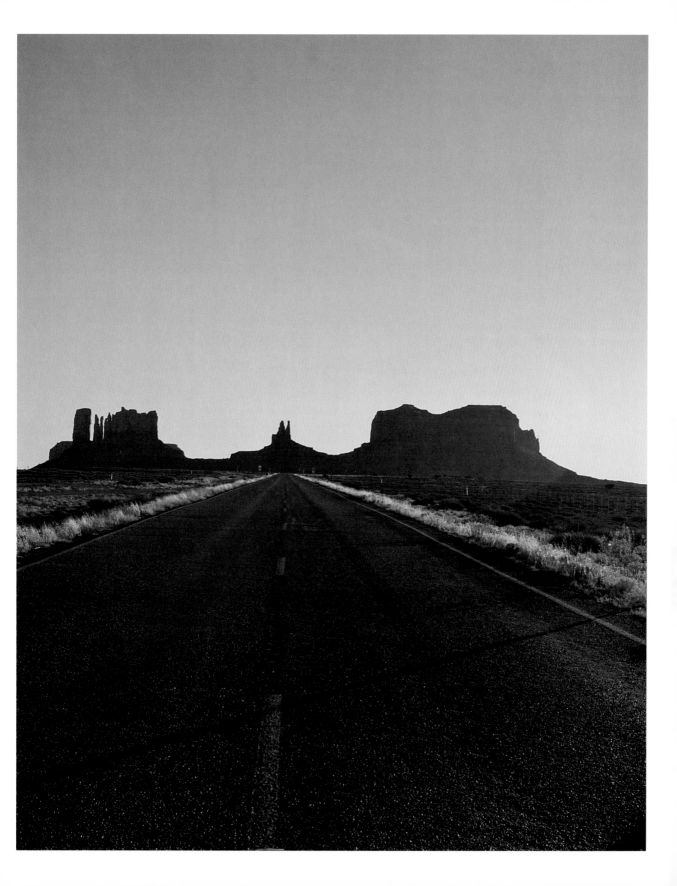

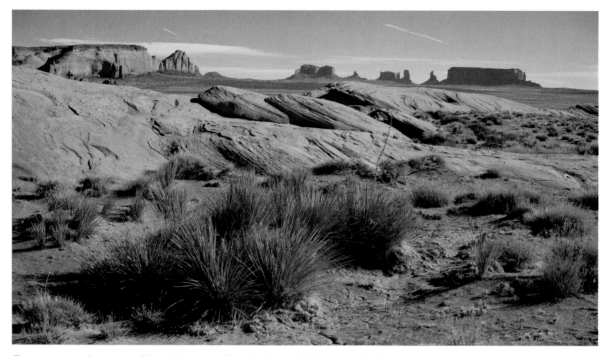

Tourists can explore some of the valley on a self-guided tour. A Navajo guide offers access to areas that would otherwise be off-limits.

Part of the expansive Colorado Plateau, the "valley" consists of a wide flatness interrupted not by trees but by stone formations rising as much as a thousand feet. Sand-blown wind and water spent fifty million years peeling away the surface of the plateau, wearing down layers of soft and hard rock to carve the mesas, buttes, and towers. The characteristic red comes from iron oxide; the blue-gray from manganese oxide. The Navajo name *Tse'Bii'Ndzisgaii* means "Clearings Among the Rocks."

Don and I followed Dad's advice and stayed at historic Goulding's Lodge. Our second-story motel room looked out on the Mitten Buttes. We saw sunset create streaks of pink and crimson, wrapping the sandstone like a graceful chiffon scarf. The next morning, we awoke before sunrise to find a dusting of snow on the Mittens, as though a heavenly cook had sprinkled them with powdered sugar.

In Navajo tradition, the formations represent hands left behind by the gods, a sign of their ongoing connection to the Diné. After Dad died, I learned that he had purchased the lights for a sports field at the predominately Navajo Monument Valley High School just down the road from the lodge.

Encompassing more than 91,000 acres, Monument Valley Tribal Park extends from Arizona into Utah.

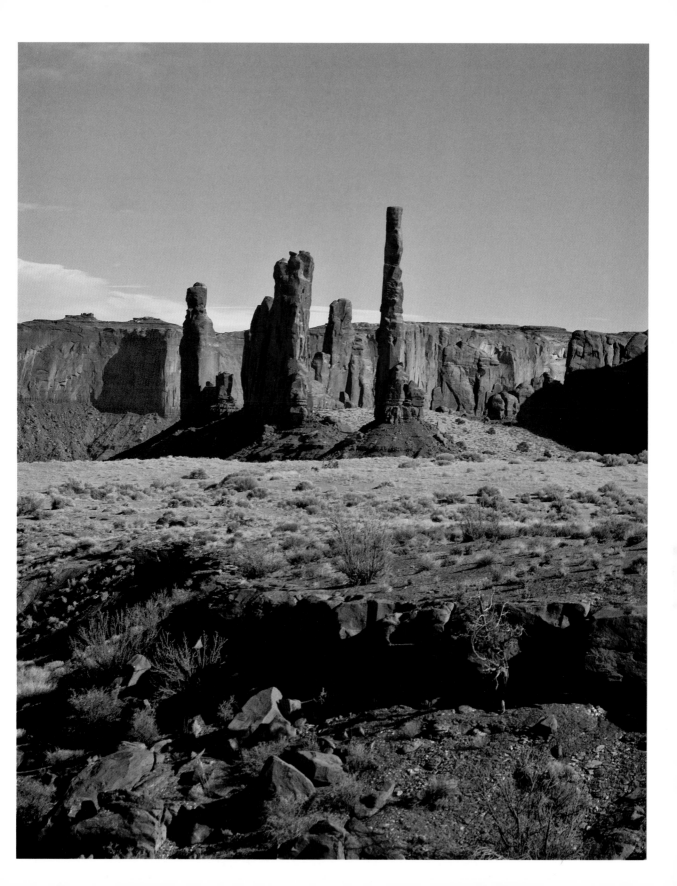

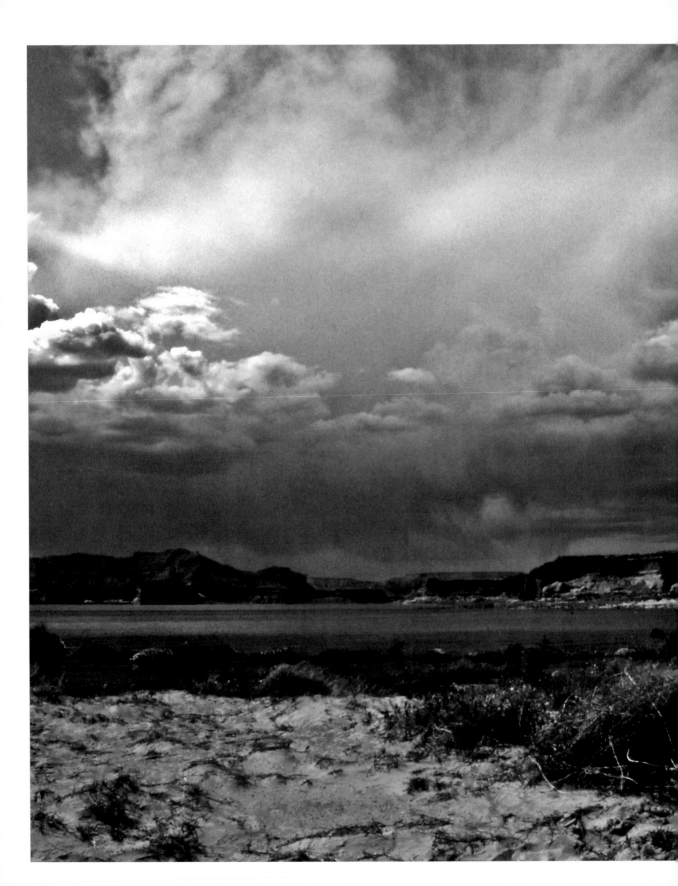

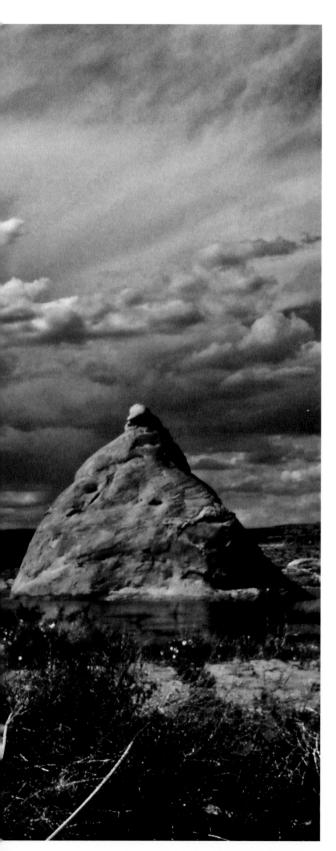

LAKE POWELL

The line extended between Navajo Mountain and Short Mountain—into the Nokaito Bench and onward into the bottomless stone wilderness of the Glen Canyon country and across Lake Powell Reservoir. . . . Leaphorn wound his way through the sandstone landscape, his khaki-uniformed figure dwarfed by the immense outcroppings and turned red by the dying light.

[CHAPTER 4]

[Leaphorn] looked down at its surface, toward the source of light. And then he realized that this water must be part of Lake Powell—backed into the cave as the lake surface rose with spring runoff and draining out as the level fell with autumn and winter. He drank thirstily.

[CHAPTER 16]

ABOUT LAKE POWELL

Lake Powell and the surrounding Glen Canyon National Recreation Area span almost 2,000 square miles of high desert landscape in southern Utah and northern Arizona. The lake, formed by Glen Canyon Dam, is named in honor of Civil War veteran and one-armed explorer John Wesley Powell. Powell led the first scientific expedition in wooden boats down the Colorado River through the Grand Canyon in 1869.

The second largest reservoir in the country, the lake stores water and provides power for much of

Lake Powell flooded many sites the Navajo held sacred.

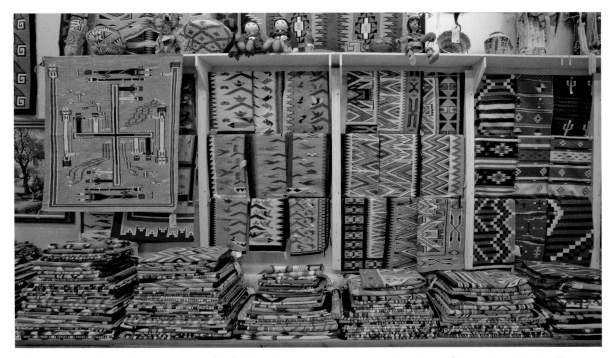

A Navajo rug with a sand painting design (far left) by Chinle, Arizona weaver Arlene Yazzie (Richardson's Trading Post, Gallup, New Mexico)

the southwestern United States. The creation of Lake Powell flooded many sites the Navajo held sacred, including the confluence of the San Juan and the Colorado Rivers and the landscape near Rainbow Bridge.

In *Listening Woman*, Dad uses a cave in the empty country along the San Juan River arm of Lake Powell as the place where Indian militants hold a troop of Boy Scouts hostage. Sacred paintings preserved here (and mentioned in the next section) provide a key to the mystery.

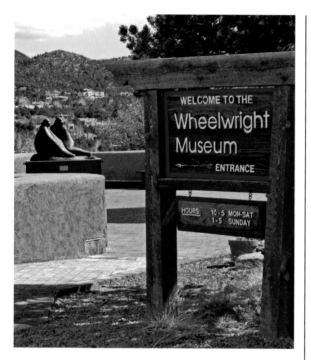

The Wheelwright Museum began as the Museum of Navajo Ceremonial Art. The bronze sculpture, **Dineh,** *is by Chiricahua Apache sculptor Allan Houser.*

NAVAJO SAND PAINTINGS

"Very strange," Leaphorn said. The only place he knew of that a bona fide singer had produced genuine dry paintings to be preserved was at the Museum of Navajo Ceremonial Arts in Santa Fe. There it had been done only after much soul-searching and argument, and only after certain elements had been slightly modified. The argument for breaking the rules had been to preserve certain paintings so they would never be lost.

[CHAPTER 10]

Leaphorn took two steps toward the old hearths and stopped abruptly. The floor here was patterned with sand paintings. At least thirty of them, each a geometric pattern of the colors and shapes of the Holy People of the Navajos. Leaphorn studied them, recognizing Corn Beetle, the Sacred Fly, Talking God, and Black God, Coyote and others. He could read some of the stories told in these pictures-formed-of-colored sand. . . . But some of the paintings were totally unfamiliar to him. These must be the great heritage Standing Medicine had left for The People—the Way to start the world again.

[CHAPTER 18]

ABOUT NAVAJO SAND PAINTINGS AND THE MUSEUM OF NAVAJO CEREMONIAL ART

Santa Fe's Wheelwright Museum, known as the Museum of Navajo Ceremonial Art when Dad wrote *Listening Woman*, began as a depository for sacred Navajo religious information. The

museum preserved copies of sand paintings used in Navajo ceremonies, recordings of the healing chants and weavings by esteemed Navajo singer or "medicine man" Hastiin (or Hosteen) Klah. As a child, I visited the museum several times with Dad. Although I was too young to understand much, I realized this was a place full of unexplained mysteries.

In the 1920s, Klah and many others believed traditional Navajo religious practice had a shaky future because of the U.S. government's policy of sending Navajo children to boarding schools where they could not speak the Navajo language or follow their traditions. The efforts of Christian missionaries to discredit Navajo spirituality also were taking a toll.

Mary Cabot Wheelwright, a widely traveled, wealthy Bostonian with a deep interest in the study of religions, met Klah in 1921. They collaborated to record and preserve Diné ritual knowledge. Franc Newcomb, a trusted Navajo trader, sketched the sand paintings created and destroyed during healing ceremonies. Klah wove huge tapestries of the ritual designs. They planned for their work to be preserved in the museum Wheelwright financed. Klah blessed the ground on which the museum was to be built.

Over the next forty years, history contradicted the assumption that the Navajo traditional way of life would disappear. The Navajo people expressed concern that non-Navajos had access to the sacred material preserved at the museum. In 1977, the museum board voted to repatriate several Navajo medicine bundles and other sacred items. The Diné maintain these at the Cultural Center Museum at Navajo Community College in Tsaile, Arizona. The Wheelwright Museum maintains world-renowned collections that document Navajo art and culture from 1850 to the present, and broadened its focus to present traditional and contemporary Native American art.

Out of respect for the Navajos' wishes, the museum does not allow non-Diné, and that included Don and me, to see the weavings or take photographs of them.

Modern Navajo weaving and jewelry may include designs based on images used in sand paintings. Artists also create and sell framed sand paintings, some inspired by ceremonial images.

In one of *Listening Woman*'s most chilling scenes, Leaphorn discovers an intricate library of sacred Diné sand paintings preserved in a cave. Deranged militants have rigged the place for explosive destruction.

PEOPLE OF DARKNESS

The Story: Navajo Tribal Police Officer Jim Chee investigates the murder of a dying man and a bizarre burglary at a white man's house—the theft of a box of rocks and trinkets. The trail leads to more deaths, each connected by a mole talisman. In solving the mystery, Chee uncovers a thirty-year-old crime that endangers his life and the life of Mary Landon, a young schoolteacher he's fond of. Settings include Crownpoint, New Mexico, and the Mount Taylor/Grants/Malpais/Ambrosia Lakes landscape.

Of Interest: This is the first of three books to feature Jim Chee as the sole protagonist. Hillerman noted that his idea for the villain came from an interview he did as a newsman, a conversation with a condemned murderer facing death in New Mexico's gas chamber. The inmate hoped the article might catch the attention of his long-lost mother who would come to claim his body. Hillerman said the incident "implanted in my brain." It re-emerged years later to help create Colton Wolf, one of his most complex antagonists.

The inspiration for another central character, B. J. Vines, grew from a biographical sketch Hillerman wrote to augment his salary as a faculty member at the University of New Mexico during a time when income from his novels was negligible. In his research on the life of the featured banker, he learned that an oil-drilling explosion had left the man blind. A similar accident found a place in the novel.

Tony Hillerman's Comments: "Older, wiser, urbane Leaphorn refused to fit into my plan to set a plot on the Checkerboard Reservation, in which the government gave alternate square miles of land to the railroads and in which Navajo was intermixed with a plethora of whites, Zunis, Jemez, Lagunas, etc., and a dozen or so missionary outposts of different religions. Since Joe wouldn't be surprised by any of this I created younger, less culturally assimilated, Jim Chee."

[FROM *Seldom Disappointed*]

Buyers and weavers assembled for the Crownpoint auction

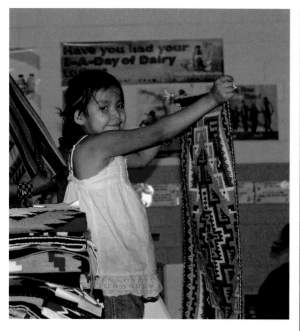

Volunteer Valtina Perry helps display a rug.

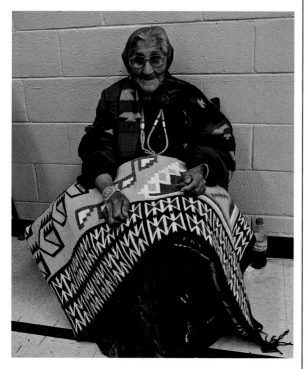

Alica Bahe Begay, 89, with her rug

CROWNPOINT RUG AUCTION

It was after sundown when Chee drove past the Tribal Police office. It was dark. On the other side of the village, perhaps two hundred assorted vehicles were parked at the Crownpoint elementary school, suggesting a good turnout for the November rug auction . . .

Inside the school, the air was rich with a mélange of aromas. Chee identified the smells of cooking fry bread, floor wax, blackboard chalk, stewing mutton and red chile, of raw wool, of horses and of humans. In the auditorium perhaps a hundred potential buyers were wandering among the stacks of rugs on the display tables, inspecting the offerings and noting item numbers.

[CHAPTER 12]

ABOUT THE CROWNPOINT RUG AUCTION

The Crownpoint rug auction brings Navajo weavers from all over the vast Navajo Nation to Crownpoint, New Mexico. The Crownpoint Rug Weavers Association runs the sale, the largest auction of contemporary Navajo rugs in the world, in the gymnasium of Crownpoint Elementary School. Usually held on the third Friday of the month, the auction features all styles and sizes of rugs and draws buyers and the curious from all over the country and the world. Prices range from around fifty dollars to several thousand. Just as the Navajo landscape surrounds visitors with inspiring beauty, so does the outpouring of creativity found here.

In addition to its role in *People of Darkness*, the auction appears again in Dad's final book,

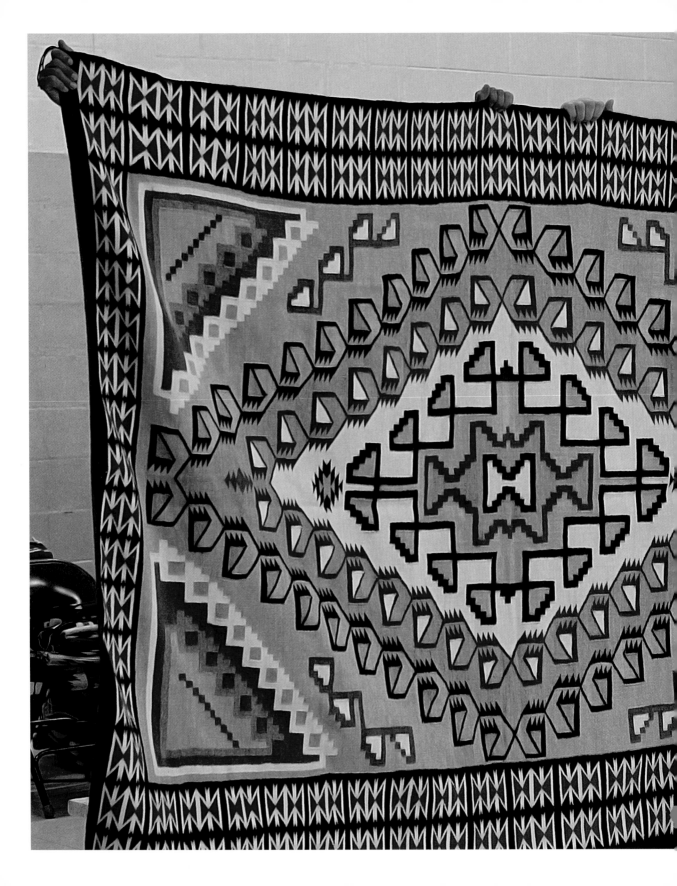

The Shape Shifter, and he refers to Crownpoint in seven other Chee/Leaphorn novels. In *People of Darkness*, the auction sets the stage for Chee to arrange a date with Mary Landon and to catch a glimpse of the killer.

Dad and Mom went to the auction several times, coming home with a rug or two each trip. Dad also collected stories about the challenges of raising and shearing sheep, spinning yarn, and weaving; information that made its way into his books as interesting trivia or, in *The Shape Shifter*, an integral part of the plot.

Don and I have (so far) resisted buying a rug but at a food trailer outside the auction hall we discovered Rez Dogs, a pair of hotdogs covered with chili and served on fry bread. Tasty, but not for the faint of heart!

MOUNT TAYLOR

[Chee] sat smoking, looking at Mount Taylor thirty miles to the east. The sun had dropped behind the horizon but the top of the mountain, rising a mile above the valley floor, still caught the direct light. Tsoodzil, the Navajos called it, the Turquoise Mountain. It was one of the four sacred peaks which First Man had built to guard Dinetah. He had built it on a blue blanket of earth carried from the underworld and decorated it with turquoise and blue flint.

[CHAPTER 5]

A rug by Alica Bahe Begay, from Pinon, Arizona on the auction block

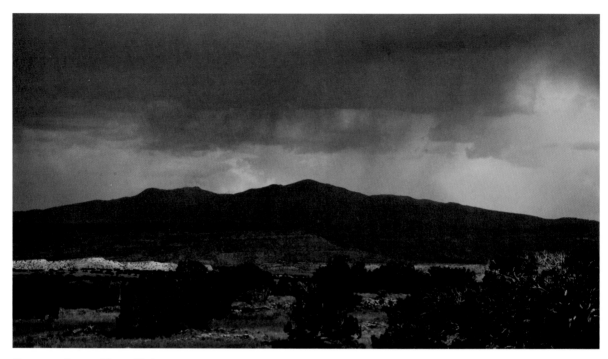

Summer rain over Mount Taylor

ABOUT MOUNT TAYLOR

The highest peak in New Mexico's San Mateo Mountains, Mount Taylor gets its English name from Zachary Taylor, the twelfth president of the United States. It is the Navajo sacred mountain of the south. Zuni, Laguna, Acoma, and other Native people also consider it a holy place.

An extinct volcano, Mount Taylor began to form about four million years ago, growing from repeated eruptions that created lava domes and rivers of molten rock. Its huge hot clouds of volcanic ash covered the earth for miles. The last eruption occurred more than two million years ago. Snowcapped much of the year, Mount Taylor rises as a landmark visible from many points in Navajo Country and from Tesuque Peak above Santa Fe, some 110 miles northeast. It appears in a dozen of Dad's books as a signpost of Indian country.

In *People of Darkness*, Dad introduces Jim Chee as he waits in the sleet outside a mining mogul's luxury home, a white man's palace constructed on the slopes of Mount Taylor. Chee is moved, not by the structure itself, but by the glorious view across the Malpais toward the Zuni Mountains.

A train near Grants, on its way to Gallup, New Mexico, passing through the Malpais lava flow

THE MALPAIS

The ceiling rose in a soaring curve toward a great wall of glass. Beyond the wall, the mountain slope fell away. Now the view was obscured by clouds and gusts of sleet, but on the usual day Chee knew the glass overlooked immense space—across the Laguna and Acoma Indian reservations to the south and east, southward across the forty-mile sea of cooled lava called the Malpais toward the Zuni Mountains, and eastward across the Cañoncito Reservation to the great blue hump of the Sandia Mountains behind Albuquerque.

[CHAPTER 2]

The new lava was at least a thousand years old. It looked as if it had hardened yesterday. It was as black as coal, raw and rough, still marked with the froth of its white-hot bubbling as it boiled across the landscape. They climbed from the ancient lava onto the final wave of the new and stood looking across ten miles of tumbled, ragged blackness at the blue shape of Cebolleta Mesa.

"I'm impressed," Mary said finally. "It's like looking backward a hundred million years."

[CHAPTER 13]

ABOUT THE MALPAIS
El Malpais, "the badlands," is an eerie landscape complete with cinder cones, pressure ridges, rock hardened into ropelike strands, extensive caves

and delicate tubes. The dramatic formations come from three million years of eruptions from volcanoes in the Mount Taylor area and elsewhere.

Managed as a national monument and a national conservation area, the lava flow is more than sixty miles wide and thirty-five miles long. Interstate 40 crosses its northern margin. Several hiking paths, including the seven-mile Zuni–Acoma Trail, traverse the lava. Although the landscape looks foreboding, archaeologists have discovered signs of human occupation. Ancestral Pueblo Indians lived here in the greatest numbers between 950 and 1350 A.D. People from Acoma, Laguna, Zuni, and the Ramah Navajo community come to the Malpais to gather plants for ceremonial uses as they have for generations. Anglo homesteaders moved in beginning around 1920.

The Navajo name for the area translates to "Where Big God's Blood Coagulated," a reference to the blood of a monster the Twin War Gods killed on Mount Taylor.

In *People of Darkness*, Chee and Mary Landon hike over the hardened lava as Chee tells stories of the way the Twin War Gods made the world safer for the Diné. In the course of their hike, they discover a freshly killed corpse.

Although the area seems desolate, the lava supports a variety of plants including cane cholla cactus, which blooms in early summer.

FETISHES

The amulet he extracted was black, and dull, and shaped into the eyeless, sharp-nosed form of a mole. He held it up for Mary's inspection. It was heavy, formed from a soft stone. Some sort of shale, Chee guessed. "Here we have Dine'etsetle," Chee said. "The predator of the nadir. The hunting spirit of the underworld. One of the People of Darkness."

He stared at it, heavy on his palm, hoping for some information. It was well formed—better than most amulets. . . . He slipped the mole back into the pouch.

"Did it tell you anything?"

Chee recited two lines of Navajo. "That's from one of the blessing chants," he said.

The mole, his hunting place is darkness.
The mole, his hunting song is silence.

[CHAPTER 25]

ANIMAL FETISH CARVINGS

The mole, the traditional Native American animal of the underground, is one of many fetish animals. Because Mole lives in darkness, his purpose, according to some interpretations, is to remind humans to trust what we feel, not what we see. The Zuni people, famous for their beautifully carved fetishes, honor Mole as the guardian of Mother Earth. In Navajo tradition, fetishes form part of the sacred bundles of Navajo medicine people. Individuals also may carry them for added protection.

Anthropologists believe ancient fetishes began as rocks that naturally resembled an animal and, according to tradition, conveyed some of that an-

A mole fetish by Zuni artist Lena Boone (courtesy Keshi, the Zuni Connection Gallery, Santa Fe)

imal's wisdom and power. Contemporary Native American fetishes range from highly abstracted representations to detailed, lifelike forms. The artists use a variety of materials including marble, shell, coral, jet, antler, bone, turquoise, and even fossilized ivory. In addition to wolves, bears, and mountain lions, artists carve parrots, owls, snakes, bats, buffalo, and a range of other animals—including those from Africa.

When Don and I began working on this book, a friend from Zuni gave us a beautifully carved mole, not knowing that Dad featured the mole in *People of Darkness*. On a trip to Zuni during our research for *Dance Hall of the Dead*, a diminutive, weathered-looking Zuni man approached me with fetishes in a handmade wooden box. He didn't have a mole but I bought a badger with a medicine bundle on its back and an eagle with bright turquoise eyes. Over the years, Navajo and Zuni acquaintances gave Dad several fetishes. He remained skeptical about the power of animal spirits to influence his life, but he believed strongly in the power of friendship that inspired the gifts.

THE HOPI BOOKS

The Dark Wind

The Story: A vandalized windmill sends Navajo Tribal Police Sergeant Jim Chee to Navajo-Hopi borderland country. His curiosity and sense of justice involve him in a web of evil that includes a corpse whose palms and soles have been "scalped." A mysterious nighttime plane crash in the desert and a vanishing shipment of cocaine add to the suspense. Chee uses his instincts and his training as an apprentice Medicine Man to solve a crime driven by sorcery and white man's greed. Hillerman introduces Chee's Hopi friend Cowboy Dashee to help unravel the complications.

Of Interest: This was Hillerman's second book featuring Jim Chee as the protagonist. In 1991, *The Dark Wind* became a movie with actor Lou Diamond Phillips as Chee. Director Errol Morris, better known for his documentary work, made his feature film debut with this project. The Hopi tribal government approved filming on the reservation but the religious leaders of the village of Shungopavi and some Hopi people maintained

that the script gave a negative image of the tribe. Controversy stirred.

Tony Hillerman's Comments: "One of the many facets of Navajo culture that appeals to me is the lack of value attached to vengeance. This 'eye for an eye' notion pervading white culture is looked upon by the Diné as a mental illness. I planned to illuminate this with a vengeance-motivated crime—the problem being how to have Jim, who doesn't believe in vengeance, catch on. The answer came to me in the memory of a long interview I once did with a private detective about his profession. I never used any of that, but a card trick he showed me proved to be just what I needed. My villain, a trading post operator, showed the same trick to Chee, and when he solved it he knew how the crime was done."

[FROM *Seldom Disappointed*]

The First Eagle

The Story: When Acting Lieutenant Jim Chee catches a bloodied Hopi eagle poacher huddled over a murdered Navajo tribal police officer, it looks like an open-and-shut case. But first impressions can be deceiving. Meanwhile, a distraught grandmother hires Joe Leaphorn, now a private investigator, to find a missing scientist who has been investigating mysterious outbreaks of a drug-resistant strain of bubonic plague on the reservation. Hillerman uses the joint-use area near Hopiland, the Hopi mesas, and Tuba City among his settings.

Of Interest: Reviewers had a chorus of praise for this thirteenth novel in the Chee/Leaphorn se-

The Grand Canyon, nesting territory for golden eagles, in early spring

ries. *The New York Times* wrote: "In addition to its finely wrought plot, *The First Eagle* offers a wealth of Tony Hillerman's signature gifts— glorious evocations of the high desert, delicately drawn characters and eloquent insights into the foibles and wisdom of the Southwest's native peoples."

Tony Hillerman's Comments: "I gave myself a problem by picking Gold Tooth, Arizona, as a crucial location because my map showed it in the very empty country where Hopi and Navajo territory abut. Wonderful name, Gold Tooth, and a ghost town, too, but I couldn't find the unimproved dirt road that was supposed to lead to it to get a visual fix. That bothered me. So Marie

and I made another 'find Gold Tooth' journey along the road between Moenkopi and the Hopi Mesa, looking for some sort of junction. We failed again, but at the Tuba City Trading Post found a Navajo woman who knew the way. 'Past the top of the hill out of Moenkopi Wash, drive slow and keep a close watch beside the road to your right. In about a mile you see a place where people have turned off the pavement. Follow the track maybe fifteen miles or twenty miles or so.'

"We found the tire tracks, drove the fifteen or so miles, past one distant windmill, past three cows, and came finally to a roofless, windowless stone building to our right and an old-fashioned round hogan to the left. It didn't look much like what I'd described, but Marie consoled me with

the reminder that not many of my readers would be seeing it."

[FROM *Seldom Disappointed*]

Skeleton Man

The Story: Former lieutenant Joe Leaphorn helps investigate what seems to be a simple trading post robbery—except that it involves a diamond missing since 1956. Sergeant Jim Chee and his fiancée Bernadette Manuelito are also on the case, which includes the search for the bones of a passenger on a plane that crashed over the Grand Canyon more than fifty years ago. A Hopi ritual, a strange old hermit, a daughter's longing for the truth about her father, and a flash flood at the bottom of the canyon add to the suspense and mystery.

Of Interest: The year that *Skeleton Man* was published Hillerman received the Robert Kirsch Award for lifetime achievement, sponsored by the *Los Angeles Times.* The settings include the Shiprock area and the bottom of the Grand Canyon.

Tony Hillerman's Comments: "The start of the book is a historic plane crash. After World War II, the big passenger planes started flying and two of them collided over the Grand Canyon. That accident, sometime in the 1950s, was the beginning of airline safety regulations. I'd been thinking about diamonds, and that I'd like to have something about them in a plot. I talked to a dealer and he told me that the cut of the stone had a lot to do with its value. He told me about a diamond cutter

Hopi Country, approximately 1.5 million acres in northeastern Arizona, includes three mesas that rise from the desert to an elevation of 7,200 feet.

in Los Angeles who was famous for a certain cut. I thought that was fascinating. So I worked it in with the airline crash and it gave me the chance to use the Grand Canyon as a setting, with a guy bringing back a big diamond for his fiancée. And there are a couple of tribes down there that no one hears about much.

"The idea for the flood came from the Park Service people, who mention that the hard rains, the male rains, come from huge black clouds and those torrential rains up the canyon lead to floods on the river far below."

[FROM A CONVERSATION WITH ANNE HILLERMAN]

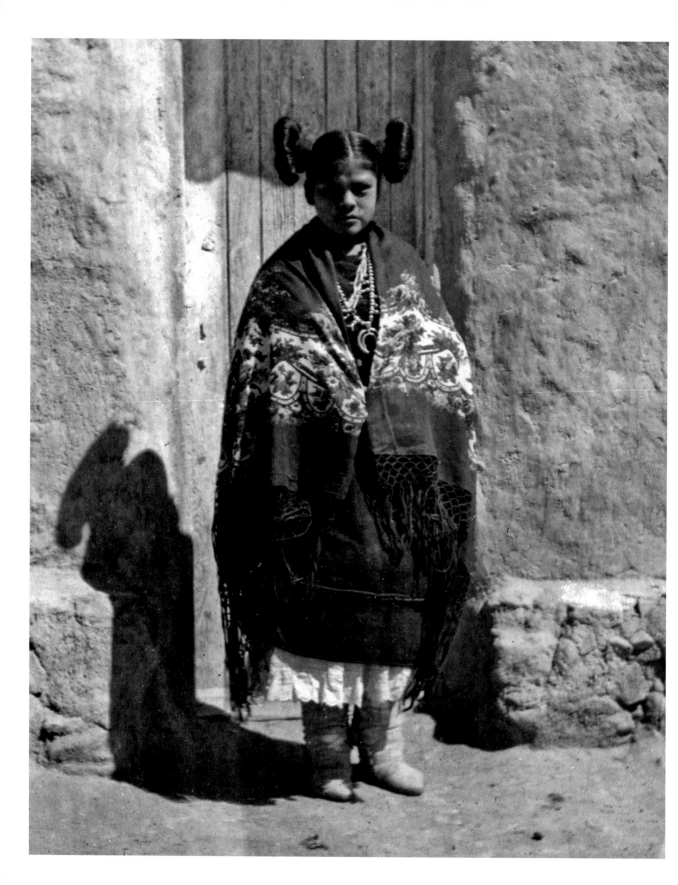

HOPI MESA COUNTRY

Hopi Man Approaching Kiva *by Elizabeth Willis DeHuff, Center for Southwest Research, University Libraries, University of New Mexico*

Unidentified Hopi Girl, *negative # 043273 by Wesley Bradfield, from the photo archives, Palace of the Governors, Santa Fe*

They took [Cowboy] Dashee's patrol car up Third Mesa to Bacobi. There Cowboy talked to the man who had passed the tale along to him. The man sent them over to Second Mesa to see a woman at Mishogovi. Dashee spent a long fifteen minutes in her house and came out smiling.

"Struck gold," Cowboy said. "We got to Shipaulovi."

"Find where the report started?" Chee asked.

"Better than that," Cowboy said. "We found the man who found the body."

[CHAPTER 10, *The Dark Wind*]

[Chee] came across another [bird] blind a half mile down the rim, and several places where stones had been stacked with little painted prayer sticks placed among them and feathers tied to nearby sage branches. Clearly the Hopis considered this butte part of their spiritual homeland, and it probably had been since their first clans arrived about the twelfth century. The federal government's decision to add it to the Navajo Reservation hadn't changed that, and never would. The thought made him feel like a trespasser on his own reservation and did nothing good for Chee's mood. It was time to say to hell with this and go home.

[CHAPTER 12, *The First Eagle*]

She would have lost him again just past the Polacca settlement when he made a turn . . . but she did an illegal U-turn across the highway, and followed . . . up a narrow road that struggled up the slopes of First Mesa to serve the little stone

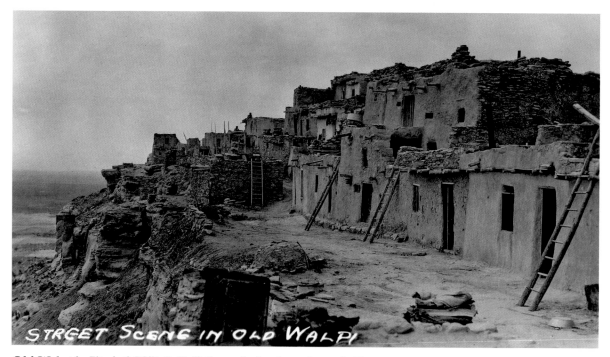

Old Walpi *by Elizabeth Willis DeHuff, Center for Southwest Research, University Libraries, University of New Mexico*

villages of Walpi, Hano, and Sichomovi and whatever lay beyond them. . . . No need for the car's air conditioner in the cool, dry air of the Hopi Mesa.

[CHAPTER 13, *Skeleton Man*]

ABOUT THE HOPI

Of all the places he wrote about in Indian Country, Dad had a special affinity for the mesa country of Arizona. He often spoke of his introduction to the Hopi, which also involved the first Pueblo Indian dance he and Mom witnessed. They had driven from Albuquerque to First Mesa where they noticed a parade of pickups. They followed the crowd to what he remembered as a Butterfly Dance. They watched with respectful amazement.

When gifts of food came falling on the crowd, tossed from people on the rooftops down to the onlookers, they quickly stepped aside so the rush of residents could claim their prizes.

This is sandstone country, big sky country, land of distances and a place where two very different Native American cultures come edge to edge. It's a setting ready-made for stories, as the crew who filmed *The Dark Wind* discovered.

Director Errol Morris invited Dad and Mom to watch some of the production and they went to a movie site near Moenkopi. Dad loved to tell the story of how a Jeep came bouncing into the production area, halting the work. The two sunburned men inside looked wide-eyed at this bit of Hollywood in the middle of nowhere. The crew

TO ALL VISITORS
YOU ARE WELCOME TO
RESPECTFULLY VISIT
OUR VILLAGE AND TO
OBSERVE OUR CEREMONIES
**=ABSOLUTELY NOT
PERMITTED=**
1. NO SOUND RECORDING
2. NO SKETCHING
3. NO PHOTOGRAPHING
4. NO REMOVAL OF OBJECTS
5. NO VIDEO TAPING
 FOR MORE INFO. CALL
 428-283-8051
 M-F
ENJOY YOUR VISIT

LEFT: *Text from a sign near the Hopi reservation* RIGHT: Walpi Pueblo, Hopi, Arizona, *negative # 161439 by Edward Curtis, from the photo archives, Palace of the Governors, Santa Fe*

shared cold drinks and gourmet food from the company food truck with the visitors. Dad had a small role in the movie, but his one line never made the final cut.

The Hopi village of Orabi, perched on the edge of Third Mesa, is the oldest continuously inhabited settlement in the United States; archaeologists date it to about 1150. The Hopi believe that this land was intended by the gods as their home because, in addition to beauty, it offers enough hardship and challenge to nourish a spiritual life.

Dad often expressed his dismay at the igno-rance of people he encountered who thought all Indians were the same. One of his goals in writing about the Zuni in *Dance Hall of the Dead,* the Hopi in *The Dark Wind* and other novels, and in adding Hopi officer Cowboy Dashee as a character was to turn this "Indian" stereotype on its head.

The photos here are archival shots taken many years ago. Don requested permission to photograph the Hopi landscape but a tribal spokesman reaffirmed that the Hopi do not allow photography on their reservation.

GRAND CANYON

Tuve . . . was going to take part in an initiation.
That involved a pilgrimage by potential members
from their village on Second Mesa all the way to
the south rim of the Grand Canyon. From there
they made the perilous climb down the cliffs—a
descent of more than four thousand feet—to the
bottom near where the Little Colorado pours into
the Colorado River.

[CHAPTER 8, *Skeleton Man*]

Getting down to the river took almost six hours.
. . . For Bernie, standing on the sand catching her
breath, this descent was already a sort of dream,

part of a thrilling close-up look at the nature
she loved at its rawest beauty. And it had been a
nerve-racking experience as well, where a wrong
step on a loose stone could have sent her plunging
down five hundred feet, to bounce off a ledge, and
fall again, and bounce again, until the journey
terminated with her as a pile of broken bones
beside the Colorado River.

On the way down, to believe what she
was seeing, Bernie found herself recalling the
reading she'd done to prepare herself for this.
That wavering streak of almost white between

Spring thunderstorm at the Grand Canyon

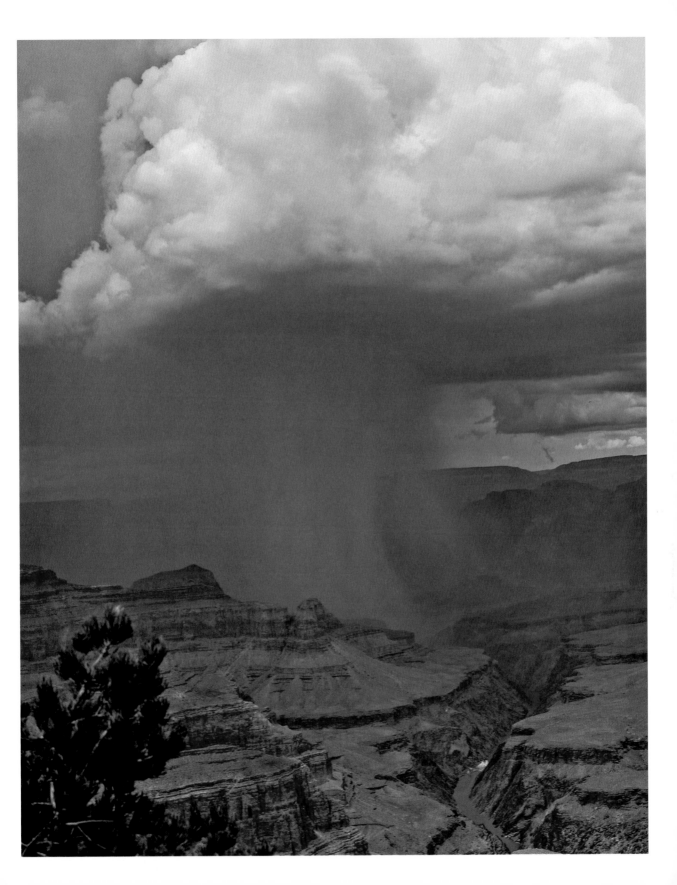

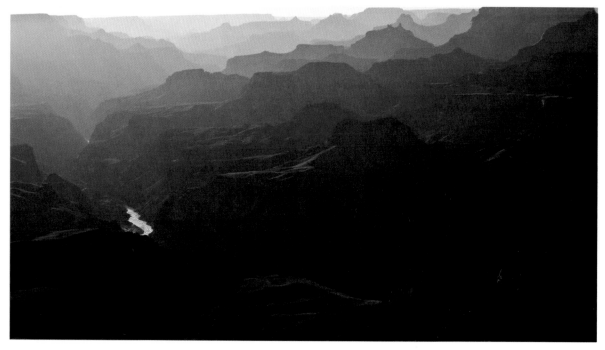

Late afternoon sun at the Grand Canyon

the salmon-colored cliffs catching the sun would be Mesozoic era sandstone, reminders of sand dunes buried when the planet was young, and the bloody red in the strata above that would be staining from the dissolved iron ore, and the name for that, required on Professor Elrod's geology exam, was hematite, and that thought would be jarred away by an inadvertent downward glance which showed her death. . . .

She focused down the cliffs. The angle of the sunlight now made it clear why one of the early explorers she had read—John Wesley Powell, she thought it was—had described them as "parapets." They formed a seemingly infinite row of light and shadow, sort of like looking down a picket fence, which each shadowed space representing a place where drainage from the mesa top had—down through a million years or so of draining off snowmelt and rainwater—eroded itself its own little canyon in its race to get to the Colorado and on to the Pacific Ocean.

[CHAPTER 15, *Skeleton Man*]

ABOUT THE GRAND CANYON

Like many little girls, I first saw the Grand Canyon on a family vacation. Mom, Dad, and the six of us frisky, argumentative children drove the four hundred miles from Albuquerque at the start of summer. The canyon looked like a painted backdrop, so huge I had a hard time comprehending it.

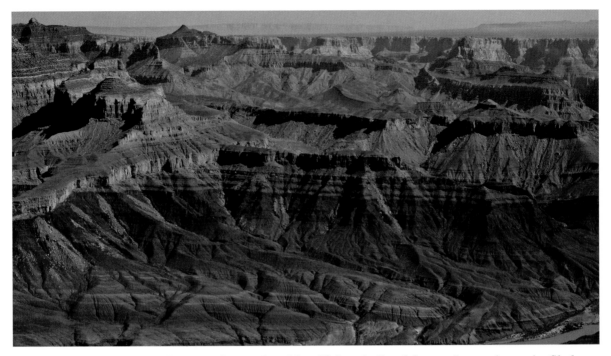

Temple Butte and Chuar Butte, shown at right, are where debris fell from the Grand Canyon plane crash central to Skeleton Man.

Years later, Dad, one of my college friends, and I came here for a weekend. Dad loved to tell the story of the family who pulled up next to us at an overlook. The parents and children piled out to look at the view. Their dog, happy to be free, ran in circles around them. The circles grew larger, closer to the canyon's edge. "I remember watching that cocker spaniel with a growing sense of horror," Dad said. "The dog pranced right off the edge, never to be seen again. End of dog."

Long before we modern tourists arrived, Native Americans knew this place. The Havasupai live on the canyon floor. Generations of Navajos have camped and hunted in the area; the Zuni and Hopi consider the Grand Canyon sacred. Hikers can find a Hopi Salt Trail similar to the one Dad describes in *Skeleton Man* on some maps, shown as a difficult climb down to the bed of the Colorado River.

A few years ago, I invited an editor from St. Martin's Press to make a presentation at the Tony Hillerman Writers Conference in Albuquerque. He planned to take a few extra days, see Santa Fe, head on to the Grand Canyon, hike to the bottom, climb out the next morning, drive to Phoenix, and get back to New York for work on Monday. I didn't try to dissuade him—even though I knew he'd spend as much time driving as hiking—because the Grand Canyon is a place every person in America deserves to see. He sur-

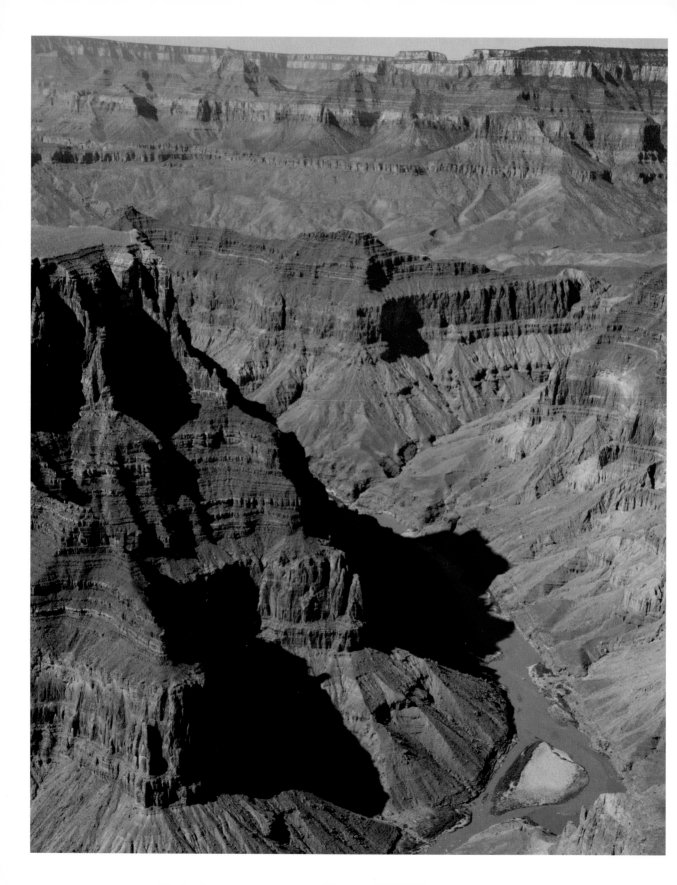

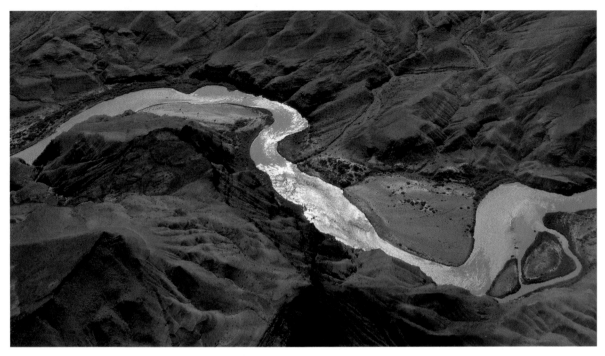

The Colorado River draws rafters from around the world to enjoy the Grand Canyon's beauty from the bottom up.

vived the whirlwind visit, returning to city life with sore muscles and grand stories.

The Grand Canyon plays a major role in *Skeleton Man*. The climatic flash flood that sweeps away the villains and the diamonds they lusted after follows a scene in which Officer Bernadette Manuelito shows brains and grit. Her savvy gives

readers another reason to be happy that, after more than a dozen books, Jim Chee has finally met the right woman.

I find inspiration at the Grand Canyon. In the face of such deep, old beauty, human problems seem insignificant. I know Dad felt the same.

The view from a helicopter with the confluence of the Colorado and Little Colorado rivers nearby

BLACK MESA

*Just as he reached Balakai Mesa, Pauling checked
the chronometer. . . . Ahead, just to the left of the
setting moon, Low Mountain rose to 6,700 feet
and beyond that Little Black Spot Mesa was even
higher. Southward, blocking radar from Phoenix,
the high mass of Black Mesa extended for a
hundred miles or more . . .*

*"Lonely country," the passenger said. He
looked down upon it out of the side window, and
shook his head. "Nobody. Like there was nobody
else on the planet."*

[CHAPTER 2, *The Dark Wind*]

*Black Mesa is neither black nor a mesa. It is
far too large for that definition—a vast, broken
plateau about the size and shape of Connecticut.
It is virtually roadless, almost waterless, and
uninhabited except for an isolated scattering of
summer herding camps. It rises out of the Painted
Desert more than seven thousand feet. A dozen
major dry washes and a thousand nameless arroyos
drain away runoff from its bitter winters and the
brief but torrential "male rain" of the summer
thunderstorm season. It takes its name from the
seams of coal exposed in the towering cliffs, but
its colors are the grays and greens of sage, rabbit
brush, juniper, cactus, grama and bunch grass, and
the dark green of creosote brush, mesquite, piñons
and (in the few places were springs flow) pine and
spruce. It . . . has always been territory favored by
the Holy People of the Navajo and the kachinas
and guarding spirits of the Hopis.*

[CHAPTER 17, *The Dark Wind*]

ABOUT BLACK MESA

As Dad points out in *The Dark Wind*, Black
Mesa is not a traditional flat-topped mesa. Nor
is it black, although dark streaks of coal, some
seams eighteen feet thick, are one of its charac-
teristics. Because it doesn't match its name, Don
and I drove beside Black Mesa for miles before we
figured out from the American Automobile As-
sociation Indian Country Map—a slightly newer
version than the one Dad used—that we were in
the right place.

Located on the Colorado Plateau near Kay-
enta, Arizona, Black Mesa measures seventy-five
miles east to west and fifty miles north to south,
and rises to more than 8,000 feet. Its buttes, slop-
ing valleys, steep canyons, and rolling hills have
been home to the Southwest's native peoples for at
least 7,000 years. Occupants included the ances-
tors of the modern Hopi. Northern Black Mesa
remained uninhabited until 1800, when Navajo
people moved here from New Mexico, bringing
their sheep in the winter and farming at lower
elevations in the summer. Some used the area's
remoteness to hide from Kit Carson's invading
army. Navajo families began to live on northern
Black Mesa year-round in the 1920s but most of
the area remained without roads until the late
1960s.

Black Mesa is a land of controversy, at the
heart of a dispute between the Hopi and the Na-
vajo tribes, and the argument between mining
and environmental protection.

The Hopi, an island pueblo surrounded by a sea
of Navajo land, live on three finger-shaped mesas
that stretch south from Black Mesa. Between 1962
and 1976, Arizona courts considered the disputed

Black Mesa, Arizona

land a "Joint Use Area," a compromise that left both sides unhappy. The government divided the Joint Use Lands between the two tribes in 1977. In 1996, Congress passed the Navajo-Hopi Settlement Act, requiring all Diné remaining in the disputed area to lease the land from the Hopi or leave by the year 2000.

In 1969, Peabody Coal Company of Kentucky, the largest coal producer in the United States, began strip mining in the Joint Use Area in exchange for royalty payments to the Navajo and Hopi governments. Some tribal leaders defended mining as a source of jobs and better incomes for their constituents. Critics charged that the operations desecrate what both tribes consider a sacred site, and that the use of groundwater to transport coal harms the springs needed for indigenous agriculture. Dad sided with the environmentalists, and decried the damage caused by coal mining on Black Mesa in *The Wailing Wind*.

Both controversies continue as I write.

GOATS

They turned up the track toward Yells Back Butte, circled around a barrier of tumbled boulders, and found themselves engulfed in goats. And not just the goats. There, beside the track was an aged woman on a large roan horse watching them.

[CHAPTER 26, *The First Eagle*]

ABOUT NAVAJO GOATS

We saw many herds of goats grazing on the Navajo reservation, often attended by dogs. Angora goats, prized for their meat and fleece, are among the breeds that survive in the reservation's challenging conditions. Traditional Navajo women often started their married life with a herd of goats and sheep as their dowry. The animals provide meat, milk, and the material for making beautiful weavings.

In *The First Eagle*, goats offer a clue to the fate of a missing researcher looking for a cure for an especially lethal variation of bubonic plague. A herd lead Chee and Leaphorn to their keeper, an observant Diné woman who realizes that an apparition she mistook for a skinwalker was a scientist in protective clothing.

Bubonic plague, the Black Death that decimated medieval Europe, still hides in the rodent populations of the Southwest and beyond, claiming a few lives each year. Dad loved to include such odd-but-true peculiarities of the Southwest in his novels.

Goats are important to many Navajo families for their meat, milk, and as a subject in many pictorial weavings.

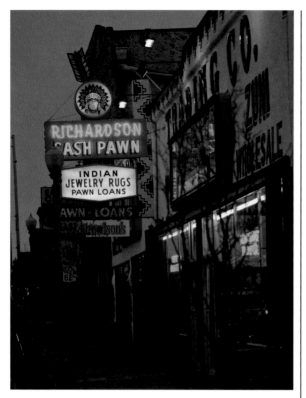

Gallup, New Mexico, became a trade center for visitors traveling on the railroad and driving along old Route 66.

El Rancho Hotel, Gallup, New Mexico

GALLUP

The El Rancho Hotel had been built in the long-gone golden days of Hollywood movie studios. One of the big names in the industry had financed it to house the stars and production crews making the cowboy-and-Indian films that filled the theaters in the 1930s and '40s. . . . Its walls were still lined with autographed publicity photographs of the Hoot Gibson/Roy Rogers generations and its atmosphere was rich with old and dusty glamour.

"Yes," the desk clerk told Dashee. "A Ms. Joanna Craig. She has 201. We call that the Clark Gable Suite. . . .

. . . The windows offered a view to the east and north of the mainline railroad tracks, now carrying a seemingly endless line of freight cars toward California, the traffic flowing by on Interstate Highway 40, and beyond all that the spectacular red cliffs that had attracted Hollywood here to produce its horse operas.

[CHAPTER 8, *Skeleton Man*]

ABOUT GALLUP, NEW MEXICO

Navajo, Acoma, Hopi, and Zuni people have lived in the Gallup area for generations. Spanish conquistadors visited beginning in 1540, followed by waves of outsiders drawn to the natural resources and diverse indigenous cultures. The Atlantic and Pacific Railroad came through as part of its westward expansion, founding the community as a railhead. The city took its name from David Gallup, an early paymaster. Mr. Gallup moved on but the railroad remained, an important part of Gallup's economic life.

Trains were instrumental in establishing the community of Gallup, which is named for a railroad paymaster.

In 1890, traders began opening outlets here to sell Navajo and Zuni arts and crafts to travelers. Gallup became one of the country's largest wholesale centers for Indian products. Coal and uranium mining also shaped the community, bringing in settlers from throughout the United States and the world. As the most populous city between Albuquerque and Flagstaff, Gallup continues as a trade center and stopping place for travelers.

When Don and I visit, we like to stay at El Rancho, a hotel with a National Historic Site designation, Old West charm, and walls decorated with the black-and-white publicity photos of movie stars Chee observes in *Skeleton Man*. For breakfast, we walk up Route 66 a few blocks to Earl's restaurant. Navajo and Zuni vendors stroll through the dining room selling jewelry, pottery, flutes, and other handmade treasures. It's like eating at a craft show with table service.

As Dad noted in *Skeleton Man*, the area has long been a favorite for filming movies, including the 1940 classic *The Grapes of Wrath*, and more modern productions including *Natural Born Killers* and *Superman*. Gallup is one of the places Dad mentioned most frequently in his novels, partly because of its strategic location on I-40 and partly because he found the mix of cultures here intriguing. The red cliffs east of town are some of New Mexico's most memorable scenery.

The dining room of the Cameron Trading Post featuring a classic Navajo Tree of Life rug

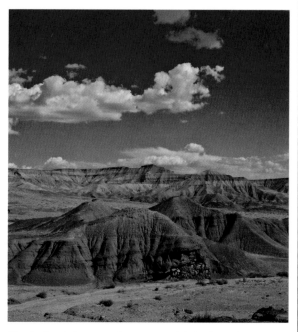

The badlands between Cameron and Tuba City, Arizona

CAMERON

Chee left a note for Largo and headed for Cameron . . . In Cameron, he bought a sack of cement at the lumberyard, a tub at the hardware store, and a flexible plastic funnel at the drugstore. Then he made the long, lonely drive back to the Hopi Reservation, still thinking.

[CHAPTER 24, *The Dark Wind*]

As they drove northward out of Cameron, Leaphorn explained to Louisa what was troubling Cowboy Dashee . . .

He took another sip [of coffee], gestured out of the windshield at the cumulus clouds, white and puffy, driving on the west wind away from the San Francisco Peaks.

"That's our sacred mountain of the west, you know, made by First Man himself, but—"

[CHAPTER 14, *The First Eagle*]

ABOUT THE CAMERON AREA AND ITS TRADING POST

Cameron Trading Post, a complex that includes the original trading post, an art gallery, hotel, restaurant, and RV park, draws visitors from around the world—mostly folks on their way to the south rim of the Grand Canyon. Author Zane Gray, actors Errol Flynn, John Wayne, and Clara Bow, and President Richard Nixon have signed the guest book. Cameron visitors often encounter Navajo, Hopi, and Zuni artists who come here with items to sell or trade. The store also has supplies for locals, including most of what Chee needed in *Skeleton Man*. It's the community equivalent of drugstore, five-and-dime, and supermarket.

Bridge over the Little Colorado River at Cameron, Arizona

Built in 1916, the original trading post, with its creaky wood floors, pressed tin ceiling, and glass-topped display cases, is still in use. Eclectic merchandise, everything from skeins of yarn to junk food to exquisite jewelry, makes the place interesting. You'll find Navajo rugs, Pueblo pottery, Hopi kachinas, old silver and turquoise squash blossom necklaces left as pawn. Temptation abounds.

Cameron takes its name from Arizona's last territorial senator, Ralph Cameron, a colorful and controversial figure who played a leading role in the construction of the Grand Canyon's famous Bright Angel Trail but opposed making the Grand Canyon a national park.

North from Cameron, the drive on U.S. 160 offers a compelling view of an interesting badlands area. The countryside unfolds in a striking panorama of shapes and colors—grays, reds, white, black, and tan—that recalls those used in Navajo weaving. Created by natural minerals, silt, and volcanic ash deposited more than 200 million years ago, this eroded vista is especially gorgeous at sunrise and sunset. Look for it at mile marker 313.

Dad didn't hide any bodies here or give a character a room at Cameron's Grand Canyon Motel. But because there's almost nowhere else to stop between Tuba City and Flagstaff, Cameron becomes the place for Leaphorn to meet Cowboy Dashee for a cup of coffee and man-to-man conversation in *The First Eagle*.

TUBA CITY

Tuba City Trading Post, built in the early 1900s, is directly next door to the Explore Navajo Interactive Museum, and a Navajo Code Talkers Memorial.

Traffic in downtown Tuba City. The library used in the movie based on **The Dark Wind** stands in the background.

Chee waited. From where he stood he could see through the glass past the captain's broad back. He could see the expanse of bunch grass, bare earth, rocks, scattered cactus, which separated the police building from the straggling row of old buildings called Tuba City. The sky had the dusty look of a droughty summer.

[CHAPTER 12, *The Dark Wind*]

He headed north out of Tuba City, driving faster than he should, but when he made the left turn onto the washboard gravel of Navajo Route 6130, the westering sun was low enough to be blinding.

That discomfort was more than offset in the eyes of Leaphorn . . . by the great ranks of towering clouds rising like white castles to the north and west. The usual late summer "monsoon" was late. Maybe the much needed rain was finally arriving.

[CHAPTER 5, *Skeleton Man*]

Chee knew just about every track on the east side of the Big Rez, the Checkerboard Rez even better, and the territory around Navajo Mountain fairly well. But he'd worked out of Tuba City very briefly as a rookie and had been reassigned there only six weeks ago. This rugged landscape beside the Hopi Reservation was relatively strange to him.

[CHAPTER 2, *The First Eagle*]

ABOUT TUBA CITY, ARIZONA

When I first heard Dad mention Tuba City, my teenaged brain immediately thought of *The Music*

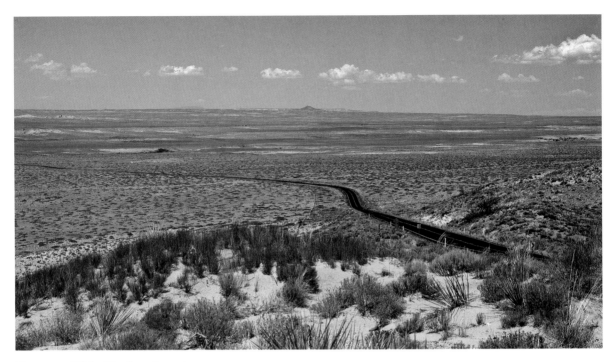

View toward Tuba City from the east

Man and the brass section in a marching band. But the name has nothing to do with music. It honors a Hopi leader, Tuuvi or Toova, who gave Mormon newcomers permission to homestead here. Paleontologists have uncovered fossils of mammoths, prehistoric horses, and bison, and least two sets of dinosaur tracks in the area. Dad and Mom took a look at the dinosaur tracks when Dad went to speak to a class at Tuba City High School about his books. My parents didn't book a room, so they ended up sleeping in their truck.

The U.S. government added Tuba City to the Navajo reservation in 1884, and eventually created a boarding school here. In the 1950s, the town became a regional hub for uranium min-ing. The Tuba City Indian Medical Center, a sixty-five-bed regional hospital, serves 35,000 Hopi, Navajo, and Paiute tribal members. Tuba City resident Lori Ann Piestewa, a member of the Hopi tribe, was the first woman in the U.S. armed forces killed in the 2003 Iraq war and the first Native American woman to die in combat while serving in Iraq.

When Robert Redford produced a movie based on *The Dark Wind*, Tuba City became his head-quarters. Don and I discussed the little town's potential as a movie set while we waited behind several other cars and trucks for dawdling black cows to stroll down the middle of the street. No one honked.

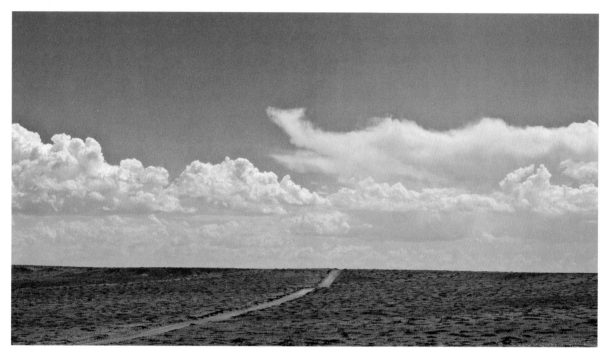

View from the west looking toward Hopi

EAGLES

"Could you catch the eagle without harming it?"

"Probably," Chee said. "I tried twice when I was young. I caught the second one."

"Checking the talons and the feathers for dried blood, would the laboratory kill it then?"

Chee considered, remembering the ferocity of eagles, remembering the priorities of the laboratory. "Some of them would try to save it, but it would die." . . .

"Then take your sweat bath. Make sure you remember the hunting songs. You must tell the eagle, just as we told the buck deer, of our respect for it. Tell it the reason we must send it with our blessings away to its next life. Tell it that it dies to save a valuable man of the Hopi people."

"I will," Chee said. . . .

"I will try to sleep now," Nakai said, and smiled at Chee. "Tell the eagle that he will also be saving you, my grandson."

. . . At 10:23, the eagle he wanted showed up.

It came from the east, drifting over Black Mesa in lazy circles that brought it nearer and nearer . . .

And then the eagle produced a raucous whistle and swept down.

Chee pulled the rabbit back toward the center of the blind. As he did, the eagle struck it with a crash, blanking out the sky with extended wings.

Chee tugged at the cord, pulling against the thrust of beating wings, reaching for the eagle's legs.

[CHAPTER 23, *The First Eagle*]

ABOUT ARIZONA'S GOLDEN EAGLES

Golden eagles, *Aquila chrysaetos*, are pure muscle and wing-borne energy. Their wingspan can stretch to seven feet and their talons might grow two inches long. At a weight of thirteen pounds, the birds are formidable predators.

In Arizona, golden eagles range from low desert areas to high mountain terrain. They prefer wild country and often nest on cliffs, including those on and near Black Mesa, soaring, diving, and swooping to assert territorial nesting claims. Many Native American tribes consider eagles sacred. But white ranchers have historically had low regard for eagles because of their reputation for killing domestic animals, especially sheep. Thousands of golden eagles were shot or poisoned before federal laws protected them.

The Hopi have a federal permit to gather young eagles and usually take fifteen or so each year for use in religious ceremonies. Eagles and their role in Hopi ceremonial life are crucial to the plot in *The First Eagle*, and readers get to see Jim Chee catch one of these huge wild birds as part of his investigation.

Don photographed bald and golden eagles at The Wildlife Center in Española, New Mexico, a home and rehabilitation clinic for injured wild animals. We also saw both types of eagles at an eagle center on Zuni Pueblo.

A rescued golden eagle housed at the nonprofit Wildlife Center near Espanola, New Mexico

INDIAN COUNTRY AND BEYOND

Author's note: I grouped these books together because although each includes scenes set in Hillerman's favorite locations, much of their action takes place outside the usual Chee/Leaphorn landscape. Believing most people already have an idea of Los Angeles and Washington, D.C., we focused on the Southwestern elements here.

The Ghostway

The Story: A mysterious death, an enigmatic photograph, and a Navajo girl missing from boarding school send Officer Jim Chee on an odyssey that takes him from Shiprock to the underside of Los Angeles and back to a curing ceremony on the Navajo reservation. On the way, Chee encounters a chilling villain and gets important clues from an old white man in a retirement village.

Of Interest: This book and *Talking God* take the story farthest from the Navajo Nation. *Ghostway* was the third novel and final novel to feature only Jim Chee. Hillerman did three drafts of the first

chapter before deciding to open the book with the pivotal murder at the laundromat. It is the last novel to feature Chee's girlfriend, Mary Landon, although her memory and letters linger for several more books.

Tony Hillerman's Comments: "The trigger for this book was a roofless stone hogan with adjoining shed in a little spring-fed pocket on Mesa Gigante, which dominates the Cañoncito Navajo Reservation. I happened across it one autumn afternoon, noticed a hole had been knocked in its north wall, the traditional exit route for the body when death has infected the hogan. But why had the dying person not been moved outside before he died, so the *chindi* [ghost] could escape?

"From this the story grew. The dead person becomes a wounded fugitive from the mafia who had come to the home of his Granddad to die. But Chee notices this poor fellow had been given only part of the burial ritual and denied other parts, and that the old man who abandoned the hogan left behind his Four Mountains Bundle, the sacred objects that traditional Navajo collect from the reservation's Four Holy Mountains. Of course the FBI neither knows these oddities are crucial nor how to explain them. Chee does, and thus I have my chance to lead readers through some of the margins of Navajo culture."

[FROM *Seldom Disappointed*]

Talking God

The Story: While Officer Jim Chee tracks an illusive part-Navajo activist, Lieutenant Joe Leaphorn investigates the strange case of an unidentified toothless man found dead with the name of a respected Navajo woman in his pocket. The crimes reunite Leaphorn and Chee and take them to cold, rainy Washington, D.C., where they encounter one of the series' most chilling antagonists. Much of the action unfolds at the Smithsonian in busy Washington, D.C. Navajo country settings include Fort Wingate, New Mexico,

Fort Defiance and Window Rock, Arizona, and the area between, in, and around Ganado and Greasewood, Arizona.

Of Interest: In a review in *The New York Times*, Timothy Foote, an editor at *Smithsonian Magazine*, had special praise for the book and even its hit man. He called Hillerman's ruthless killer "a curiously winsome Dickensian character, an urban hit man who knifes his victims with surgical skill but spends his off-duty hours trying desperately to find a nursing home willing to keep his savagely obstreperous mother."

Tony Hillerman's Comments: "A book modified by coincidences. While writing chapter 3, I stop because it's time for Sunday Mass. But the problem stays with me during the ceremony, how to describe a corpse found beside the railroad outside Gallup. I notice an elderly Hispano usher with an aristocratic face dressed in an expensive but well-worn suit. He becomes the victim. But such a man refuses to fit my gang murder plot and turns the book into a Central American political conspiracy assassination. Next, old writing friend Bill Buchanan (*Shining Season*, *Execution Eve*, etc.) mentions a man responding to Bill's refrigerator sale want-ad was not a potential buyer but a lonely fellow needing to exchange words with a fellow human. That, too, sticks in my mind. I use it. It turns my assassin into a terribly lonely man and provides a much better ending. The first chapter was no problem at all. I have an urban wannabe Navajo send a Smithsonian official a box of her ancestor's bones, dug from an ancient Episcopal graveyard, for her to display along with the bones of his ancestors. I received 'good-for-you' applause from about twenty tribesmen for that one."

[FROM *Seldom Disappointed*]

The Sinister Pig

The Story: Bernadette Manuelito, formerly an officer with the Navajo Tribal Police and now an agent with the U.S. Border Patrol, comes across suspicious activity at a rich man's big-game ranch along the New Mexico–Mexico border. Her work converges with the unsolved murder of an undercover agent that Officer Jim Chee and private de-

tective Joe Leaphorn are working on back home on the Navajo reservation. Is there a link to billions of dollars diverted from tribal trust funds? Greed, oil pipelines, cross-border trade in drugs and illegal aliens and even romance add to the plot's complications.

Of Interest: Hillerman noted that a true story, the continuing scandal over the government's mismanagement of funds due Southwest Indian tribes for oil, gas, and coal taken from their reservations under Federal auspices, sparked this book.

Publishers Weekly wrote, "With his usual up-front approach to issues concerning Native Americans, such as endlessly overlapping jurisdictions, Hillerman delivers a masterful tale that both entertains and educates." *Booklist* noted, "As always with Hillerman, an intricate pattern of ingenious detective work, comic romance, tribal customs, and desert atmosphere provide multifaceted reading pleasure." And *Library*

Journal said, "This outing ventures beyond the Navajo landscape that Hillerman's fans expect, but they—and general readers—should enjoy the broader geographical and social canvas just as well, in this tale of ordinary people unraveling knots of fraud and skullduggery."

Tony Hillerman's Comments: "Part of the idea came from thinking about my brother who at one time had a job as a well logger. He recorded what kinds of rocks the oil rigs were drilling through. He knew about how pigs cleaned the pipelines. I thought that was interesting.

"Then, I ran into a woman who worked for the bureau of public lands who was checking into abandoned pipelines, especially the ones that cross state lines and into Canada and Mexico. She told me that this would be a wonderful way to smuggle drugs into the country, because the pigs (pipeline inspection gauges) are hollow."

[FROM *Seldom Disappointed*]

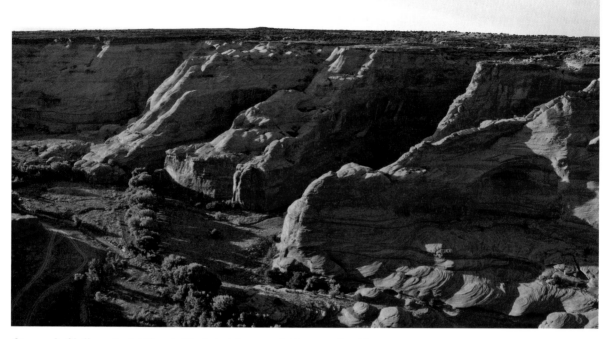

Canyon de Chelly, a special place in Dinétah, is home to deities central to Navajo creation stories.

THE NAVAJO HOMELAND: DINÉ BIKÉYAH

From Flagstaff, near the western edge of the Navajo Big Reservation to Shiprock, near its northern border is about 230 miles if you take the most direct route through Tuba City. Chee took that route, checking out of his motel before sunrise and stopping briefly at Gray Mountain to call Largo. . . .

Outside the Gray Mountain store Chee stretched . . . the snowcapped shape of the San Francisco Peaks twenty miles to the south looked close enough to touch in the clear, high altitude air . . . The only clouds this morning were high altitude cirrus so thin that the blue showed through them. Beautiful to Chee. He was back in Diné Bikéyah, back between the Sacred Mountains and he felt easy again—at home in a remembered landscape.

[CHAPTER 22, *The Ghostway*]

ABOUT THE NAVAJO HOMELAND

Whenever Dad needed inspiration to spur along a lagging plot or clarify his thoughts, he and Mom would drive out to Indian country, usually the Navajo reservation.

The modern Navajo Nation's land covers more than seventeen million acres, much of it stark and beautiful, between the mountains of southern Colorado and northeastern Utah and the low deserts of northeast Arizona and northwestern

New Mexico. Canyon de Chelly National Monument, Monument Valley, Rainbow Bridge National Monument, and Ship Rock are among its scenic attractions. This vast area, the largest Indian reservation in the United States, is about the size of the state of West Virginia. Some 250,000 people live here, according to the Nation's 2000 census estimate. (West Virginia's population was 1.8 million in 2006.)

The Diné traditional and spiritual homeland, *Diné Bikéyah*, includes a larger area that encompasses their four sacred mountains—Mount Taylor in New Mexico, the San Francisco Peaks in Arizona, and Blanca Peak and Mount Hesperus in Colorado. The landscape stretches to cool, deep canyons, colorful mesas, imposing deserts, and a photographer's dream of amazing, expansive views. In addition to its natural beauty, the Navajo Nation is the site of thousands of ancient Pueblo Indian ruins and rich deposits of oil, coal, and uranium. The seat of tribal government is in Window Rock, Arizona.

As some explain it, for the traditional Navajo, the land is their religion, their temple, their cathedral. It is home to their deities and the place for sacred ceremonies. The mesas, mountains, and plateaus come with stories. Some are petrified bodies of monsters who inhabited the earth before the Hero Twins made it safe for humans.

The Southwest's Indian country landscape has little in common with the tidy, green, water-blessed farming country of central Oklahoma where Dad grew up. The Chee/Leaphorn books reflect his passionate affection for the Navajo landscape and its people. "Mostly they're country folks," he said of the Navajo. "They remind me of the people I grew up with." When asked which

of the honors he received meant the most to him, Dad always spoke of his joy when the Navajo Nation named him a Special Friend of the Diné.

On the walls of his Albuquerque home he hung two photographs of Ship Rock, one by Don and one by Navajo photographer LeRoy DeJolie. Like the Navajo, he felt at home in the land that the Hero Twins made safe.

ST. CATHERINE INDIAN SCHOOL

Largo walked to the window and stood, back to Chee, inspecting the weather in the parking lot.

"We've got a girl missing from St. Catherine Indian School." Largo said. "Probably a runaway. Probably nothing much." The captain exercised the storyteller's pause for effect. "She's the granddaughter of Hosteen Begay. Told a friend she was worried about him. The nuns at St. Catherine called the police there at Santa Fe because they said she wasn't the type that runs away. Whatever type that is. . . ."

[CHAPTER 5, *The Ghostway*]

ABOUT SANTA FE'S ST. CATHERINE INDIAN SCHOOL

Founded by Katherine Drexel in 1887 as St. Catherine's Industrial Indian School, this school became a Santa Fe landmark and a respected institution, especially among its many alumni. The religious order Mother Drexel founded, the Sisters of the Blessed Sacrament for Indians and Colored People, operated St. Catherine's for more than 100 years. Mother Drexel also started another Indian school in the Southwest, St. Michael's Boarding

ABOVE: *St. Catherine Indian School, Sante Fe* BELOW: *Mural by Edwin O'Brien in the administration building*

Graves of Sisters of the Blessed Sacrament who taught at St. Catherine's

School near Window Rock, in 1902. In 2000, she became the second American canonized by the Roman Catholic Church.

St. Catherine's campus, a mile northwest of the Santa Fe Plaza, included more than a dozen buildings, among them the largest two-story adobe building in New Mexico. Some buildings were made from stone quarried in the Lamy, New Mexico area, just like the rock used for the Cathedral Basilica in Santa Fe. Masons who oversaw the construction of St. Francis Cathedral for Bishop Jean Lamy also worked here. Lamy personally blessed the school's cornerstone.

When my siblings and I were growing up in Santa Fe, only Native American students could go to St. Catherine's. In the 1990s, the policy changed to admit non-Indians. The expansion couldn't save the school, however, and the sisters closed it because of financial difficulties in 1998. In 2001, the New Mexico Registrar of Cultural Properties added the school to its list. As I write this, the property stands vacant except for the nuns buried in its cemetery and on-site security guard.

In *The Ghostway*, Chee unexpectedly encounters his runaway at the abandoned hogan of her dead grandfather. Margaret Sosi, like the real-life girls who attended the Santa Fe school for Indians, knows how to think on her feet, outwitting Chee and prompting his trip to the underside of Los Angeles. Margaret is safe at the end of the book, getting ready to return to the world of St. Catherine's.

Bridge over the San Juan River at Shiprock, New Mexico

SHIPROCK, NEW MEXICO

Chee rolled his patrol car southward across the San Juan bridge with the north wind chasing him, then west toward Arizona, and then south again across the dry slopes of snakeweed and buffalo grass toward the towering black spire of basalt that gave the town of Shiprock its name. It was the landmark of Chee's childhood—jutting on the eastern horizon from his mother's place south of Kayenta, and a great black thumb stuck into the northern sky during the endless lonely winters he spent at Two Grey Hills boarding school.

[CHAPTER 7, *The Ghostway*]

ABOUT SHIPROCK, NEW MEXICO

Located in northwestern New Mexico, Shiprock sits along the San Juan River at the junction of U.S. Highways 64 and 491 (known as 666 in the Chee/Leaphorn books). The community began as a ranching and farming center. The town gets its name from the rocky pinnacle that rises to the southwest. The spelling differs from the rock's two-word name because of an old post office regulation that discouraged two-word names for towns.

In 1903, the U.S. government established a post office, boarding school, and Northern Navajo agency here. Shiprock had a brief boom spurred by uranium milling activity and helium

gas processing. The Shiprock Fair, the town's biggest event, began in 1909 and continues annually the first week of October. When weather allows, a weekend flea market draws customers from miles away. In 2007, with a population of about 8,000, Shiprock was the largest community on New Mexico's Navajo reservation.

The Ghostway opens in Shiprock in the parking lot of a coin-operated laundry. An old Navajo man attempts to explain to the driver of a new car—obviously a tourist—that he doesn't know the person in a photograph because he "don't live in here with all these people." Don and I stopped for green chili stew and Navajo fry bread at Shiprock's That's A Burger on our way to Farmington, and then passed a coin-op laundry reminiscent of the one in the book.

THE SANDIA MOUNTAINS

Jimmie Yellow's place . . . seemed to have been selected more for the view than for convenience. It perched near the rim of the mesa, looking down into the great empty breaks that fell away to the Rio Puerco. To the west, across the Laguna Reservation, the snowy ridges of Turquoise Mountain reflected the light of the rising moon. To the east, the humped ridge of the Sandia Mountains rose against the horizon, their base lit by the glowing lights of Albuquerque. To the north, another line of white marked the Sangre de Cristo Mountains, and the bright smudge of yellow light below them was Santa Fe, one hundred miles away.

[CHAPTER 25, *The Ghostway*]

The Shiprock flea market features healing herbs, T-shirts, garage sale items, and fresh produce.

The Sandia Mountains are a favorite of rock climbers and hang glider pilots.

The Sandia Mountains, a central New Mexico landmark and Albuquerque's signature

ABOUT THE SANDIA MOUNTAINS

Dad loved the view of the Sandias from his kitchen window. The crystal beauty of winter snow against their rugged purple cliffs always delighted him. Dad and I often watched the summer thunderheads build over the Sandia Crest as we solved the world's problems over cups of Mom's good coffee.

Sitting in Albuquerque's backyard, the Sandias are central New Mexico's landmark and the state's most visited mountain range. Their iconic blue bulk lies immediately northeast of Albuquerque. The Sandia Peak Tramway, the longest tram of its kind in the United States, ascends to the crest through four different biological life zones and over the site of a 1955 plane crash. At

the 10,678-foot summit, the view encompasses the Rio Grande Valley, glittering Albuquerque, and ancient volcanoes rising to the west. The massive blue bulk of Mount Taylor, about seventy miles beyond this cool summit, looms on the horizon. When the air is clear you can almost see the shimmer of its aspen forest. I especially enjoy standing here at dusk, when the air smells like pine trees and the glow of sunset mixes with the diamond shimmer of Albuquerque's lights.

The Sandias don't play much of a role in *The Ghostway* or any of the Chee/Leaphorn novels, but I included them because they were Dad's marker of home. On our last big trip together, we flew to Dallas in 2005 for a reunion of the 103rd Division, Company C, 401st Infantry, the graying

remainders of the young men he'd served with during World War II. He enjoyed the weekend, but it left him exhausted. When we saw the Sandias below us from the plane window, he squeezed my hand. "Would you look at that view?" he said. "I'm glad to be home."

BLANCA PEAK

The [medicine] bundle represented weeks of work, a pilgrimage to each of the four sacred mountains to collect from each the herbs and minerals prescribed by the Holy People . . . Mount Taylor and the San Francisco Peaks had been easy enough, thanks to access roads to Forest Service fire lookouts on both of their summits. But Blanca Peak in the Sangre de Cristos and Hesperus Peak in the Las Platas had been a different matter.

[CHAPTER 22, *The Ghostway*]

ABOUT BLANCA PEAK

This 14,345-foot mountain, the sacred Navajo mountain of the east created by First Woman and First Man, is known as *Sisnaajiní*. The fourth highest mountain in Colorado, Blanca Peak rises in the Sangre de Cristo Mountain range about twenty miles east of Alamosa. The pinnacle of Blanca Peak is only eighty-eight feet lower than that of Colorado's highest, Mount Elbert. As Chee indicates, hikers rate the trail to the summit of the Blanca Peak as one of Colorado's toughest climbs. *Ghostway* is the only Chee/Leaphorn book in which I found Blanca Peak mentioned.

Blanca Peak, the sacred mountain of the East

BABY ROCKS MESA

*And so, for the past four hours Chee had been
at the Agnes Tsosie place waiting for Henry
Highhawk to arrive at this Yeibichai ceremonial
so that he could arrest him. Chee was good at
waiting. He waited at his favorite lurking point
near Baby Rocks Mesa for the endless empty miles
of U.S. 160 to provoke drivers into speeding.*

[CHAPTER 4, *Talking God*]

ABOUT BABY ROCKS MESA AND U.S. 160
It's hard to beat U.S. 160 north from Kayenta to
Teec Nos Pos, Arizona, for scenery on the road.
I understood, again, why Dad would come to
Navajo country when he needed inspiration. As
he often said, looking at this huge and beautiful
world put his own petty problems in perspec-
tive. A weekend, or even just a day surrounded
by this landscape helped set stalled projects back
on track.

East from Kayenta—home of a Navajo Cul-
tural Center that gives tribute to the code talkers
inside a unique Burger King restaurant—the land-
scape opens to an amazing collection of forma-
tions. Church Rock and Agathla Peak, like Ship
Rock, are volcanic plugs, towering reminders of
the force of molten rock and the power of eons
of erosion. Beyond them, the dune-shaped forma-
tion of Comb Ridge, a monocline of pink, orange,
and gray Navajo sandstone, extends seventy miles,
all the way to Blanding, Utah. Baby Rocks, an as-
sortment of spires and knobs, sits south of High-
way 160, eleven miles east of Kayenta. The name
comes from an eye-catching collection of small
spires. According to a Navajo story, one rock is a
little girl whom supernatural forces punished for
fighting and selfishness by turning her to stone.

Just past the junction with U.S. 191, the road to
Bluff, Utah, Red Mesa dominates the view to the
north. This lonely-looking, stunningly beauti-
ful formation is a classic flat-topped table created
during the dinosaur era with Jurassic sediment in
reds, browns, and grays.

We spent several hours driving these seventy-
two miles. When he climbed a ridge to catch the
perfect photograph, I stood quietly, stunned
by the stark and gorgeous landscape. I pictured
Dad standing here as he did his research for *The
Ghostway*. Even his words seemed too small to
capture this magnificence.

*Baby Rocks on Highway 160,
about 30 miles from the Utah border*

Charcoal rock art drawing of three Yeibichai figures from southern Colorado, circa early 1800s

YEIBICHAI

Talking God led a row of masked Yei, moving slowly with the intricate, mincing, dragging step of the spirit dancers. The sound of the crowd died away. Chee could hear the tinkle of the bells on the dancers' legs, hear the yei singing in sounds no human could understand. The row of stiff eagle feathers atop Talking God's white mask riffled in the gusty breeze. Dust whipped around the naked legs of the dancers, moving their kilts.

[CHAPTER 4, *Talking God*]

ABOUT THE YEIBICHAI

Traditional Navajo honor Talking God, the teacher of other gods, in Yeibichai ceremonies. The *hataalii* or "medicine man" invites Talking God and several other spiritual beings, or yeis, to cure a serious illness in a nine-day prayer called a *Yeibichai*. The ceremony is usually a family affair held in cold weather when the snakes hibernate and there is little threat of lightning. Navajo artists sometimes depict Yeibichai spirits in paintings, rug designs, and in sand paintings.

Dad's Navajo friend Austin Sam invited him to witness a Yeibichai ceremony in the Cañoncito area of the reservation, the same general area where Chee waits for his suspect at a similar dance. "It was cold out there and I was the only

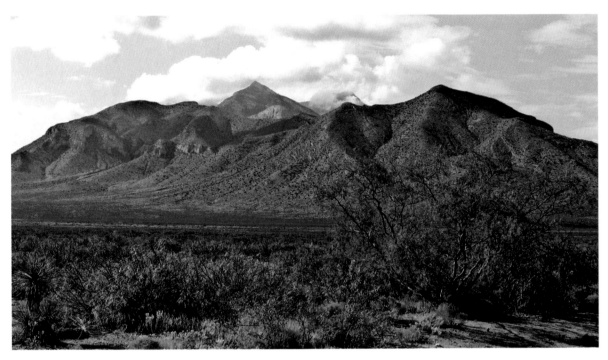

The Little Hatchet Mountains of New Mexico's boot heel

white man," Dad said. In addition to the dancing and chanting, he was impressed with the way cooks prepared great chunks of mutton for the assembled crowd. He describes a Yeibichai in vivid detail in *Talking God* to show one of the character's obsession with the Navajo culture.

THE NEW MEXICO BOOT HEEL

They had been bumping along the absolute southernmost bottom of New Mexico's so-called boot heel. For hours Bernie had been mostly silent. She'd seen no evidence of human existence except the steel fence posts and three (sometimes two) strands of barbed wire stretched between them. Dry, ragged mountains to the south in the Sonora, northward in New Mexico, the same ahead, same behind. . . . This landscape was interesting as well as hostile. Various variety of cacti, with little herds of javelina browsing on the pods of some of them, clumps of gray and tan desert grasses waving their autumn stems, the orderly scattering of creosote brush, and species of mesquite new to her and swarming with bees attracted by the honey in the flowers, and brush with more thorns than leaves.

[CHAPTER 3, *The Sinister Pig*]

[Jim Chee] stopped on the ridge, got out his binoculars, and checked. . . . Mountain ridges in

every direction, but dry mountains here. Far to the east the Little Floridas and to the west, the Big and Little Hachets. Far beyond them, and blue with distance, the ragged shapes of the Animas and the Peloncillos. Chee was comfortable with the emptiness of his tribe's Four Corners country, but here all he could see seemed to be a lifeless total vacuum.

[CHAPTER 12, *The Sinister Pig*]

ABOUT NEW MEXICO'S BOOT HEEL: SOUTHERN NEW MEXICO AND ITS MOUNTAINS

New Mexicans commonly refer to the extreme southwestern corner of the state as the "boot heel" because of the way it juts into Mexico. In-

terstate Highway 10 passes into Arizona here, following the route of the Butterfield Trail stagecoach road.

This is the edge of the Chihuahuan Desert, stretching far south into Mexico. Miners, ranchers, and railroad pioneers who settled this land had to be as tough as the desert plants. Annual precipitation averages only nine inches, most of which comes in intense thunderstorms between July and September.

Dad spoke fondly of the trip he and Mom made to research settings for *The Sinister Pig*. They timed their driving adventure to coincide with snowy weather at their home in Albuquerque, and raved about the blooming desert plants, migratory birds, and temperatures in the sixties.

Yucca, New Mexico's state flower, with the Animas Mountains on the horizon

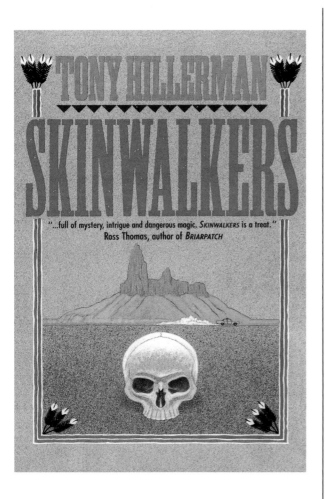

"...full of mystery, intrigue and dangerous magic. *SKINWALKERS* is a treat."
Ross Thomas, author of *BRIARPATCH*

SKINWALKERS

The Story: Do three seemingly unconnected homicides and the attempted murder of Navajo Tribal Officer Jim Chee point to the activity of a "skinwalker" or Navajo witch? Chee and Lieutenant Joe Leaphorn team up, solving the case using their own knowledge of Navajo tradition, solid inductive reasoning, and a little luck. Hillerman's settings include the Utah-Arizona border country, Window Rock, Teec Nos Pos Trading Post, Black Mesa, Casa del Eco Mesa, Gallup, Shiprock, Chilchinbito Canyon, Piñon, and Long Flat Wash.

Of Interest: This Golden Spur and Anthony Award winner paired Leaphorn and Chee for the first time and introduced another long-running character, Janet Pete. *Skinwalkers* was the first Hillerman novel to make the best-seller lists, moving him from regional to national attention. The novel drew European acclaim as well, receiving the French International Grand Prix de Littérature Policière.

Executive producer Robert Redford helped craft the story into a PBS *American Mystery!* movie in November 2002, the first of three TV

movies based on Hillerman's books. Independent filmmaker Chris Eyre directed the film, which costarred Native American actors Wes Studi and Adam Beach. Hillerman said he liked the movies "because they'll encourage people to read the books."

Tony Hillerman's Comments: "How do I awaken Jim Chee, sleeping in his cot beside the paper-thin aluminum wall of his trailer home, so he will not be killed when the assassin fires a shotgun through said wall? Everything I try sounds like pure psychic coincides—which I detest in mysteries. Nothing works until I remember the 'clack, clack' sound made when a friend's cat goes through the 'cat door' on his porch. I write in a spooky stray cat, for whom Chee makes this cat door (thereby establishing him as a nice guy and giving me a chance to explain Navajo 'equal citizenship' relationships with animals). The cat, spooked by the assassin's approach, darts from its bed under a piñon into the trailer and awakens Chee. At book's end, when I need to terminate a budding romance, the cat serves a wonderfully symbolic role."

[FROM *Seldom Dissapointed*]

WINDOW ROCK RODEO

The councilwoman finally left, replaced by a small freckled white man who declared himself owner of the company that provided stock for the Navajo rodeo. He wanted assurance that his broncos, riding bulls, and roping calves would be adequately guarded at night. That pulled Leaphorn into the maze of administrative decision, memos, and paperwork required by the rodeo—an event dreaded by all hands in the Window Rock contingent of the tribal police.

[CHAPTER 2]

ABOUT THE WINDOW ROCK RODEO

Held each year over the Fourth of July, the Window Rock Rodeo is one of the largest rodeos in the West in terms of the number of competitors and the prize money at stake. Sanctioned by the Professional Rodeo Cowboys Association, the rodeo brings reigning world champions, past world champs, and other top-ranked contestants to Window Rock, Arizona, the capital of the Navajo Nation. An all-Indian rodeo, junior rodeo, senior rodeo, and a wild horse race add to the *Ahoohai Days* celebration that runs concurrently. The events draw thousands of folks from throughout the reservation. Don and I noticed that we non-Navajos were clearly in the minority.

When we lived in Santa Fe, Dad would leave his office to watch the Rodeo de Santa Fe parade with Mom and us kids. Afterwards, he sometimes finagled tickets so we could see the rodeo

A saddle bronc rider at the Window Rock fair

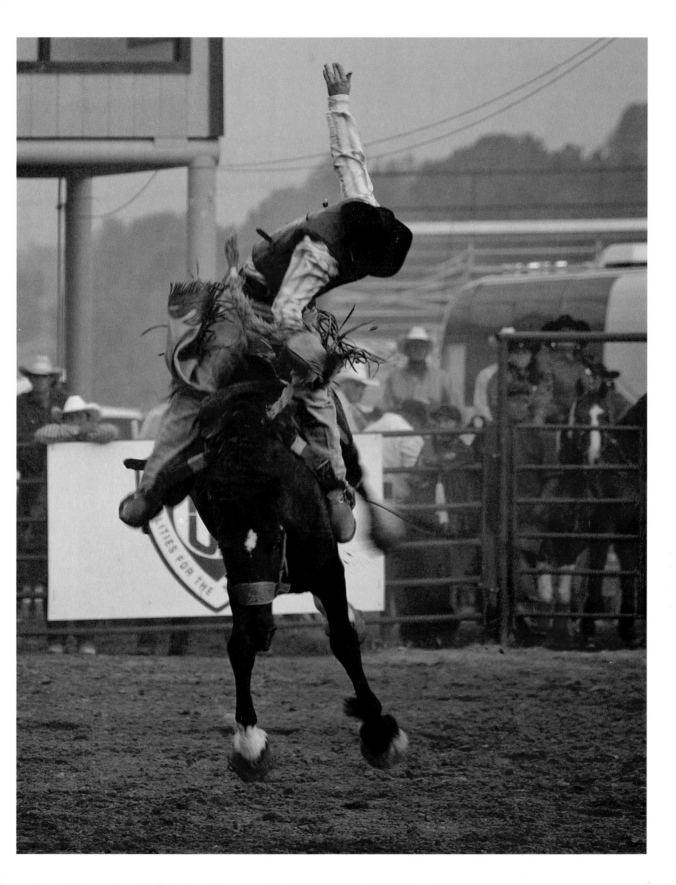

At Teec Nos Pos Trading Post visitors can see Navajo rugs that reflect the complex designs developed on this part of the reservation.

itself. Like many little girls, I was crazy about horses. From his former farm boy perspective, Dad viewed them as necessary work animals and never gave in to my pleas for a pony. Years later, the Navajos honored him at the Shiprock Fair. The organizers wanted Dad to ride a horse in their big parade, and he told them he would only if they could find a very old, very tired one. They let him ride in a convertible instead.

In *Skinwalkers*, Dad uses the rodeo as an example of the distractions that keep Leaphorn from focusing on a series of murders. Leaphorn describes it as a "three day flood of macho white cowboys, macho Indian cowboys, cowboy groupies, drunks, thieves, con men, Texans, swindlers, photographers, and just plain tourists."

TEEC NOS POS TRADING POST

Why did the white culture either cool things or heat them before consumption? The first time [Chee] had experienced a cold bottle of pop had been at the Teec Nos Pos Trading Post. He'd been about twelve. The school bus driver had brought a bottle for everyone on the baseball team. Chee remembered drinking it, standing in the shade of the porch . . .

[CHAPTER 3]

ABOUT TEEC NOS POS, ARIZONA AND ITS TRADING POST

This small community sits at the junction of U.S. Highways 64 and 160, west of Shiprock, New

The store sells supplies, including Blue Bird Flour for fry bread, to area residents.

Mexico. The name is a variation on the Navajo words *Tiis nazbas*, which mean "cottonwoods in a circle." Teec Nos Pos is best known for two things: as the childhood home of Peter MacDonald, former chairman of the Navajo Nation, and for its weaving. Collectors prize Teec Nos Pos rugs for their skilled artisanship and intricate designs. They often feature zigzags, triangles, or serrated diamonds enclosed within a border. Weavers from this area tend to create larger works than do their Navajo neighbors.

The trading post, which resembles a convenience store from the outside, is worth a look. Hamblin Bridger Noel started the business in 1905. Noel, from Virginia, was the first white man the Navajo permitted to establish a post in this section of the reservation. John McCulloch owned the store when we visited. I was thrilled to see children's books in Navajo and in English for sale here—and a pair of pint-sized Navajo girls sitting on the floor, enraptured by the stories.

In addition to using the trading post as a memory trigger for Chee in *Skinwalkers*, Dad also mentioned it in several other novels including his first, *The Blessing Way*.

DUST STORM

The turbulence caused by the thunderhead was sweeping across the valley floor toward them. It kicked up an opaque gray-white wall of dust which obscured the distant shape of Black Mesa and spawned dust devils in the caliche flats south of them. They were standing, officer Al Gorman and Joe Leaphorn, beside Gorman's patrol car on

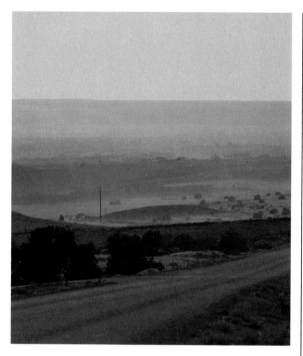

Dust storm over Chinle near Canyon de Chelly

the track that led across the sagebrush flats below Sege Butte toward Chilchinbito Canyon.

[CHAPTER 10]

Leaphorn grunted. He was watching the dust storm moving down the valley with its outrider of whirlwinds. One of them had crossed a gypsum sink, and its winds had sucked up that heavier mineral. The cone changed from the yellow-gray of the dusty earth to almost pure white. It was the sort of thing Emma would have noticed and found beauty in. . . .

[CHAPTER 10]

PAINTED DESERT

By midnight there was no more thunder; the cloud formation had sagged into itself, flattening to a vast general rain—the sort the Navajos call female rain—which gently drenched an area from Painted Desert northward to Sleeping Ute Mountain.

[CHAPTER 22]

ABOUT THE PAINTED DESERT

The Painted Desert, a broad area of colorful badland formations, stretches about 160 miles in northeastern Arizona east of Holbrook. Much of this brilliant and eerie landscape lies within the Navajo Nation; the Hopi Mesas sit on the northern boundary.

Petrified Forest National Park, easily accessible from Interstate 40, preserves some of the fascinating scenery.

The colors—vivid bands of reds, oranges, soft grays, whites, and yellows—come from stratifi-

Dust storm over the desert, Navajo Nation

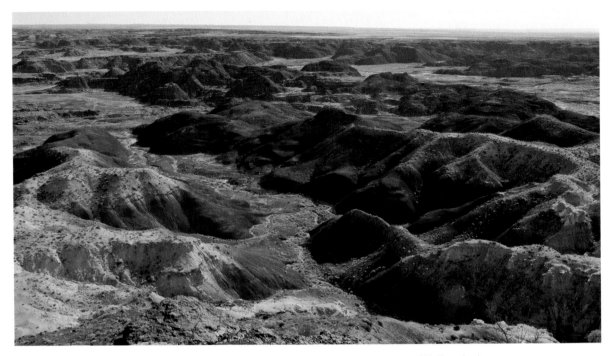

An overlook of the Painted Desert from inside the national park, about 28 miles east of Holbrook, Arizona

cations of minerals and decayed organic matter. Unlike some "deserts," this one includes mesas, buttes, trees turned to stone, and dinosaur tracks. The clay soil expands when wet, then cracks as it dries. The moving surface prevents plants from growing, giving the area its barren look. The landscape also shows evidence of ancient volcanoes. The lava here is pillow basalt, the same type of lava found in Hawaii.

The steady work of wind and water continue to erode the landscape, exposing new layers of what geologists call the Chinle Formation, rock that is 200 million years old. The south part of the desert is rich in petrified wood and fossils from the Triassic period. The park's north entrance has a visitor center with hands-on exhibits, orienta-tion information, post office, café, gas station, and gift shop. The Painted Desert Inn National Historic Landmark is a hotel-turned-museum that sometimes hosts demonstrations by Native American artists.

Dad never used Painted Desert as a setting for his action, but rather as a bookend for Navajo Nation landscape. His references to the Painted Desert include not only the park but the whole lovely parade of colors and shapes beyond park boundaries. Toward the end of *Skinwalkers*, Leaphorn anchors his thoughts in this landscape as he begins to consider the good news that his wife, Emma, does not have Alzheimer's disease but an operable brain tumor.

A THIEF OF TIME

The Story: When Jim Chee discovers grave robbers at an ancient burial site, his search for the truth takes him deep into the past. Meanwhile, Lieutenant Joe Leaphorn searches for a noted woman anthropologist who has vanished, a quest that leads to a moonlit Indian ruin where "thieves of time" have ravaged sacred ground for profit. The story unfolds with a string of discoveries that involve a father's love, greed, jealousy, and murder—all against the backdrop of a real-life mystery, the fate of the people who once lived at Chaco Canyon. Settings also include the scenic San Juan River canyon country.

Of Interest: A Thief of Time was the first Hillerman novel to become a *New York Times* best seller. The novel won a Macavity Award from Mystery Readers International and received nominations for Edgar and Anthony awards. The U.S. Department of the Interior and the American Anthropology Association honored Hillerman for the book because of its message about the damage pot hunting does to the archaeological record. He also received the Center for the American Indian's Ambassador Award, which remained on

display in his office for more than thirty years—a beautiful bronze of a Comanche warrior holding his coup stick. In 2000, the Independent Mystery Booksellers selected *A Thief of Time* as one of the 100 Favorite Mysteries of the Century. PBS filmed it as an *American Mystery!*, the third in the series based on Hillerman's Navajo police officers.

Tony Hillerman's Comments: Hillerman once said that *A Thief of Time* was his favorite book in the Chee/Leaphorn series because here, he believed, all the pieces of the plot came together smoothly for the first time.

"Oddly enough, I got the idea for *A Thief of Time* from seeing this Bureau of Land Management poster. It had a sinister looking fellow with dark glasses. I remember the headline, THIEF OF TIME. The message here was obvious—this guy is not only stealing artifacts, he's stealing our ability to learn about our past. I saw that and I thought, 'Wow, what a great title for a book.'"

<div align="right">

[FROM A CONVERSATION WITH
ANNE HILLERMAN]

</div>

In *Seldom Disappointed* he wrote about reasons for the book's popularity, sharing what he learned from readers at book signings. "They'd assure me they were not mystery readers. They read my books because of the tribal cultural material intermixed with the plot line. They wanted to learn a bit about American Indians. It occurred to me that I had tapped into a mass of American readers who suffer from the same workaholic problem that besets me. Reading for idle amusement left them feeling guilty. My books, like a sausage sandwich spiced with antacid tablets, give absolution along with the sin."

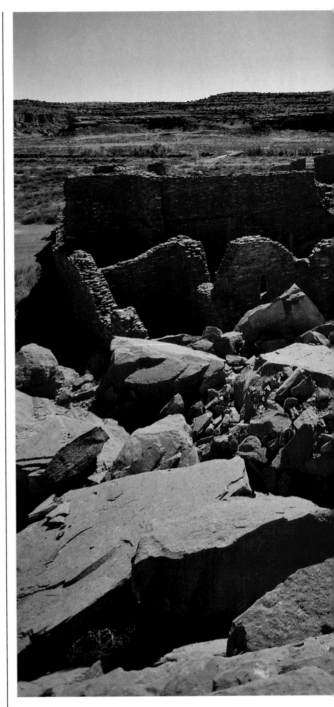

Chaco Canyon, despite its remote location, attracts some 80,000 visitors annually.

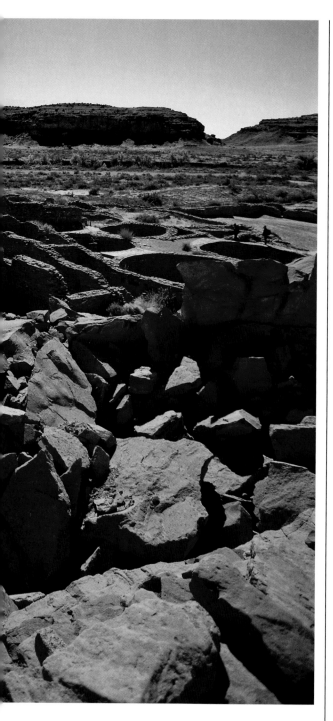

CHACO CANYON

Beyond him, the slanted light of the autumn afternoon outlined the contours of the Chaco Plateau with lines of darkness. The shadow of Fajada Butte stretched all the way across Chaco Wash now. Outside the shadow, the yellow of the cottonwood along the dry streambed glittered in the sun. They were the only trees in a tan-gray-silver universe of grass. (Where had they found their firewood, Leaphorn wondered, the vanished thousands of Old Ones who built these huge stone apartments? . . .)

[CHAPTER 2]

ABOUT CHACO CULTURE NATIONAL HISTORICAL PARK

The combination of open space and human effort makes Chaco Canyon one of the world's special places. Dad wasn't alone in his love of this hard-to-get-to destination. Despite its location, Chaco draws thousands of visitors from all over the world. New Mexico's Pueblo Indians and the Hopi of Arizona place the Chacoans among their ancestors and consider this part of their homeland.

The National Park Service established Chaco Canyon National Monument in 1907, some twenty years after a pair of cowboys discovered these extensive ruins in arid northwestern New Mexico. Chaco Culture National Historical Park became a United Nations World Heritage Site in 1987. Encompassing fifty-three square miles, the park preserves a key center of ancient Native American culture. Indians lived here for about 400 years, beginning around the same time Vi-

kings sacked Canterbury Cathedral and Muslims invaded Rome.

Despite more than a century of archaeological research, the park has thousands of unexcavated sites and scores of unsolved mysteries—an ideal setting for *A Thief of Time*. Since the builders left no written language, archaeologists have to puzzle out the mystery of these great cities. Why did people settle in this desolate place? What compelled them to haul logs from the mountains fifty miles away? Why would a civilization without the wheel or pack animals build more than 200 miles of straight, wide roads? What rituals transpired in the great kiva? How did astronomy influence Chaco's daily life? Why did they walk away from the amazing stone buildings they had spent decades meticulously constructing?

Mom and Dad once brought some German visitors here. Dad recalled how they marveled at the ruins, but after a few hours insisted that he drive them back to Albuquerque. "They were used to green, used to trees," he told me. "They loved Pueblo Bonito but all that empty space, well, it made them very uneasy."

When Don and I camped here, we noticed scores of bats emerging from the ruins at sunset, a surprise because I hadn't seen any insects, their favorite food. Later, the stupendously dark night sky blazed with a million stars.

Pueblo Bonito, one of the canyon's great structures, includes 37 kivas.

ROCK ART

A great place for pictographs. Just ahead, beyond the cottonwoods on the sheer sandstone wall where the canyon bottom bent, was a gallery of them. The baseball gallery, they called it, because of the great shaman figure that someone had thought resembled a cartoon version of an umpire . . . Above it, a clutter of shapes danced, stick figures, abstractions: the inevitable Kokopelli, his humped shape bent, his flute pointed almost at the ground; a heron flying; a heron standing; the zigzag band of pigment representing a snake.

[CHAPTER I]

The petroglyphs were exactly as she had stored them in her mind. The spiral that might represent the sipapu from which humans had emerged from the womb of Mother Earth, the line of dots that might represent the clan's migrations, the wide-shouldered forms that ethnographers believed represented kachina spirits. There, too, cut through the dark desert varnish into the face of the cliff, was the shape Eddie had called Big Chief looking out from behind a red-stained shield, and a figure that seemed to have a man's body but the feet and head of a heron.

[CHAPTER I]

ABOUT PICTOGRAPHS AND PETROGLYPHS

New Mexico, Arizona, and Utah have thousands of examples of ancient rock art left by the Pueblo Indian ancestors and many other Native Americans. To my eye, some seem whimsical; some tell a story; some make me wonder. One of the largest

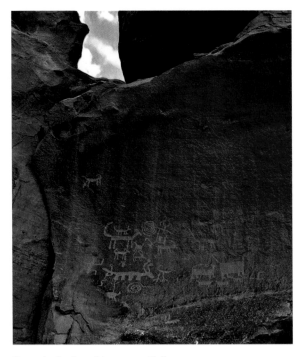

Petroglyphs from Monument Valley

Petroglyphs at Flute Player Cave, Canyon de Chelly

concentrations of petroglyphs lies along the San Juan River at Butler Wash, Utah, an area similar to that featured in *A Thief of Time*.

Early artists created pictographs by painting on rock with a mineral or vegetable dye and a binder such as blood or fat. Paintings in locations protected from rain and sun can survive the ravages of time. To make petroglyphs, artists carved, pecked, or chipped into stone, removing an outer patina to expose the lighter-colored rock beneath. They often used sandstone and basalt for petroglyphs. Common symbols include serpents, birds, antelope, deer, the sun and moon, human stick fig-

ures, and Kokopelli, the humpbacked flute player. Look for petroglyphs and pictographs near ruins, in caves, and beneath overhangs.

Among my favorites are the dozens of red handprints of different sizes painted outside pueblo ruins in Monument Valley. I imagine children pestering their parents to trace their little hands . . . or doing it themselves! It's tempting to follow the old patterns with your fingertips, but please resist. Touching the rock art hastens its deterioration.

In *A Thief of Time*, Dad used distinctive petroglyphs as the sign Leaphorn needs to realize he's close to finding the missing archaeologist.

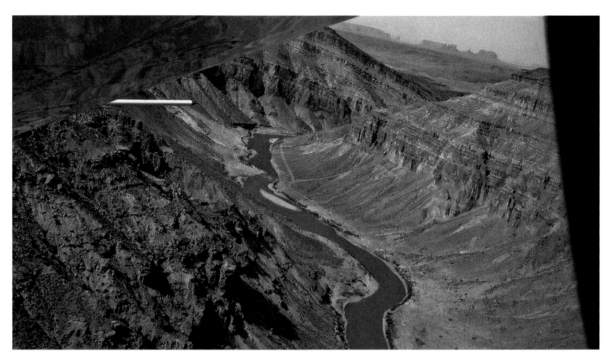

The San Juan River with Monument Valley on the horizon

SAN JUAN RIVER

The cliffs that walled in the San Juan between Bluff and Mexican Hat limited takeout places to a few sandy benches and the mouths of perhaps a score of washes and canyons . . . About four miles below the Bluff bridge, he let the kayak drift into a sandbar on the north side of the river, as much to stretch cramping muscles and give himself a rest as in any hope of finding something. On the cliffs here he found an array of petroglyphs cut through the black desert varnish into the sandstone. He studied a row of square-shouldered figures with chevron-like stripes above their heads and little

arcs suggesting sound waves issuing from their mouths.

[CHAPTER 18]

ABOUT THE SAN JUAN RIVER

The San Juan, flowing through Utah, Colorado, and New Mexico, is one of the major rivers of the Southwest. Traditional Navajos hold the river itself and several of its confluences with other rivers sacred. Rafters enjoy the section between Bluff and Mexican Hat, Utah, because of the many petroglyphs and ancient Indian ruins along the way.

When Don and I did a San Juan float trip here years ago, we unknowingly booked with the

same company and the same guide Dad had used in his research for a magazine article. That river experience later became part of *A Thief of Time*. Dad charmed fellow passengers with his stories, our guide recalled, and the journey with "famous author Tony Hillerman" became the most memorable of his hundreds of trips down the river.

The San Juan near Farmington, New Mexico

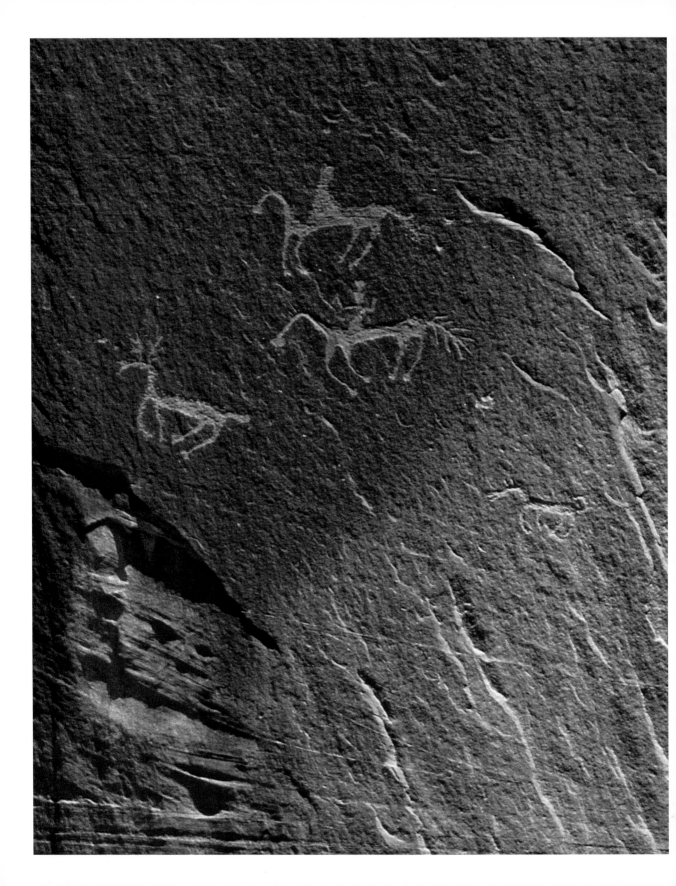

Petroglyphs from Canyon de Chelly

COYOTE WAITS

The Story: Officer Jim Chee's friend and fellow Navajo Tribal Police Officer Delbert Nez lies dead and Chee blames himself. He apprehends Ashie Pinto, an ancient drunken Navajo, holding the murder weapon. Attorney Janet Pete is assigned to defend Pinto, but the suspect won't utter a word of confession—or denial. The story grows with the death of a University of New Mexico professor who is searching for the bones of Butch Cassidy and the Sundance Kid, and the homicide of a former South Vietnamese colonel. Chee and Lieutenant Joe Leaphorn unravel a multilayered plot that involves a lost fortune, one of history's famous unsolved mysteries, and the mythical Coyote. Settings include Ship Rock, Window Rock, Arizona, and Albuquerque's University of New Mexico campus and Frontier Restaurant.

Of Interest: With executive producer Robert Redford, *American Mystery!* presented *Coyote Waits* as a two-hour special on PBS premiering in November 2003. The movie, the second Hillerman novel adapted by PBS, featured Wes Studi as Leaphorn and Adam Beach as Chee. Studi, who lives in Santa Fe, discussed the books and movies with

Hillerman before an audience of fans and other writers at The Tony Hillerman Writers Conference: Focus on Mystery in 2006.

Tony Hillerman's Comments: "When my brother Barney and I were prowling the Four Corners with me writing and him photographing stuff for our *Hillerman Country* he taught me a lesson in optical perspective that solved Leaphorn's problem in finding the needed witness. Barney anthropomorphized cliffs, canyons, trees, etc., turning their reflected lights and shadows into presidential profiles, bears, and so forth. (Something I do with cloud formations, seeing in them not only God's glory but dragons, Popeye, and aircraft.)

"'Stop,' Barney would say, and point at a rock formation. 'See the zebra with the pipe in his mouth?'

"I'd say no. He'd say back up a little. We'd stop where all the necessary elements would line up properly and I would either see suggestions of a zebra or, often, simply say I did and drive on with Barney explaining how viewer position and the optics of telescopic lenses affect what you see. It was the sort of data I usually find easy to forget, but I remembered it when stuck for a logical way to have a witness out in empty country witnessing a murder. He became a lonely high school kid whose hobby was landscape photography and who found a way to declare his love for a girl by careful placement of white paint on basalt rocks so the message could be read only from the perspective of her hogan.

"I spent weeks trying to have Leaphorn figure that out, wishing I'd never heard of optical perspective."

[FROM *Seldom Disappointed*]

LAVA FLOWS NEAR SHIPROCK

He would be looking across the tops of the cottonwoods lining the San Juan and southwestward toward the sagebrush foothills of the Chuskas. He would be seeing the towering black shape of Ship Rock on the horizon, and perhaps Rol Hai Rock and Mitten Rock. No. Those landmarks would be beyond the horizon from Mr. Ji's viewpoint at the window. Chee was creating them by looking into his own memory.

[CHAPTER 6]

Ship Rock rose like an oversize, free-form Gothic cathedral just to their right, miles away but looking closer. Ten miles ahead Table Mesa sailed through its sea of buffalo grass, reminding Chee of the ultimate aircraft carrier. Across the highway from it, slanting sunlight illuminated the ragged black form of Barber Peak, a volcanic throat to geologists, a meeting place for witches in local lore.

[CHAPTER 6]

GALLUP TO SHIPROCK, NEW MEXICO

The route between Gallup and Shiprock, New Mexico was known as U.S. 666 or "The Devil's Highway" when Dad created most of his Chee/Leaphorn novels. (It became U.S. 491 in 2003.) The ninety-four-mile drive offers fine views of Bennett Peak, Ford Butte, Barber Peak, Table Mesa, and Ship Rock. Dad made this trip many times; each time the landscape stirred his creative energy.

Ford Butte

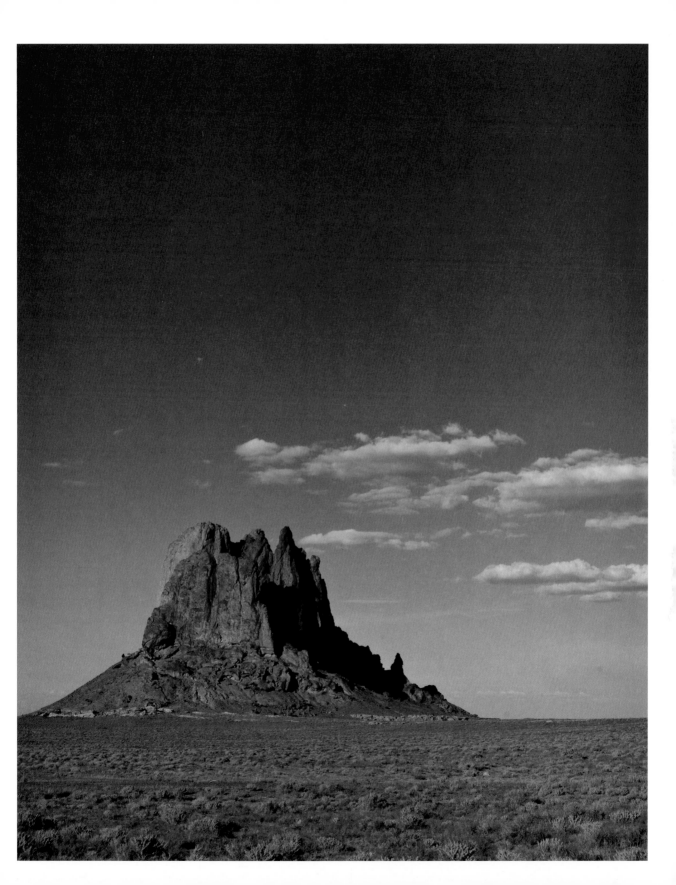

THIS PAGE, TOP:
*Table Mesa with
Ute Mountain in the distance*

THIS PAGE, BOTTOM:
Barber Peak

FACING PAGE: *Ship Rock*

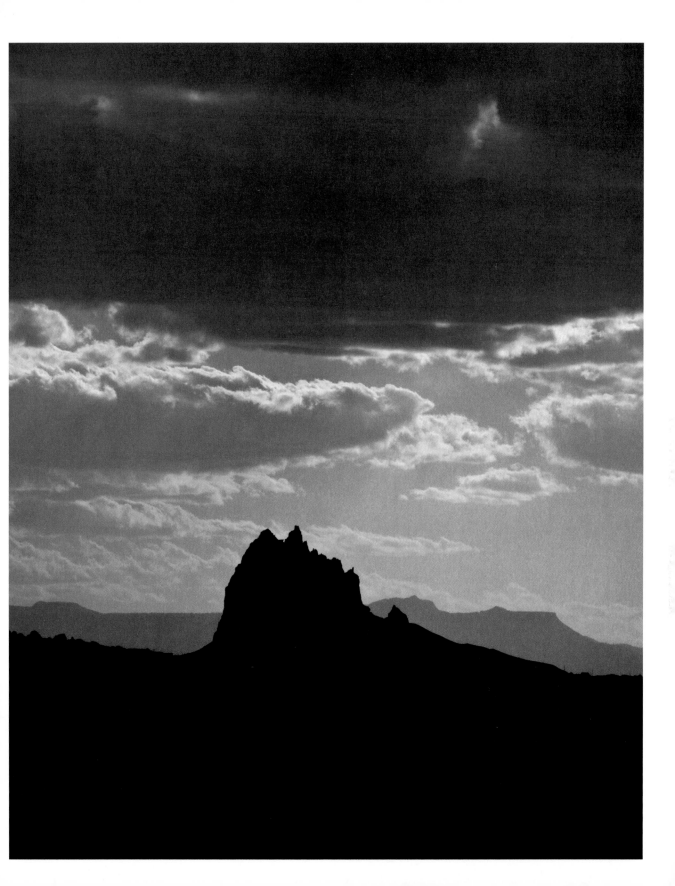

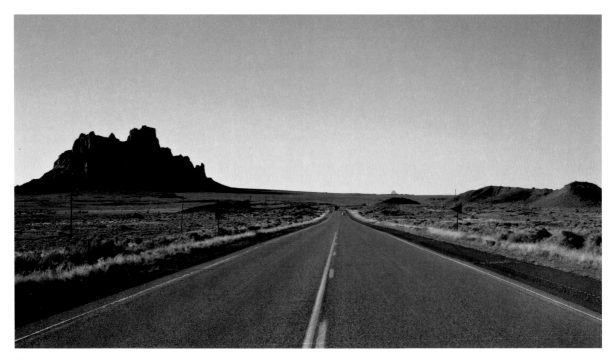

Bennett Peak

Table Mesa is actually three separate mesas lying close together. Since *mesa* means "table" in Spanish, the name is redundant, and easy to remember. Rol Hai Rock, a huge black basalt formation, rises about 200 feet from the high desert landscape north of the tip of Table Mesa. As *Coyote Waits* makes clear, some traditional Navajos avoid the lava formations, especially at night. In the book, much of the action happens here—the death of a tribal officer, the arrest of the suspect, and, ultimately, a snakebite that saves Jim Chee's life.

In addition to using the lava flow area as the site of a policeman's murder in *Coyote Waits*, Dad wrote about this eerie landscape in *The First Eagle* and *Fallen Man* and mentions it in many other books.

NARBONA PASS

They took the road that wanders over Washington Pass via Red Lake, Crystal, and Sheep Springs. Winding down the east slope of the Chuskas, Leaphorn stopped at the overlook. He pointed east and swept his hand northward, encompassing an immensity of rolling tan and gray grasslands. Zuni Mountains to the south, Jemez Mountains to the east, and far to the north the snowy San Juans in Colorado.

Narbona Pass, high in the Chuska Mountains, was named after the esteemed Navajo leader.

"Dinetah," he said. She would know the meaning of the word. "Among the People." The heartland of the Navajos. The place of their mythology, the Holy Land of the Diné.

[CHAPTER 12]

ABOUT WASHINGTON/NARBONA PASS

Highway maps used to call this Washington Pass, the name Leaphorn and Chee use in the novels. In 1993, members of the Navajo Nation successfully petitioned the U.S. Geological Survey to change the name to Narbona Pass to honor the great Navajo hero rather than the U.S. Army colonel who ordered Narbona's death. The pass received Narbona's Spanish name, not his Navajo name, as a compromise with those Navajos who believe it is inappropriate to use the names of the dead.

The drive over Narbona Pass through the Chuska Mountains stands out as one of the top five scenic roads in Indian Country. From Narbona's 9,000-foot summit, the view encompasses much of the Navajo Nation.

Like Leaphorn, Dad loved this spot and never tired of the vista. I remember him talking about how the view had changed over the thirty-plus years of his visits as dust, smoke, and pollution made their mark on the air. Despite that, he considered it one of the world's special places.

Last time we drove this route, we ran into highway construction, a five-person Navajo crew hard at work on a Friday evening. Just beyond the roadwork, we encountered a huge Christian revival meeting, complete with a Navajo band. We resisted the temptation to stay and headed on toward Gallup through the fragrant mountains.

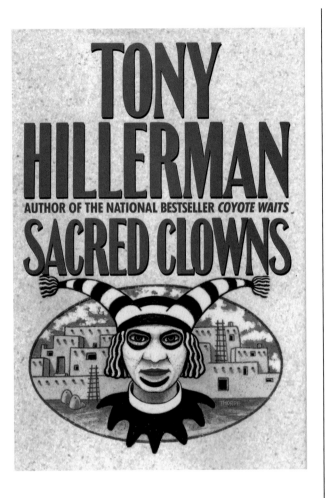

SACRED CLOWNS

The Story: Officer Jim Chee and Lieutenant Joe Leaphorn are challenged to solve two mysterious murders, the killing of a bighearted mission schoolteacher and the death of a Pueblo elder slain in the midst of a ceremonial dance. A hit-and-run accident, tribal corruption, and a racket in counterfeit sacred artifacts add to the action. Settings include Gallup, Crownpoint, and Farmington, New Mexico; Window Rock and Flagstaff, Arizona; and the fictional Pueblo Indian village of Tano. Hillerman says in his author's note, Tano "is not a Hopi village."

Of Interest: Hillerman originally called this book *Mudhead Kiva.* While writing it, he discovered that he had cancer and spent time in the hospital. He described the experience as "wonderful periods away from the telephone for thinking." When he got back to it, the book had become *Sacred Clowns.* "The story improved as much as the title," he said. He dedicated the novel to the director and volunteers at St. Bonaventure Mission, where he sets some of the action. This is the final book in which Leaphorn works as a Navajo

police officer; in subsequent titles, he is a private investigator.

"Telling his story the Navajo way," wrote *Publishers Weekly*, "Hillerman fully develops the background of the cases . . . so that the resolutions . . . ring true with gratifying inevitability."

Tony Hillerman's Comments: "This book grew from something left over from an earlier one. *The Dark Wind* had required me to learn about the Hopi. I had slept in my pickup at the edge of Walpi, awaiting morning to interview a fellow for a magazine article. I awoke at sunrise (easy when you've been cramped in a Toyota truck) and saw a man emerge from a house. He held the bundle he was carrying up toward the rising sun, stood like that for a long moment, apparently chanting, and then disappeared again into his house. I learned he had been presenting his eight-day-old child to God, symbolized by the rising sun, in a ceremony in some ways like a Christian baptism and in some ways more than that. The elder I interviewed explained that the chant he had sung presented the infant as a child of God, and recognized the human father and mother as foster parents—promising to nurture God's child by the Creator's rules and asking God's blessings on this task."

[FROM *Seldom Disappointed*]

KOSHARES

Hopi koshare by Abe Sakiestewa (Nat and Shirley Holzer Collection)

Four figures had emerged on a roof across the plaza. They wore breechcloths and their bodies were zebra-striped in black and white, their faces daubed with huge black smiles painted around their mouths, their hair jutting upward in two long conical horns, each horn surmounted with a brush of what seemed to be corn shucks. Koshares. The sacred clowns of the Pueblo people. Chee had first seen similar clowns perform at a Hopi ceremonial at Moenkopi when he was a child, and since then at other Hopi dances.

[CHAPTER 1]

ABOUT KOSHARES

Koshares, the black-and-white-striped clowns who appear at some Pueblo Indian dances and on the Hopi Mesas, portray both the human and the divine. Their trademark is exaggeration, including overly loud conversations and slapstick action, all with the idea of reinforcing proper community values. The Sacred Clowns sometimes make fun of non-Indian onlookers at dances, mimicking tourists taking photos, standing in front of Pueblo residents or otherwise being rude. You can often find carvings of koshares in shops that sell Native American arts. A popular interpretation portrays smiling clowns gorging themselves on watermelon. Dad had a small collection of the figures, gifts from Navajo and Hopi friends, including one pudgy watermelon eater that the artist said he had modeled after Dad himself.

In an opening chapter of *Sacred Clowns*, Chee watches the koshares from his seat on a pueblo rooftop. He's come to the village to look for a

Hopi koshares (Richardson's Trading Post, Gallup)

half-Navajo boy. The clowns stand on the parapet of a building, pointing at a line of dignified costumed dancers, gesturing, and then climbing a ladder upside down. Their antics include a skit designed to embarrass those who sell sacred artifacts. During a pause in the dancing, someone murders a koshare, an esteemed man of the pueblo, creating a major complication for Chee in his search for the boy.

ST. BONAVENTURE INDIAN MISSION

The file so far included only two sheets of paper, on which were the preliminary report from the investigating officer at the Navajo Tribal Police office in Crownpoint. . . . Eric Dorsey, aged thirty-seven, wood and metalwork teacher, school bus driver, and maintenance man at Saint Bonaventure Indian Mission. Found dead on the floor of his shop by students arriving for their afternoon class.

[CHAPTER 2]

Normally Leaphorn was good at waiting, having learned this Navajo cultural trait from childhood

Sister Natalie, St. Bonaventure's principal, surrounded by admirers in 2009

as many Navajos of his generation learned it.... But this morning he was tired of being patient and especially tired of being patient with Officer Jim Chee.

He paced back and forth across the grounds of the Saint Bonaventure Mission School ... Leaphorn had watched the mission's small fleet of castoff and recommissioned school buses discharge their loads of noisy Navajo kids.

[CHAPTER 27]

ABOUT ST. BONAVENTURE INDIAN MISSION AND SCHOOL

St. Bonaventure Mission and School in Thoreau, New Mexico works with more than ten local Navajo agencies to serve Diné in need on the Eastern Navajo Nation. In addition to offering tuition-free education, the mission provides water hauling to families within a fifty-mile radius, free hot meals for the elderly and disabled, affordable housing, a thrift store, and other services to those living in poverty. The Catholic mission is the largest employer in the community; 75 percent of the workers are Navajo.

Established in 1974, the school enrolls about 200 students from pre-kindergarten to the eighth grade and provides free bus transportation for the children, many of whom live far from paved roads. Dad often recommended the school and its programs to friends and fans looking for worthy causes to support; our family suggested it as a charity in his obituary.

Dad uses the school for an off-page murder in *Sacred Clowns*, a killing with no apparent motive and no logical suspects. When Leaphorn supervises a search of the St. Bonaventure workshop where the teacher died, Dad shows the reader the "Legendary Lieutenant's" acumen. Leaphorn discovers unusual wood shavings and an atypical form for sand casting silver, subtle but important clues that ultimately solve the case.

ANGEL PEAK

On the north side of Highway 44, the ocean of sagebrush stretched away into the Angel Peak badlands. On the south side of the highway where the NAI held domain, the black-gray-silver of the sage had been replaced by mile after mile of green, the shade depending on the crop and the season.

[CHAPTER 19]

ABOUT ANGEL PEAK

Angel Peak, rising to 6,800 feet, is the chief attraction of the Garden of Angels, an eighty-square-mile expanse of old ocean and river bottom landscape in San Juan County, New Mexico. Over the course of the last few million years, tributaries of the San Juan River and wind-driven sand eroded the rocks to carve this maroon, gray, and yellow badlands. The "angel" that towers over it all is made of sandstone sitting on siltstone

Angel Peak sits outside of Bloomfield in northwestern New Mexico

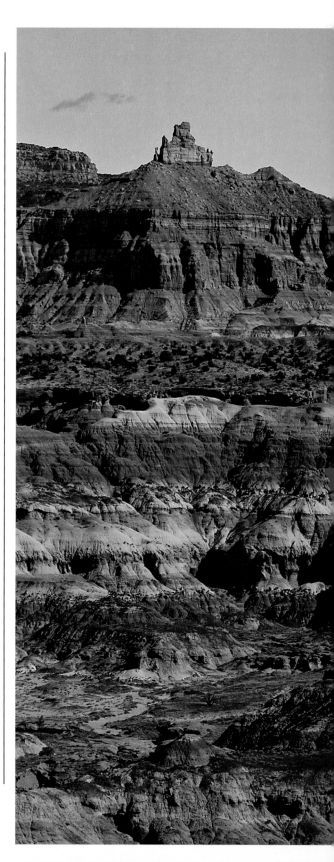

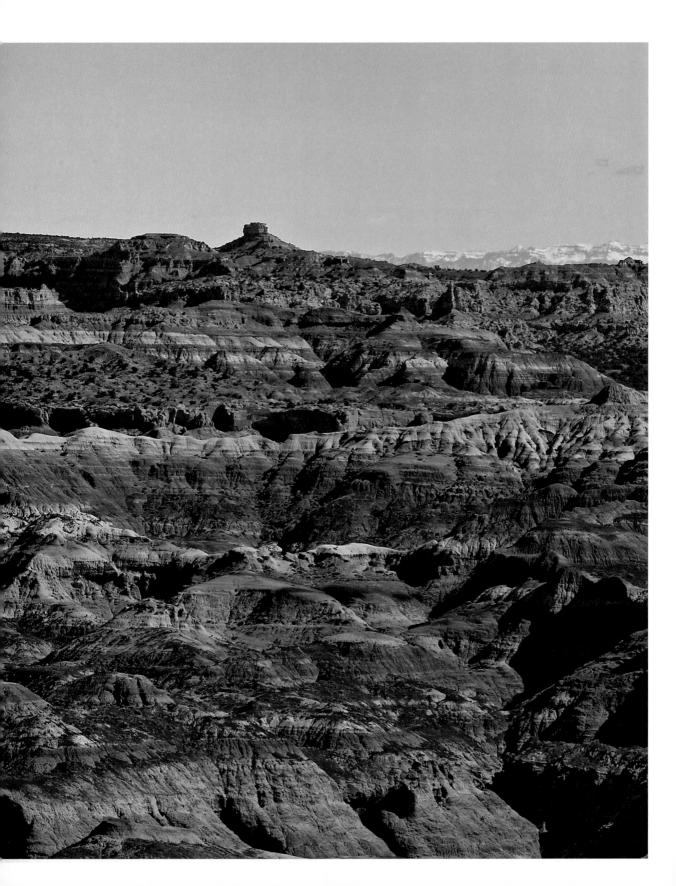

and a second kind of sandstone. Rich in fossils of early mammals and petrified wood, the area is preserved and managed as Angel Peak National Recreation Site by the Bureau of Land Management. Visitors can camp and picnic here.

One Navajo name for the peak refers to its resemblance to a pair of seated coyotes. Dad calls Jim Chee's attention to Angel Peak in *Sacred Clowns*, the only book in which it appears, as Chee hunts for a driver who confessed on a Navajo-language radio station to a hit-and-run death. He uses the formation to point out the contrast between the natural arid landscape and the difference water and human engineering can make. Chee wonders if green fields with their onion crops are more beautiful and valuable than the sagebrush they replaced. I know Dad wondered about it too—the perennial question about progress and its costs.

THOREAU/LITTLE HAYSTACK MOUNTAIN/AMBROSIA LAKE

In fact, they talked very little on their way to Crownpoint. East of Gallup, Chee pointed to the places along the red sandstone cliffs of Mesa de los Lobos where various movies had been shot. He explained that Thoreau was pronounced "threw" because the village had been named after a railroad engineer and not the poet-essayist. He pointed southward to Little Haystack Mountain and told her how a Navajo prospector named Paddy Martinez had found a vein of radioactive pitchblende near there and opened the great Ambrosia Lake uranium mining district.

[CHAPTER 26]

ABOUT THE AMBROSIA LAKE AREA AND URANIUM

New Mexico has the second largest reserve of uranium ore in the United States. (Wyoming is first.) Most uranium lies in the Grants Mineral Belt, which includes the Ambrosia Lake area and Mount Taylor. As Dad mentions, Navajo sheepherder Paddy Martinez discovered uranium here in 1950. The resulting mines created numerous jobs and substantial royalties for the Navajo and Laguna tribes and turned the sleepy village of Grants into a boomtown. During the uranium era's peak, from the early 1950s to the early 1980s, miners extracted about 400 million pounds of ore here, valued in excess of $25 billion.

Uranium took a toll on the residents' health. Miners and those who lived near the tailings suffered high rates of lung cancer, kidney disease, birth defects, and other ailments. Thousands of Navajos are receiving or seeking federal compensation for the damage uranium exposure caused to their health. No uranium ore has been mined in New Mexico since 1998.

Dad explores the damage uranium exposure causes in *People of Darkness*; the miners' radioactive talismans lead to their mysterious deaths. Although well aware of the problems with uranium, Dad also believed that the United States was myopic about the value of atomic energy as a source of power. In the 1990s, he appeared on the television show *Politically Incorrect* with Bill Maher as part of a panel on the pros and cons of nuclear power.

Little Haystack Mountain, New Mexico

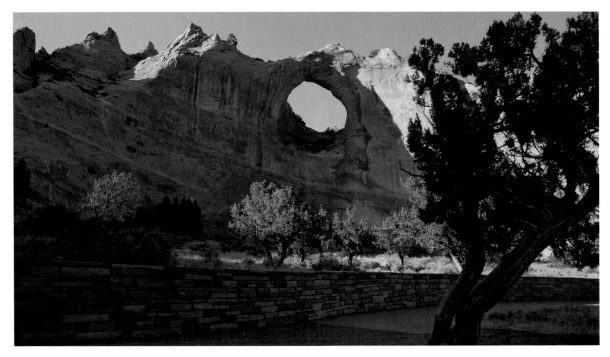

The community of Window Rock takes its name from this natural sandstone arch.

WINDOW ROCK

"Eight minutes late," she said. "In Washington, I could blame it on the traffic. In Window Rock, no traffic to blame it on, so that won't work."

"Eight minutes you don't mention," Chee said. "You have to be a lot later than that to claim you're working on Navajo time." . . .

"What's he doing in Window Rock?"

"What everybody's doing in Window Rock," she said. "He's lobbying." She gestured around the room. The tables in the coffee shop of the Navajo Nation Inn were crowded with Navajos in their best boots and silver and with white men in dark business suits. "When the tribal council's in session

it draws lawyers like, like—" She searched for the proper simile.

"I'd say like a dead sheep draws crows," Chee said. "But since you're a lawyer yourself, I guess I won't."

[CHAPTER 6]

The window was why he'd picked the office over a slightly larger one when he was transferred from Shiprock to Window Rock. From it [Chee] could look eastward at the ragtag southern end of the Chuska range, the long wall of sandstone along which Window Rock had been built and which, because of the great hole eroded through it, gave the capital of the Navajo Nation its name.

He looked out today into a windless autumn

The Navajo Nation's Window Rock, Arizona, headquarters

afternoon. No traffic moving on Navajo Route 23 and a single pickup truck was ambling northward up Route 12 past the Navajo Veterans Cemetery. The trees at Tse Bonito Park were yellow, the roadsides were streaked with the purple of the last surviving October asters, and overhead the sky was the dark, blank blue.

[CHAPTER 8]

ABOUT WINDOW ROCK, ARIZONA

Window Rock, a town of about 3,500 in northeastern Arizona just across the New Mexico border, gets its American name from a graceful natural arch, a portal to the sky carved by the wind and water in the red sandstone. In 1923, the Navajo Nation established its tribal government here, near the arch, a spot traditional Navajos consider holy. Inside the Navajo Nation Council Chambers, colorful murals depict the history of the Navajo people and the Navajo way of life. The tribe's eighty-eight elected council delegates meet here to discuss issues—often in the Navajo language—and enact legislation. When the council is not in session, twelve standing committees do legislative work. Tribal government also has an executive and judicial branch.

The Navajo Nation Veterans Memorial, at the base of the Window Rock arch, honors the many Navajos who have served in the U.S. military.

Window Rock, an area trade center, has a seventy-acre fairgrounds for the annual Navajo Tribal Fair, not only the reservation's largest event but also the biggest festival of its kind in the United States. The fair includes Navajo song and dance awards, a beautiful baby competition—with divisions for tots under a year old and for those 13–36 months—bull riding, a wild horse race, fry

The Veterans' Cemetery north of Window Rock

bread contests, and the crowning of Miss Navajo Nation. The fair fills all hotel rooms in Window Rock. If you want to visit, book early.

Dad wrote about Window Rock in nearly every book because it is headquarters for the Navajo tribal police. He often told me how much respect he had for the Navajo officers because there were so few of them to cover such a huge area. As Don and I followed Chee and Leaphorn around the reservation, a white Navajo Nation police car pulled me over for speeding outside of Window Rock. When the officer saw the name on my driver's license he asked if I was Tony Hillerman's daughter. I confessed, and he told me that reading Dad's novels made him proud to be a cop. He sternly advised me to watch my speed, and let me off with a warning.

THE FALLEN MAN

The Story: Mountain climbers discover a human skull in a climbing helmet on a ledge beneath the peak of the Navajo's sacred Ship Rock on Halloween. As Joe Leaphorn works on the case as private investigator for the widow, Jim Chee, recently promoted to acting lieutenant, investigates a fresh murder 300 miles away. Could the death of a seasoned Canyon de Chelly Navajo guide by a sniper's bullet have anything to do with the aged bones? Of course! Cattle rustling and lawyer Janet Pete add complications on many levels.

Of Interest: Hillerman took a hiatus from Chee and Leaphorn in the early 1990s, turning to other projects including *The Mysterious West*, an anthology of mystery short stories, and *Finding Moon*, a 1995 novel set in Vietnam. He returned with a new character, Officer Bernadette Manuelito, and with Leaphorn in retirement from the Navajo police force working occasionally as a private detective. Hillerman dedicated the book to "members of the Dick Pfaff philosophical society," a tongue-in-cheek acknowledgment of the group he played poker with each week for some thirty-five years.

Tony Hillerman's Comments: "Several notions in my collection of potential story ideas collided for this one. Idea one was to leave a mountain climber trapped atop Ship Rock, as was Monster Slayer in the Navajo origin story. Two was having a custom-made competition rifle firing custom-made ammo used by a sniper on the rim of Canyon de Chelly to assassinate a witness far below. Three was to involve cattle rustling and the anti-rustler tactics of working with 'watchers.' Some of these worked but a half dozen others misfired, forcing me to learn a lot more about serious mountain climbing than I wished."

[FROM *Seldom Disappointed*]

SHIP ROCK

They turned onto U.S. 666 to make the forty-mile run almost due south to Shiprock. With the icy wind pursuing them, the highway emptied of traffic by storm warnings, and speed limit ignored, Bernie outran the Canadian contribution to the storm. The sky lightened now. Far ahead, they could see where the Pacific half of the blizzard had reached the Chuska range. Its cold wet air met the dry, warmer air on the New Mexico side of the ridgeline. The collision produced a towering wall of white fog, which poured down the slopes like a silent, slow-motion Niagara.

"Wow," Bernie said. "I never saw anything like that before . . ."

They crossed the western corner of the Ute reservation, then roared into New Mexico . . . They looked down into the vast San Juan River

basin—dark with storm to the right, dappled with sunlight to the left. Ship Rock stood just at the edge of the shadow line, a grotesque sunlit thumb thrust into the sky, but through some quirk of wind and air pressure, the long bulge of the Hogback formation was already mostly dark with cloud shadow.

[CHAPTER 26]

ABOUT SHIP ROCK

Geologists describe Ship Rock as the most spectacular volcanic neck in the Four Corners region—the area where New Mexico, Arizona, Utah, and Colorado share a border. A stunning landmark, it soars to an elevation of more than 7,000 feet, thirteen miles southwest of the town of Shiprock, New Mexico. Ship Rock is one of many volcanic monoliths populating the Colorado plateau. Other beautiful examples include Agathla Peak near Monument Valley and Church Rock at Kayenta.

In Diné tradition, Ship Rock is sacred, known as *Tse Bitai*. According to one Navajo story, the rock was the great swan that flew here with the Diné on its back. Another story recalls the giant birdlike monsters that once nested on Ship Rock, feeding people they captured to their chicks. The American name dates to U.S. Geological Survey Maps of the 1870, inspired by the resemblance non-Natives saw to nineteenth-century clipper ships.

We spent many evenings watching the light change on Ship Rock, waiting for the perfect photo. The only other people we saw buzzed by

Ship Rock from the north. The Navajo name for it translates as "rock with wings."

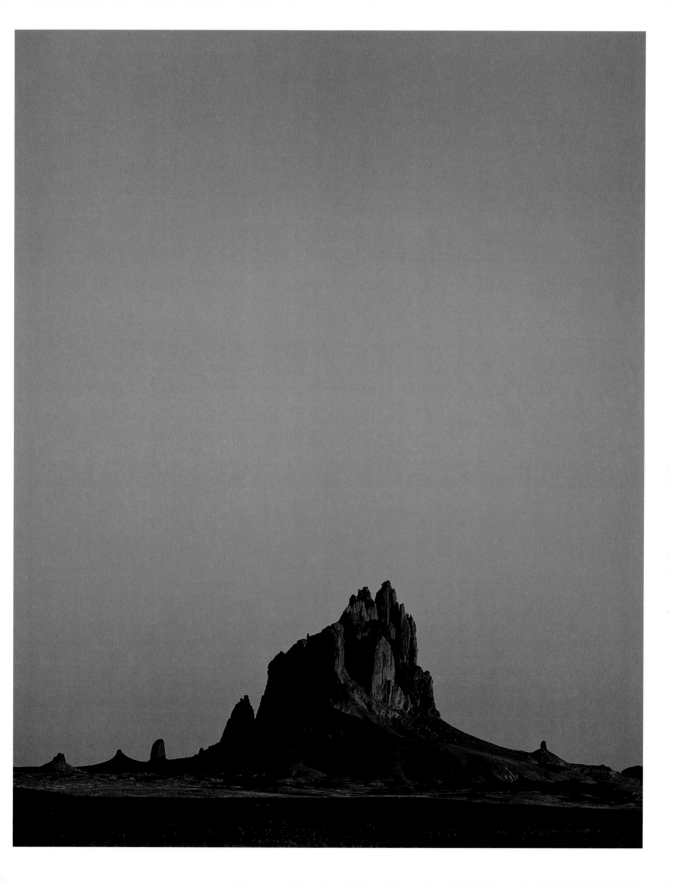

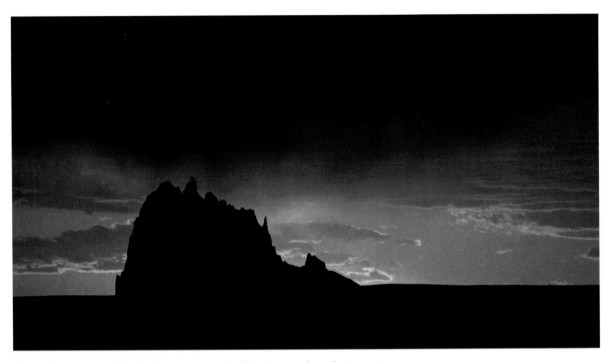

In one Navajo story, Ship Rock rose to carry the Navajo away from their enemies.

in cars, trucks, and SUVs. On one of our expeditions, a motley pair of reservation dogs, a scrawny black mutt and his brown-and-black buddy, joined us for the sunset vigil. They sat quietly, a respectful distance from the tripod, observing us with the ever-present optimism of dogs. They scarfed down our cold French fries and rewarded us with wagging tails.

Dad mentioned Ship Rock in so many books that Don and I had a hard time deciding where to place the photos of this landmark. We put Ship Rock here because, in addition to providing a scenic backdrop to the story, the discovery of a skeleton in a cave on Ship Rock's slopes plays a crucial role in the plot of *The Fallen Man*.

MOUNT HESPERUS

"I think I should go to Shiprock," Elisa said. She looked away from Chee and out the window. "To take care of things. Hal would have wanted to be cremated, I think. And his ashes scattered in the San Juan Mountains."

"Yeah," Demott said. "Over in the La Plata range. On Mount Hesperus. That was his very favorite."

"We call it Dibé Ntsaa," Chee said. He thought of a dead man's ashes drifting down on serene slopes that the spirit called First Man had built to protect the Navajo from evil. First

Mount Hesperus, Colorado

Man had decorated the mountain with jet-black jewelry to fend off all bad things. But what could protect it from the invincible ignorance of this white culture?

[CHAPTER 5]

ABOUT MOUNT HESPERUS

Mount Hesperus, also known as Hesperus Peak, marks the northern boundary of the Dinetah, the Navajo's traditional homeland. The Sacred Mountain of the North, *Dibé Ntsaa* or *Dibentsaa*, it rises in the La Plata Mountains near the southern edge of the San Juan Mountain range, eleven miles north of Mancos, Colorado. The La Platas are the most southwesterly of all the Colorado mountains and Hesperus Mountain, at 13,232 feet, is one of the highest peaks. The English name was inspired by the poem "The Wreck of the Hesperus" by Henry Wadsworth Longfellow. As Chee implies in *The Fallen Man*, the sprinkling of human ashes on a Navajo sacred site would be deeply offensive.

Of all the sacred places Don and I saw, Mount Hesperus sticks in my memory as one of the most spectacular. We came upon it at sunset, having driven all day from Utah. The pink light of February's fading sunset gave a warm glow to the snowy fields around us and to the mountain itself. The air temperature stood at barely above zero and nothing moved anywhere except the light itself.

Spider Rock at Canyon de Chelly

CANYON DE CHELLY

Leaphorn's next stop was seven-tenths of a mile up the rim road from the White House Ruins overlook—the point from which the sniper had shot Nez.... Here the layer of tough igneous rock had broken into a jumble of room-sized boulders.... He looked down and directly across the canyon floor. Nez would have been riding his horse along the track across the sandy bottom of the wash....

They sat awhile (at the bottom of Canyon de Chelly), engulfed by sunlight, cool air, and silence. A raven planed down from the rim, circled around a cottonwood, landed on a Russian Olive across the canyon floor, and perched, waiting for them to die.

[CHAPTER 7]

ABOUT CANYON DE CHELLY

Canyon de Chelly, surrounded by the Navajo reservation, reaches toward the New Mexico border just east of Chinle, Arizona. The red cliffs, rock art, and ruins are protected as a National Monument through joint administration of the Navajo Nation and the National Park Service. The power of windblown sand, streams flowing from the Chuska Mountains, and the steady work of time created this monumental landscape of stunningly eroded sandstone.

For centuries, people also have left their mark.

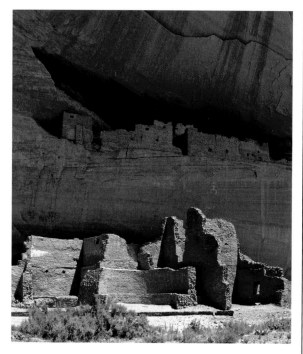

White House Ruins, Canyon de Chelly

Canyon de Chelly is one of the longest continuously inhabited landscapes in North America, home to ancestral Pueblo people, to the Hopi, and to Navajo families who now farm and raise their animals here. Well-preserved stone kivas, cliffside storerooms, living quarters, and an amazing array of petroglyphs and pictographs testify to the canyon's abiding appeal to humans.

Visitors can reach the White House Ruins, one of the most spectacular, from a self-guided hiking trail that winds into the canyon from the rim, about three miles round trip. Instead of hiking, Don and I and his backpack filled with photo equipment took a trip along the canyon floor in a little bus with other visitors and a Navajo tour guide. In addition to an up-close view of the canyon, we heard thrilling stories about the Navajo families who used it as a stronghold against Kit Carson in the days of Bosque Redondo. On one stop, we talked to Navajo jewelers and a musician who played handmade native flutes.

Among the canyon's most impressive geologic features is the sandstone monolith of Spider Rock at the junction of Canyon de Chelly and Monument Canyon. In the Navajo creation story, Spider Woman, the benefactor who taught the Navajo the great art of weaving, lives here surrounded by white bleached bones of the naughty youngsters she punished.

In *The Fallen Man*, Dad used a Navajo guide at Canyon de Chelly as one of the central characters. When my family first visited, probably back in the late 1960s, we were allowed to drive into the canyon on our own. At Thunderbird Lodge, the park headquarters, the staff warned us to look out for quicksand. We kids were delighted when Dad found some, but disappointed that we didn't sink

in up to our chins like we'd seen in the movies. In the final pages of *The Fallen Man*, Leaphorn confronts a murderer on the west rim of Canyon del Muerto, a branch of Canyon de Chelly. The scene includes a heartfelt conversation about the difference between justice and the law and ends with a dramatic suicide.

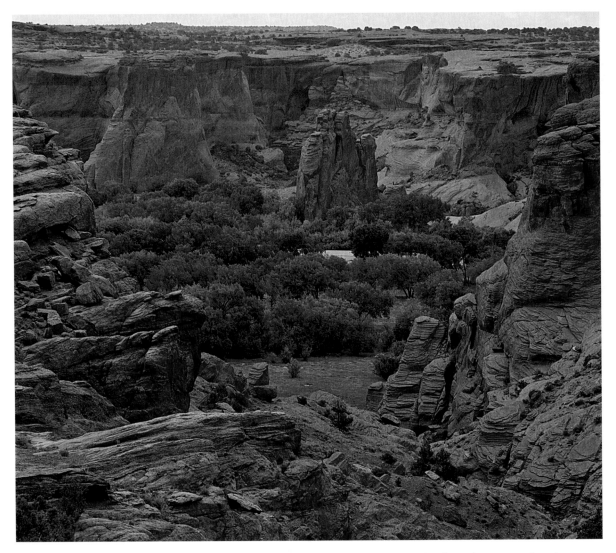

The Navajos took refuge in Canyon de Chelly—a natural fortress—from the conflict and violence that came as first the Spaniards, then the Mexicans, then the Americans pushed westward into the Diné's traditional homeland. On January 6, 1864, as part of the U.S. government's plan to evict the Navajo from their sacred land, Kit Carson led almost four hundred soldiers into Canyon de Chelly. The soldiers burned the hogans, destroyed food supplies, and damaged water sources to force the Navajo on the Long Walk to the Bosque Redondo internment camp.

HUNTING BADGER

The Story: Navajo Tribal Police Officer Jim Chee and private investigator Joe Leaphorn pursue right-wing militiamen responsible for a violent heist at an Indian casino. A stolen airplane, a missing pickup truck, the legend of a mysterious Indian with the ability to fly, and intricacies of interagency law enforcement provide other complications. The book includes the death of Chee's uncle and mentor, Hosteen Frank Sam Nakai. The story unfolds in the strikingly empty country of the Four Corners region.

Of Interest: In a review of this, the fifteenth book in the Chee/Leaphorn series, a critic for *Publishers Weekly* wrote: "Hillerman is in top form." *Booklist* also praised it, noting "Nobody uses the power of myth to enrich crime fiction more effectively than Hillerman." The novel gives Officer Bernadette Manuelito her second supporting role, planting the seed for subsequent appearances in Hillerman's work.

Tony Hillerman's Comments: "An actual crime— odd enough to fill the need of any mystery writer—was the seed from which *Hunting Badger*

grew. I planned to use the sour memories of the event: theft of a water tank truck by three heavily armed men, murder of the policeman who stopped them, an FBI-orchestrated, incredibly bungled, Keystone Cops manhunt, evacuation of Bluff, Utah, quarter-million-buck federal reward offer, which attracted a horde of bounty hunters, vast waste of tax money, etc., as the background for my plot. I thought it would make an easy book to write. It didn't. . . .

"In *Hunting Badger*, I needed an abandoned mine shaft on the margins of the Navajo–Southern Ute territories because I wanted to revive memories of the troubles between those two tribes and the legend of a Ute warrior who raided the Navajos and how he was finally disposed of. I got a lot of help from the U.S. Geological Survey on that one, and spent a lot of time driving over very bad roads on the Arizona-Utah borders. I have always felt that making the reader aware of the vast emptiness of our high desert is important to making the story work."

[FROM *Seldom Disappointed*]

SLEEPING UTE MOUNTAIN AND UTE CASINO

He walked out of the lighted area to check his memory of the midsummer starscape. Most of the constellations were where he remembered they should be. He could recall their American names and some of the names his Navajo grandmother had taught him but only two of the names he'd wheedled out of his Kiowa-Comanche father. Now was the moment his grandmother called

the "deep dark time" but the late rising moon was causing a faint glow outlining the shape of Sleeping Ute Mountain.

[CHAPTER 1]

ABOUT SLEEPING UTE MOUNTAIN AND THE UTE CASINO

Commonly known as Sleeping Ute because of their distinctively human shape, the Ute Mountains are a cluster of peaks that stand in isolation from Colorado's other mountains. Since this is Ute Indian country, they get their name from a perceived resemblance to a Ute Chief dozing on his back with arms folded across his chest. One Ute legend describes the mountain as the form of a great warrior god who fell asleep while recovering from wounds received in battle with "the Evil Ones." Others see the Sleeping Ute as a woman.

Ute Mountain Casino sits at the base of the mountain in Towaoc, Colorado, just outside of Cortez, and about 33 miles north of Shiprock, New Mexico. The casino, the largest in the Four Corners region, draws mostly Native American customers. Don and I spent a night at the casino hotel, in a room with the Sleeping Ute looking down on us from directly outside our window. The casino's dinner special surprised me—an all-you-can-eat seafood buffet!

Hunting Badger opens with a robbery at an Indian-country casino near Ute Mountain followed by a shooting in the casino parking lot.

FACING PAGE, TOP: *Sleeping Ute Mountain*
FACING PAGE, BOTTOM: *Ute Mountain Casino in Towaoc, Colorado, was that state's first Indian casino and is the largest casino in the Four Corners area.*

HOGANS

They found it, and a dusty, bumpy mile later, they came to the place of Madeleine Horsekeeper, which was a fairly new double-wide mobile home, with an attendant hogan of stacked stones, sheep pens, outhouse, brush arbor, and two parked vehicles.

[CHAPTER 6]

ABOUT NAVAJO HOGANS

Dad's detectives frequently talk about hogans, sometimes as homes occupied or abandoned by suspects or witnesses, like the hogan where Chee discovers the runaway girl in *The Ghostway*, and sometimes as ceremonial structures such as the hogan used for the Yeibichai ceremony in *Talking God*. These small buildings, usually rounded, hexagonal, or octagon-shaped, have the entrance doorway facing east. Every traditional Diné family—even if they live in a newer home—has a hogan. The story of the construction of the original hogan is part of the Diné creation legend.

Visitors can tour hogans at the Navajo Nation Park at Monument Valley, Arizona, and at the Navajo Cultural Center at Kayenta, Arizona. Diné College's modern administration and library building in Tsaile, Arizona, and the Tribal Council building in Window Rock, Arizona, are designed as octagons to suggest hogans.

I visited my first hogan at the invitation of a Navajo woman on a trip to Monument Valley in the 1980s. I remember noticing that there was no view from inside the rounded womblike walls; beyond the front door the panorama of unfolding buttes and spires made me feel fortunate to be in such a remarkable place.

The Blessingway, a sacred Diné ceremony, describes the construction of the first hogan. Once commonly used as homes, hogans are now primarily ceremonial.

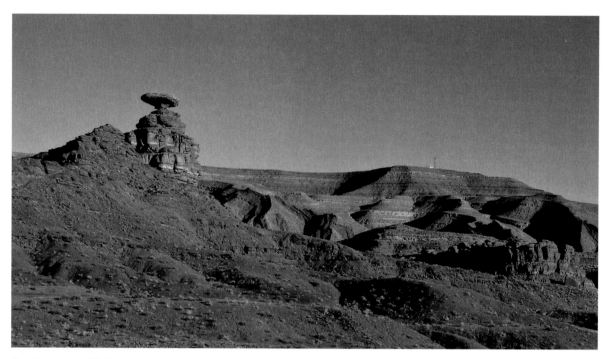

Landscape near Bluff, Utah, including Mexican Hat

BLUFF, UTAH AND THE SURROUNDING LANDSCAPE

The tableland was of multicolored stone carved into a gigantic labyrinth by canyons all draining eventually into the narrow green belt of the San Juan bottom. Multiple hundreds of miles of sculptured stone, cut off in the north by the blue-green of the mountains. The slanting afternoon sun outlined it into a pattern of gaudy red sandstone in deep shadows.

[CHAPTER 20]

ABOUT BLUFF, UTAH AND THE SURROUNDING LANDSCAPE

A small southeastern Utah town, Bluff sits on the San Juan River. To the north rise the 300-foot sandstone bluffs that give the town its name. The Navajo Nation and verdant farmland lie to the east and panoramic landscapes to the west.

Navajos fleeing Kit Carson's troops and the Long Walk found refuge here in the 1860s. Twenty years later, Mormon pioneers established the town of Bluff, arriving after a rugged, five-month, 180-mile winter trek. Their route became famous as the Hole in the Rock Trail. Today, the community offers a stopping place for Navajo country travelers and a base for those rafting the San Juan River. Dad left from here with a group

from the nonprofit Crow Canyon Archaeological Center as part of his research for *A Thief of Time*. The center, founded in Cortez, Colorado, began offering programs to teach the public about the diverse cultures of the American Southwest in the mid-1980s. The campus is just a few miles from the popular Mesa Verde National Park.

Bluff hosts the annual Utah Navajo Fair, usually in mid-September, complete with traditional song and dance, food, craft sales, and a rodeo. In *Hunting Badger*, Dad reminds readers of the actual evacuation of Bluff during an FBI manhunt in 1998, an incident that received hours of sensationalized news coverage in the Four Corners area. Bluff also plays a role in *A Thief of Time* as the place where the missing archaeologist "borrows" a canoe to visit a prehistoric Indian site on the San Juan River.

TOADLENA

Near the crest of Washington Pass [now called Nabrona Pass] he pulled off the pavement onto a dirt track that led through a grove of ponderosa pines. He pulled to a stop at the edge of a cliff and gestured northwest. Below them lay a vast landscape dappled with cloud shadows and late-morning sunlight and rimmed north and east by the shapes of mesas and mountains. They stood on the rimrock, just looking.

Louisa said, "I never get enough of this."

"It's home country for me," Leaphorn said. "Emma used to get me to drive up here and look at it those times I was thinking of taking a job in Washington." *He pointed northeast. "We lived right down there when I was a boy, about ten miles down between the Two Grey Hills Trading Post and Toadlena. My mother planted my umbilical cord under a piñon on the hill behind our Hogan." He chuckled. "Emma knew the legend. That was the binding the wandering child can never break."*

[CHAPTER 24]

ABOUT TOADLENA, ARIZONA AND THE TOADLENA TRADING POST

This small community on the eastern slopes of the Chuska Mountains, about sixty miles north of Gallup, gets its name as an English corruption of the Navajo *to'haalj*, "water flows up," an acknowledgment of the numerous springs here. In addition to its prominence as Joe Leaphorn's backyard, Toadlena is known for its beautiful old trading post, established in 1909 and still in operation. Owner Mark Winter restored the post in 1993, adding a museum to honor the weavers of the area. The museum features many old photographs of weavers, weaving family genealogies and spectacular examples of the Two Grey Hills style.

Perceptive merchants here and at the nearby Two Grey Hills Trading Post worked with Navajo women to develop beautiful rugs with subtle natural colors. Collectors consider rugs from this area among the finest examples of weaving on the Navajo reservation.

In *Hunting Badger*, Leaphorn shares his love of this landscape with Professor Bourebonette. In *The Blessing Way*, readers learn that Leaphorn's grandmother was a well-respected hand-trembler, or healer, in this area of the reservation.

TOP: *The Toadlena Trading Post, between Gallup and Shiprock, New Mexico* BOTTOM: *Near Toadlena, New Mexico*

THE FOUR CORNERS

Four Corners Monument

The TV announcer was speaking "live" from the Federal Courthouse, reporting that the bad guys who had robbed the casino on the Southwestern Ute Reservation about the time Chee was leaving Fairbanks were now probably several hundred miles away.

In other words, safely out of Shiprock's Four Corners territory and too far away to be his problem. . . .

That sounded good to Chee. The farther the better. Canada would be fine, or Mexico. Anywhere but the Four Corners.

[CHAPTER 2]

ABOUT THE FOUR CORNERS

"The Four Corners" refers to that remote spot in the desert landscape where New Mexico, Colorado, Utah, and Arizona share a border. The Four Corners Monument marks the site.

In 1912, the year New Mexico and Arizona became states, the junction was noted with a simple cement pad. Now, visitors will find a granite marker and a large bronze circle surrounded by smaller state seals and state flags. The Ute Mountain and Navajo reservations also abut here.

The Navajo Nation operates the visitor center, open year-round, which features a demonstration area for Navajo artisans. Native vendors sell handmade jewelry, other crafts, and traditional Navajo foods nearby. The park has restrooms and picnic tables, but no running water.

In *Hunting Badger*, Dad makes good use of this empty country as an ideal place for people who don't want to be found to disappear.

THE WAILING WIND

The Story: The plot revolves around an insatiable hunger for gold, obsessive love, and memories of a missing woman's voice sobbing in the darkness. Officer Bernadette Manuelito discovers a dead man in the cab of a blue pickup abandoned in a dry gulch. She finds a rich ex-con's phone number in his pocket and a tobacco tin nearby—filled with gold. Her initial mishandling of the scene spells trouble for her supervisor, Sergeant Jim Chee. Meanwhile an old unsolved crime calls Lieutenant Joe Leaphorn out of retirement and ultimately brings the three officers together on the case.

Of Interest: The story includes Hillerman's first concentrated focus on Officer Bernie Manuelito, the young Navajo policewoman he introduced as a rookie trainee in *The Fallen Man*. *Publishers Weekly* wrote: "The 15th Chee/Leaphorn mystery . . . finds [Mystery Writers of America] Grand Master Hillerman back at the top of his form as his two Navajo peace officers look into both a past and present mystery. . . . Hillerman repeatedly shines in this masterfully complex new novel."

Tony Hillerman's Comments: "I liked those empty bunkers at Fort Wingate and the fact that high school kids walked through there. I had a chance to have one opened up and got to poke around inside the box a little. It was perfectly dark in there. And I've had a longtime interest in hard-rock mining. Some of the stuff I worked in about mining came from some tales I'd heard and filed away, legends of unsolved things people wonder about. I'd already accumulated a bunch of odds and ends that sounded reasonable—Anasazi, Navajo, and Zuni legends. Next thing you know, I had a book."

[FROM *Seldom Disappointed*]

FORT WINGATE

The sun was low now, spreading the long shadow of this hill across the empty road below, and giving a shape to the rows of huge half buried Quonset huts spread for miles below. [Joe Leaphorn] looked at them awhile, watched the shadows spread, counted the bunkers in one section, tried to estimate their number, and finally guessed at a thousand, more or less.

[CHAPTER 8]

They stood engulfed in a rush of warm, stale air and peered into a vast empty darkness . . .

"You think she's in there?"

The only light in the bunker followed them through the doorway. It dimly illuminated a gray concrete floor which stretched six empty feet to the great half circle of gray concrete that formed the back wall. . . .

They found Mrs. Linda Denton . . . lying primly on a sheet of heavy corrugated cardboard behind the empty drums.

She was face down, with her head turned sideways. The cool utterly dry, almost airless climate of the sealed bunker had converted her into a mummy.

[CHAPTER 28]

ABOUT FORT WINGATE

Here's what Dad had to say about this location in one of his rare author's notes:

While The Wailing Wind is fiction, the Fort Wingate Army Ordnance Depot is real. It sprawls over forty square miles east of Gallup adjoining transcontinental rail lines, old Highway 66, and Interstate 40, causing generations of passing tourists to wonder about the miles of immense bunkers. These once sheltered thousands of tons of bombs, rockets, and missiles, but now they are mostly empty. Antelope graze along abandoned railroad sidings. . . .

The fort began in 1850, moved to its present site in 1862. It became a depot for immense amounts of military explosives at the end of World War I, grew with World War II and the Korean War, and became the principal depot for explosives used in Vietnam. Now decommissioned, it is occasionally used by the army to fire target missiles over its White Sands anti-aircraft base, and a few bunkers and other buildings are occupied by government offices.

[FROM TONY HILLERMAN'S
INTRODUCTION TO *The Wailing Wind*]

Don and I visited Fort Wingate on a fiercely cold spring day. The blowing snow, heavy gray

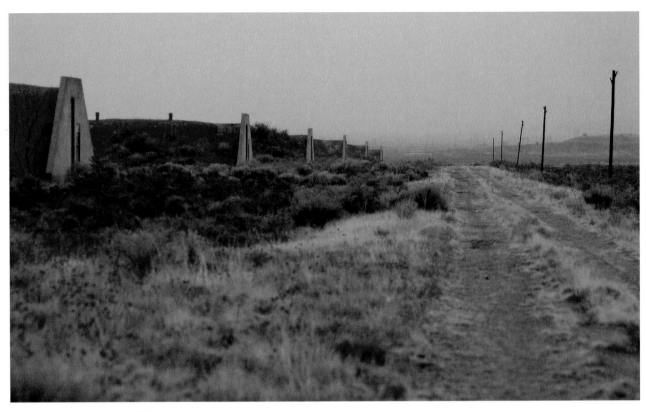

TOP: *The bunkers at Fort Wingate* BOTTOM: *For many decades, the government stored explosives in bunkers such as this one.*

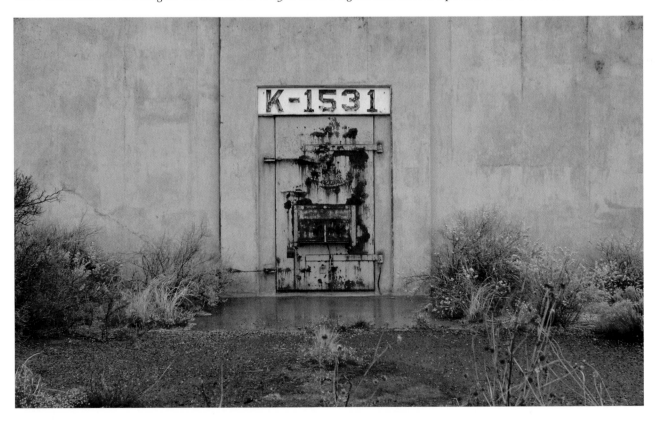

sky, and fields of black mud added bleakness to an already foreboding place. Unlike Dad, we didn't go inside a bunker. We observed the padlocked doors and mounded earth, a cacophonous serenade by ravens gliding overhead providing the soundtrack.

The bunkers play a crucial role in *The Wailing Wind*. Dad used their cold darkness to great dramatic effect in the final chapter, which includes a reference to Shakespeare and Officer Manuelito's decision to leave the Navajo police force—setting the stage, a few books down the line, for her to become Mrs. Jim Chee.

BISTI BADLANDS

She glanced down at the speedometer. Eleven miles over the limit. Oh well. Never any traffic on 371. The emptiness was one of the reasons she loved to drive it. That and passing the grotesque monument of erosion of the Bisti badlands and seeing the serene shape of the Turquoise Mountain rising to the east. Pretty soon now it would be wearing its winter snowcap, and monsoon rains of late summer had already started turning the grazing country a pale green. Enjoying that, she forgot for a moment how arrogant Sergeant Chee had acted.

[CHAPTER 4]

ABOUT THE BISTI/DE-NA-ZIN WILDERNESS

The 45,000-acre Bisti/De-Na-Zin Wilderness would make an ideal science fiction movie set. The steeply eroded sandstone cliffs, mounds, and formation here reflect the work of wind and water over the past seventy million years. Layers of

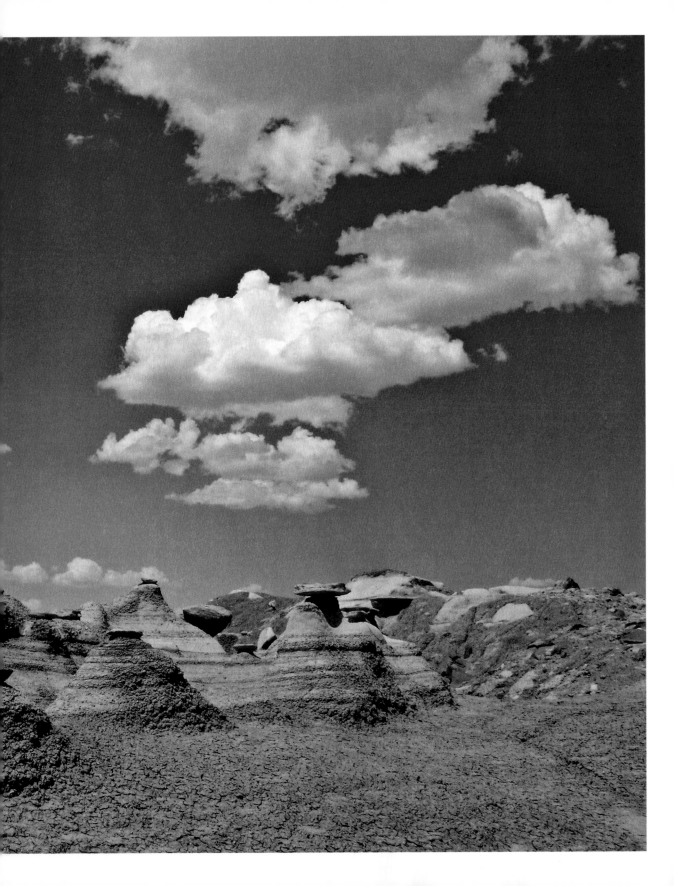

The 45,000 acre Bisti/De-Na-Zin Wilderness south of Farmington, New Mexico, offers miles of scenery with no marked hiking trails.

coal, silt, shale, mudstone, and sandstone of various colors have eroded into eerily rounded formations. Remnants of a harder sandstone caprock protect the softer stone, producing hoodoos that resemble mutant mushrooms or sculpted pinnacles. Hikers have found petrified wood and the teeth and bones of dinosaurs here. Part of the other-worldliness comes from the lack of anything much alive, including human visitors; only the hardiest plants survive.

In the Navajo language, *Bisti* means "a large area of shale hills." The De-Na-Zin wilderness takes its name from the Navajo word for cranes—petroglyphs of cranes have been found south of here. Until 1996, the Bisti and De-Na-Zin were separate wilderness areas but federal legislation added connecting land to create one large wilderness. The Bureau of Land Management manages the area for hiking, camping, and exploring. If you come, bring lots of water!

Dad and Mom visited the Bisti on a cold, gray winter day. I picture him climbing stiffly out of the car following the long drive from Albuquerque and striding over the parched earth into the landscape of hoodoos. Walking, then standing and thinking beneath this huge dome of sky, the silence broken only by the occasional faraway sound of vehicles on the highway.

In *The Wailing Wind*, Manuelito drives past here on her way to visit her favorite uncle. She enjoys the ride, as Dad did, because of its lack of distractions to interfere with the views.

Sheep at Two Grey Hills Trading Post

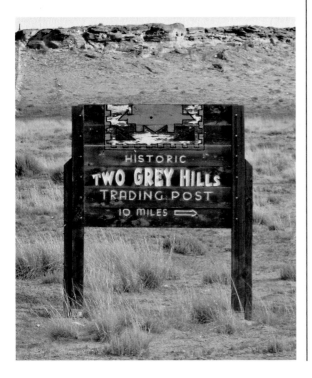

TWO GREY HILLS TRADING POST

[Leaphorn] was relaxing in [a folding chair] under a tree beside the hay barn of the Two Grey Hills Trading Post. The breeze was blowing out of cumulus clouds forming a towering line over the ridge of the Lukachukais . . . a dazzling lightning bolt connected the slope of the mountain with the cloud, producing an explosive crack of thunder. Louisa was selecting a rug from the famous stock of the Two Grey Hills store—a wedding gift for one of Louisa's various nieces. Since the professor took even grocery shopping seriously, and this was a very special gift, Leaphorn knew he had plenty of quiet thinking time. He had been thinking of Louisa's quest for perfection amid the Two Grey Hills rug stock as sort of a race with the thunderhead climbing over the mountain. Would the rain come before the purchase? . . . Or would the cloud climb higher, higher, higher, its bottom turning blue-black and its top glittering with ice crystals, and the blessed rain begin speckling the packed dirt of the Two Grey Hills parking lot, and Louisa, happily holding the perfect collectors' quality rug, signaling him to drive over to the porch to keep the raindrops from hitting it.

[CHAPTER 2]

ABOUT TWO GREY HILLS TRADING POST

Two Grey Hills Trading Post, west of U.S. 491 between Gallup and Shiprock, New Mexico, stands as one of the few remaining authentic trading posts on the Navajo reservation. It does business in the original sandstone block build-

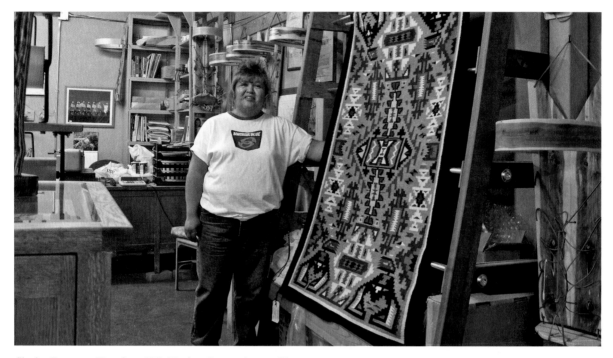

Shirley Brown at Two Grey Hills Trading Post with one of her rugs

ing with a practical metal roof. Situated between the Chuskas and the Chaco mountains, the store has been named to the New Mexico Register of Cultural Properties. It continues to serve the local Diné community, supplying their needs and buying their arts and crafts.

Established in 1897, this store played a crucial role in the development of the classic Two Grey Hills rugs between 1915 and 1925. Two traders, one from the Two Grey Hills post and one from nearly Toadlena, helped Navajo weavers develop the geometric diamond pattern with a black border. Weavers work with hand-spun yarn from the fleece of homegrown sheep in natural shades of gray, brown, black, and white. Collectors around the world covet work from the Two Grey Hills area.

When Don and I visited, owner Les Wilson and his wife, Irma Henderson, treated us like family. After a tour, Les showed us a postcard Dad had sent him, a memento safely stored in the same vault as the classic rugs. I could see Dad, Les, and Irma swapping stories. I remembered how, when people asked Dad where his ideas came from, he jokingly compared himself to a "bag lady." He characterized writers as souls who journey through life collecting scraps of anecdotes, bits of amusing human behavior, and discarded pieces of oddball situations. Some of which, someday, might find a place in a story.

THE SHAPE SHIFTER

The Story: A message from a former colleague about an unsolved case stirs Joe Leaphorn's curiosity. When the man disappears and is later discovered dead, Leaphorn finds himself involved in the tantalizing problem. The puzzle pieces include a priceless Navajo rug with a curse attached, a serial killer, an old woman irate about two missing buckets of piñon sap, and a Hmong houseboy. With Jim Chee and Bernie Manuelito just back from their honeymoon, Leaphorn is largely on his own in this book, his final adventure.

Of Interest: Hillerman's last novel, the book won the Spur Award from Western Writers of America for Best Western Novel. Just as the series began with Leaphorn, so it ended, although Chee and Manuelito play minor roles in the story. Settings include Flagstaff, Arizona, the Crownpoint Rug Auction, and the Jicarilla Apache Reservation.

Tony Hillerman's Comments: "Writing a book is like weaving a rug. All the little details add up to something that starts to grow with a life of its own. Some Navajo weavers actually did work in little pieces of feathers and things in their rugs. There

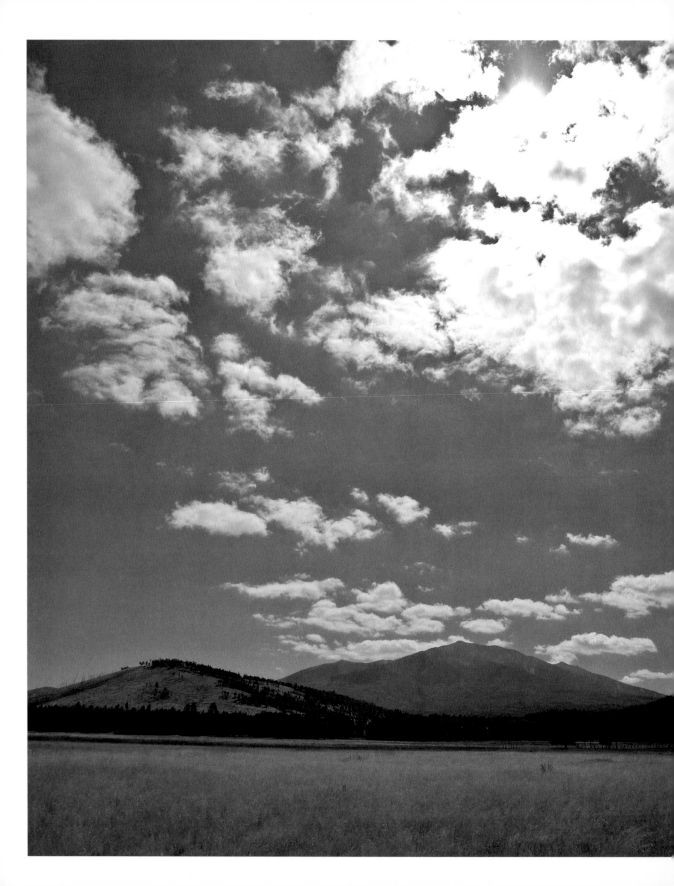

may have been a rug like the one in the book, but it goes against the Navajo tradition of forgetting the bad times and getting on with the future.

"The poison I came up with used to be found in every barn in corn country to keep down the mouse and rat population. Dan [Hillerman, his youngest son] helped me track down an authority on poison who said that, while there's some acidity in cherries, it wouldn't offset the damage of the poison. I had some trouble finding out about the Hmong religion, but I eventually got to a professor back east who gave me some information. I named [Ray] Shewnack after a guy I play poker with and [Mel] Bork after a guy who walks with me. He said he didn't mind if I killed him with a poisoned cherry.

"Mount Humphreys, a peak in the San Francisco Mountains, is where the astronomer from New Mexico State University discovered Pluto."

[FROM A CONVERSATION WITH
ANNE HILLERMAN]

THE SAN FRANCISCO PEAKS

The page was from Luxury Living and a color photograph dominated it. It showed a grand high-ceilinged room with a huge fireplace, a trophy-sized rack of elk antlers mounted above it, a tall wall of shelved books on one side, and a sliding glass door on the other. The glass door offered a view into a walled garden and, above the wall,

San Francisco Peaks, Arizona, sacred mountains to the Navajo, Hopi, and many other Indian tribes

snow-capped mountains. Leaphorn recognized the mountains. The San Francisco Peaks, with Humphreys Peak lording over them. That told him that this luxury home was somewhere on the north edge of Flagstaff.

[CHAPTER 2]

He wasted a few of those [minutes] enjoying this close view of the San Francisco Peaks . . . they were sacred indeed for the Hopis. They recognized Humphreys Peak (at [about] 12,600 feet, the tallest of the San Francisco chain) as the gateway to the other world. The route their spirits used to visit during ceremonials when Hopi priests call them. For the Zunis, as Leaphorn understood from what he'd been told by Zuni friends, it was one of the roads taken by spirits of the . . . dead to reach the wonderful dance grounds where the good among them would celebrate their eternal rewards.

[CHAPTER 12]

ABOUT THE SAN FRANCISCO PEAKS

A landmark for much of northern Arizona, this range is important to traditional Navajo as *Doko'oo'sliid*, "Shining On Top," the sacred mountain of the West. At least thirteen other Native American tribes, including the Hopi and Zuni, consider it holy. The Yavapai-Apache believe the peaks are a blessed place where the Earth brushes against the unseen world. Franciscan missionaries working with the Hopi gave the mountains their name.

The San Francisco Peaks may have been more than 15,000 feet tall before they collapsed into an empty magna chamber about half a million years ago. The central mountain in the complex is Humphreys Peak, 12,633 feet, the highest point in Arizona. The inner basin, recharged when snowmelt and rain percolate through the porous rock, provides much of the water for the nearby city of Flagstaff. Dad invited me to go with him to Flagstaff, the community at the base of these mountains, in the summer of 2006 for a book signing for *The Shape Shifter*, but his declining health denied us the trip.

Don and I drove to the parking lot at the Snowbowl ski area, the place hikers leave their cars to trek into the wilderness. On this early spring day, we were the only people about and the high-altitude air had a bite to it. Don took photos of Humphreys Peak, meadows, clouds, and flowers while I walked, enjoying the smell of evergreens and the brilliant Arizona sky. Dad must have loved this place.

Besides their beauty, the mountains are remarkable for their variety of vegetation. Plants range from those that thrive in arid conditions to those that only grow in the alpine tundra. In addition to *The Shape Shifter*, Dad refers to the peaks as beautiful scenery and markers of the Navajo's sacred land in at least four other novels in the Chee and Leaphorn series: *The Dark Wind, Listening Woman, The Sinister Pig,* and *The Ghostway.*

CABEZON PEAK

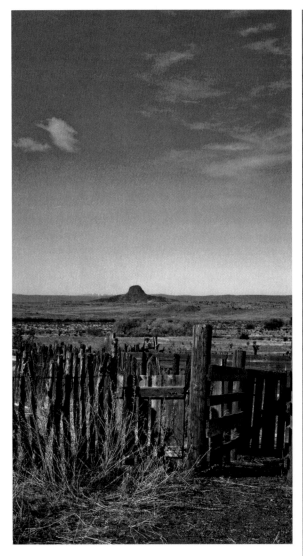

Cabezon Peak, New Mexico, a volcanic neck popular with rock climbers, is mentioned in many Navajo stories. One explains that the peak and nearby lava came from a giant who was slain upon Mount Taylor.

He glanced at the odometer. "In the thirty-one miles since we left Whitehorse we have not passed even one residential place...."

"Look to the south," Leaphorn said, gesturing to the mountain dominating that horizon with enough early winter snowpack to provide a glittery reflection of afternoon sunlight. "The map you have calls it Mount Taylor; it's fifty miles from here, and there is absolutely nobody between us and that mountain."

... Leaphorn gestured at the landscape they were driving through. The eroded slopes of the butte they were passing, the distant mountain ridges, the high, dry semi-desert landscape of rabbit brush, snakeweed, bunchgrass, and juniper and, above it all, a scattering of puffy clouds decorating the clear deep blue of the high country sky....

Leaphorn pointed at Cabezon Peak. "That's his head," he said. "It rolled all the way down there and turned into stone. And Ye-iitsoh's blood flowed down the other side of the mountain and dried into all the black lava flowing along the highway around Grants."

[CHAPTER 16]

ABOUT CABEZON PEAK

With its dramatic basalt cliffs, Cabezon Peak is a New Mexico landmark. Located south of Cuba, New Mexico, the formation is part of the Mount Taylor volcanic field. Cabezon, at 7,785 feet, is the largest of some fifty volcanic necks in the Rio Puerco Valley. The mountain gets its name from the Spanish word meaning "big head." The formation

Scenery from Monument Valley. Without the arch, the design on the right could be Cabezon. (Toadlena Trading Post textile ca. 1970, weaver unknown.)

holds spiritual significance for the Pueblo and Navajo people. One Navajo story explains that the peak is the turned-to-stone head of a giant slain upon Mount Taylor.

As far as I could find, *The Shape Shifter* is the only book in which Dad mentioned Cabezon. It shows up here not as part of the plot but as scenery that so often seems to take on the role of character in the novels. Elsewhere in this final book he described Cabezon as "a great sunlit thumb against a background of scat-tered clouds." As I looked at it, and considered the story that transformed this beautiful mountain into the head of a dead giant, I pondered the notion of things and people, evolving from one shape to the next. I thought of Dad himself and his own "shape shifting" from World War II infantry mortar man to student to reporter to husband, editor, father, teacher, administrator, writer, mentor, and grandfather. And, through it all, remaining a person who appreciated a good story.

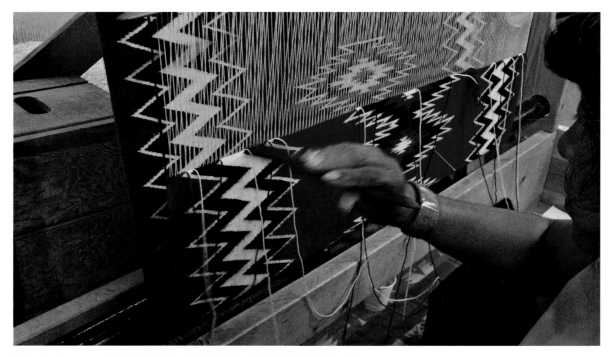
Weaving demonstration by Ruby Jane Hubdard at the Hubbell Trading Post

NAVAJO RUGS

"But are we talking about that Woven Sorrow rug? The one that woman wove after she got back from Bosque Redondo, full of things to remind you of all the death and misery that came out of that business. Was that the rug you're talking about?" . . .

"Ah yes. The magical, mystical rug woven to commemorate the return of the Diné from captivity at Bosque Redondo. Full of bits and pieces supposed to reflect memories of the miseries, starvation, of the tribe's captivity and that long walk home. It was supposed to be started in the 1860s, finished a lot later. That it?"

[CHAPTER 4]

ABOUT NAVAJO WEAVING

Dad lets the reader create a complete picture of the rug crucial to *The Shape Shifter*. I imagine it to be a woven depiction of the longed-for homeland, perhaps with images of the wretched life at the Bosque Redondo camp. Navajo pictorial rugs capture scenes from Diné life: people in traditional dress, hogans, pickup trucks, trains, social dances, and rodeos. They feature an amazing range of designs with mesas, mountains, clouds, sheep, cattle, horses, and deer among the most common. Pictorial weavers have re-created American flags, Mickey Mouse, Santa Claus, and Elvis.

Collectors recognize pictorials among the many types of Navajo weaving coming from some

thirteen weaving regions on the reservation. No two handmade rugs are ever alike but rugs from certain weaving centers on the reservation may have commonalities. No matter how complex the design, traditional weavers hold the patterns and colors in their heads, visualizing the completed tapestry as they work. Weaving is traditionally taught by mother to daughter, although there are excellent male weavers, among them the legendary Hosteen Klah.

Like a weaver, Dad held the plot, characters, setting, and backstory in his head as he wrote his novels, never working from an outline. He mentions Navajo rugs in many of his books, sometimes taking the reader with Chee or Leaphorn to the Crownpoint Weavers Association auction.

Navajo baskets, much rarer than rugs, are usually coiled from three-leaf sumac and were made traditionally for use in healing ceremonies. Pictorial baskets featuring Yei figures, eagles, flags, and other shapes became popular in the 1960s and basket artistry continues to enjoy a renaissance. The section of the Navajo Nation near Bluff, Utah and Monument Valley is a center for basket making.

One of the most memorable characters in *The Shape Shifter*, basket weaver Grandma Peshlakai, gives Joe Leaphorn an angry lecture for his inability to recover two buckets of piñon sap she needs to waterproof her baskets.

BOSQUE REDONDO

The Diné taught its people to live in the peace and harmony of hozho, they must learn to forgive . . . [The rug] memorialized the worst cruelty ever imposed on the Navajo. The Long Walk—the captivity, misery, and the terrible death toll imposed on the Navajo by the white culture's fierce hunger for gold and silver—and the final solution they tried to apply to get the Diné out of the way.

[CHAPTER 2]

"My maternal grandfather used to tell us about freezing to death out there in his winter hogan stories when I was a boy. And then my paternal great-grandfather had his own stories about the bunch who escaped that roundup, and spent those years hiding in the mountains."

" . . . They say that when the Navajo headmen signed that treaty with General Sherman in 1866 and the survivors started their long walk home, that young woman and her sister brought the beginnings of the rug with them and kept working on it, working in little reminders of their treatment. Little bit of a root woven in here, and rat hair there, and so forth, as reminders of what they were eating to keep from starving."

[CHAPTER 5]

ABOUT BOSQUE REDONDO AND THE LONG WALK

The Long Walk to Bosque Redondo was a seminal event in the history of the Navajo and one of the most shameful stories in the sordid chronicle of U.S. government's dealings with Native Americans.

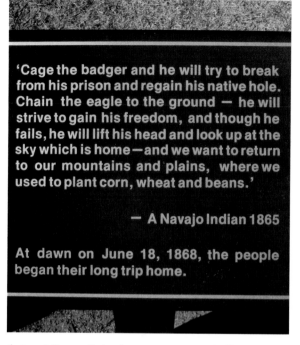

'Cage the badger and he will try to break from his prison and regain his native hole. Chain the eagle to the ground — he will strive to gain his freedom, and though he fails, he will lift his head and look up at the sky which is home — and we want to return to our mountains and plains, where we used to plant corn, wheat and beans.'

— A Navajo Indian 1865

At dawn on June 18, 1868, the people began their long trip home.

A sign at Bosque Redondo commemorating the Diné return to their sacred lands

Treaty Rock at Bosque Redondo

The army forcibly removed thousands of Navajos from their traditional homeland and forced them to walk, sometimes as far as 400 miles, to a desolate prison camp in southeastern New Mexico. Some 8,000 or more Diné, driven out by the army's relentless destruction of homes, crops, and livestock, surrendered with the promise of peace and protection. Instead, they sickened and starved on contaminated and insufficient food. They froze without adequate clothing and shelter, suffered the attacks of Indian enemies, and saw their children kidnapped to be slaves. Nearly one-third of the captives died. The Navajo name for Bosque Redondo is *Hweeldi*—place of suffering.

The Long Walk took almost two months. The Navajo arrived in more than fifty separate groups over a period of about three years, beginning in August of 1863. General James H. Carleton planned for about 5,000 Indians but the camp at one time contained at least 9,000 Navajo and Mescalero Apache.

General William T. Sherman of Civil War fame came to Bosque Redondo to negotiate the Treaty of 1868, establishing the Navajo reservation and recognizing the tribe as a sovereign nation. If the Diné agreed to cease raiding and observe much-reduced reservation boundaries, Sherman offered to send them home. He promised that America would help liberate their children from slavery and provide seed, livestock, and tools for a new start.

At sunrise on June 18, 1868, about 7,000 Diné began the joyful journey back to their sacred

land. Walking in a ten-mile-long column, they put Bosque Redondo behind them and went on to become one of the most powerful Indian tribes in the United States. More people speak Navajo than any other Native language.

Don and I started our tour of Bosque Redondo at the museum designed by Navajo architect David Sloan and shaped like a hogan and a tepee to honor the Apaches also imprisoned. We walked the dirt path to Treaty Rock, the birthplace of the modern Navajo Nation. Some people have left mementos in honor of those incarcerated. Beyond, we glimpsed ruins of Fort Sumner where troops in charge of the Indian prisoners lived. The monument is near Fort Sumner, New Mexico, about 300 miles southeast of Gallup.

When the state of New Mexico dedicated this $3.5 million museum in 2005, an official invited Dad to speak at the ceremony. He declined, saying that honor should be reserved for the Navajos themselves. In *The Shape Shifter* (and the other novels as well) Leaphorn and the other characters never come here, but the Long Walk and its role in Navajo history is frequently mentioned in Dad's books.

The oppressively hot, humid summer day of our trip was oddly silent; we were the only visitors. The place brought me to tears. Unlike the landscape of the Navajo homeland, beauty is hard to find here. Still, I'm glad I had a chance to see it.

A shrine at Bosque Redondo

An old cottonwood log at Bosque Redondo

Tony Hillerman

AFTERWORD:
WHY LOS RANCHOS?

TONY HILLERMAN

SINCE WRITERS OF fiction are free as the proverbial birds, they can live anywhere they wish. Right? So why do I live in little Los Ranchos, New Mexico, when everyone, including my mailman, seems to think I actually live in much larger Albuquerque? Or, for that matter, why not move to Hawaii, or that little place with the great beach where Ernest Hemingway hung his hat when he stopped roaming?

The answer: Albuquerque is too big for a bona fide country boy, and neither Hawaii nor Hemingway's little island offers the odd mixture of social, geographic, ecological, and historical delights I enjoy here. And all in a high and dry climate, forested mountains in every direction, and plenty of open spaces when you need a lonely moment. Our high, dry climate, combined with our mountains and the good luck of being first settled by agriculturally minded Pueblo Indians, soon joined by Hispanic explorer-soldiers-farmers, gave us irrigation ditches.

My door is maybe 200 yards from the Griego y Gallegos lateral, which is my favorite ditch. When

the need to flee from my desk and its clutter of unanswered mail and undone work hits me, that ditch offers a smooth path, lots of shade, endless rows of backyards to look down into if the yard dogs aren't barking at you. If I skip over to the Rio Grande bosque, the natural forest shading it, I find my fallen cottonwood log, which I have rested upon enough now to have worn the bark comfortably smooth. There you watch the Rio Grande roll past en route to the Gulf of Mexico, enjoy the silence, and think yourself though that problem you have managed to tangle your characters into in chapter 13.

The ditches also offer bonuses. When the autumn comes I sometimes head northward on my G y G lateral. Earlier generations of ditch walkers seem to have brought along apples and then dropped the cores into the ditch. There the seeds eventually sprouted. About a dozen steps north of my bridge a scrawny apple tree has survived amid the ditch-side competition. The apples it produces in July are small, bright red, and downright delicious, but they don't last long. That's partly because when summer vacation time arrives the young ladies whose parents live out here bring their daughters home for that vacation period. Then the ditches become ideal routes for leisurely horseback rides for these folks and the friends they bring along. The girls like the apples, too, and so do their horses.

When the apples are gone, I sometimes amble south down the G y G lateral. About 200 yards down you reach a "T" where the ditch splits. About half is diverted eastward and what's left pours westward over a neat little waterfall. This ditch waters the gardens of neighbors who live behind my house, divides again to provide water for

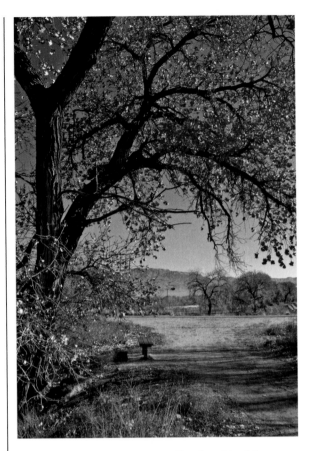

The Rio Grande Bosque near Los Ranchos, New Mexico

another housing addition next to the Rio Grande and, finally, dumps what's left into the river. In this terminal lap, it has watered a little collection of blackberry bushes and some asparagus roots. And no asparagus is tastier than the wild stuff.

Getting your share of ripe blackberries is chancy, because the robins and other birds have found them and stick around waiting for the berries to get big, fat, black, and sweet. Last summer the birds left me only fourteen eatable berries, and some other walker harvested my asparagus before I got there. However, a bit later in the summer, I turned northward at the G y G junction, jaywalked across Rio Grande Boulevard where the ditch is tunneled under the pavement, and followed it into the open fields. There one finds an old vineyard with not many plants left except those of a species that produces small bunches and small fruit. Early comers may have harvested the best of them but you want to get there anyway for the open view.

Just to the east, Sandia Mountain dominates the horizon. If you see it in the autumn sunset light you understand why the Hispanic settlers named it for their juicy red watermelon. That slanting sunlight turns its granite slopes red. Just south of the Sandias is the less impressive Manzano range, the locale of a nuclear weapons laboratory. If you find a good view to the north you'll see the Jemez Mountains, home of the Jemez tribe and site of Los Alamos National Laboratory where we built atomic bombs. It's also some of our most beautiful landscape.

However, to impress visitors I take them up Tramway Avenue to the base of the Albuquerque ski operation. There you board America's longest lift, which takes you from about a mile and a quarter above sea level to unload at about two and a quarter miles above sea level. Now you have easy access to my favorite view. At the rim, you look down at the city of Albuquerque spread below your feet. To the west along the green line of the Rio Grande bosque, you can see the roof of my house in Los Ranchos, and across the river, the burgeoning city of Rio Rancho. Beyond Los Ranchos, the peak of what our maps call Mount Taylor juts into the sky.

The Navajo account of their arrival here explains that First Man, after helping the tribe escape the flooding underworld into our Earth Surface World, built that mountain to mark the southern boundary of Navajo territory. He decorated it with blue turquoise beads, pinned it to the earth with a stone knife, and assigned two other Holy People (Yellow Corn Girl and Turquoise Boy) to live there as its protectors. I dearly love that legend.

From the rim of Sandia Mountain, I see dozens of other places—mountain ranges, cliffs, buttes, canyons, ruins, and so forth—where important religious figures did interesting deeds, affecting what has happened there. Many of these landscapes are enriched by explanations of their holiness. The landscapes and the stories behind them provide an endless list of pleasant subjects to ponder while doing your ditch walking. And, come to think of it, the people who tell me these Native American accounts of creation are the major part of the reason why I live where I do—in the Los Ranchos segment of the Duke City [a nickname for Albuquerque] part of the American West.

Editor's note: Tony Hillerman wrote this piece at the request of HarperCollins in 2006 to be included in an anthology about why authors live where they do. The book was never published.

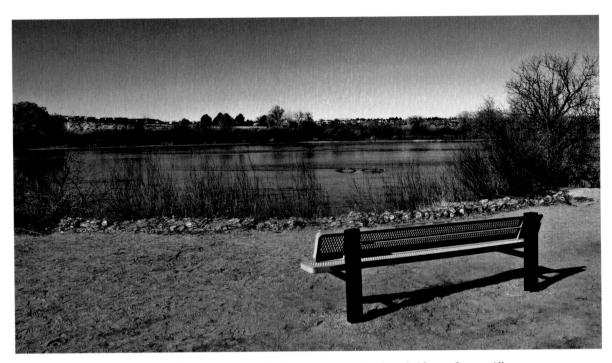

Dad's favorite bench with a view of the slow-moving Rio Grande near the Rio Grande Nature Center, Albuquerque

ACKNOWLEDGMENTS

Don and I would like to thank the many people who encouraged and supported us on this wonderful project—too many to mention them all by name. We offer special appreciation to Carolyn Marino, Tony Hillerman's longtime editor and friend at HarperCollins; Navajo Nation president Dr. Joe Shirley Jr.; the 2009 Zuni Tribal Council and Gov. Norman Cooeyate; Robyn Duncan and Brownwyn Fox-Bern of Santa Fe's Keshi Gallery; Laurance D. Linford, author of *Tony Hillerman's Navajoland*; Dan Simplicio Jr.; Judy Richardson and the kind folks at Richardson's Trading Post in Gallup; Rod Kaskala; Rick Snow of TPL, Inc.; Les Wilson and Irma Henderson of Two Grey Hills; Charles Hatch and the crew at Hatch Trading Post; pilot Ron Suess of Maverick Helicopter Tours Grand Canyon; Irving Nelson of the Navajo Nation Library; David Beers and Diana Ohlson; Casey Dukeman; and the staff and volunteers of the Wildlife Center near Espanola, New Mexico. Sally Kim and Maya Ziv kept us on track and on deadline; Cindy Bellinger, Rebecca Carrier Smith, and Jann Arrington Wolcott read early proofs of the book and offered great insights. And especially to Marie Hillerman for her memories, endless encouragement, and finely honed editing skills.